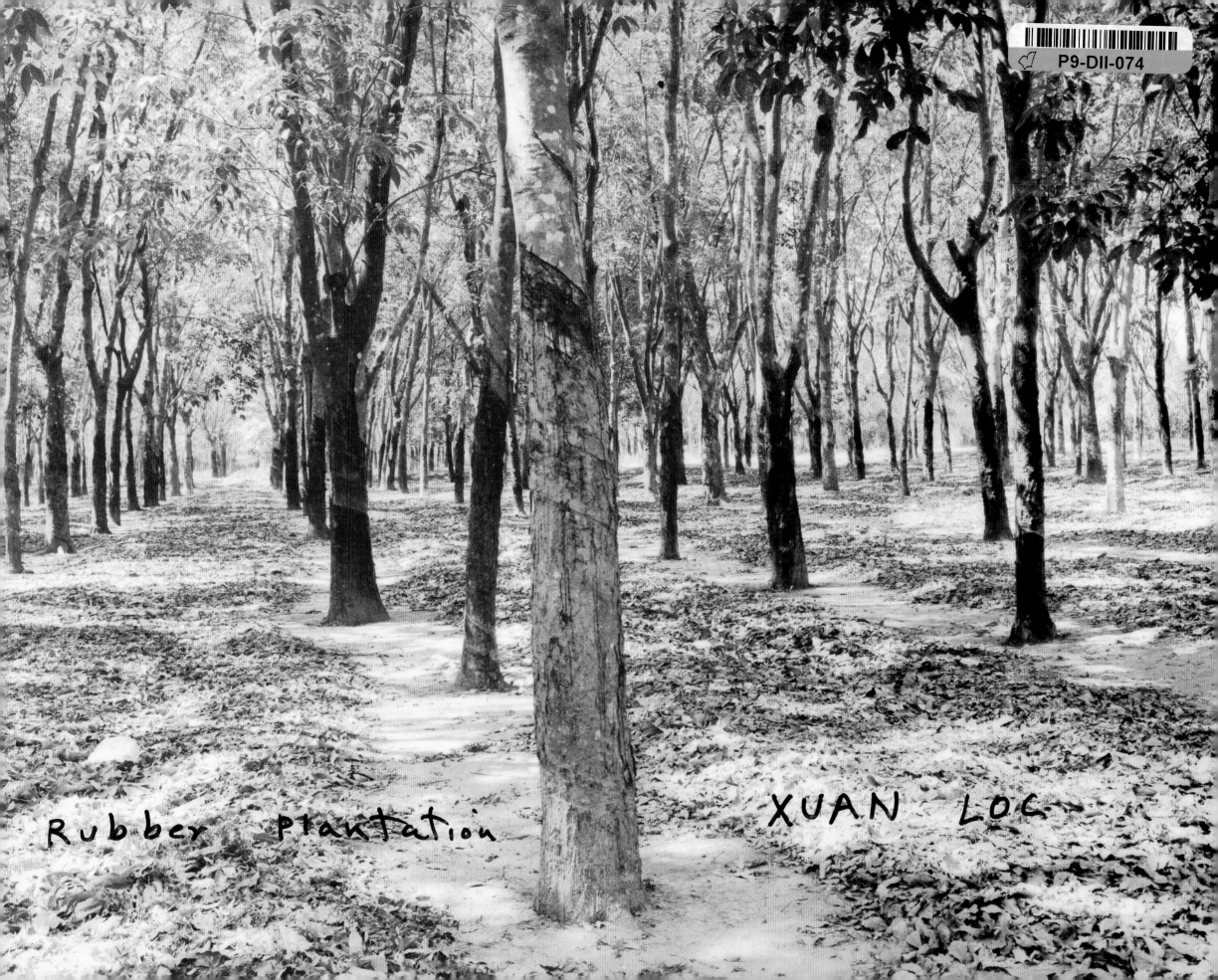

Rubber plantation

XUAN LOC

AUTREFOIS, MAISON PRIVÉE

B. N. Burke

pH powerHouse Books New York, NY

"Before (once upon a time), private house.
Now, police station.
In Sihanouk's time, movie theater.
Today, headquarters of the Party."

"Autrefois, maison privée,
Maintenant, poste de police.
Temps de Sihanouk, cinema.
Aujourd'hui, bureau de la Partie."

Spoken quietly over my shoulder by my cyclo driver. Phnom Penh, 1988

Dear Excellency and friend,

 I thank you very sincerely for your letter and for your offer to transport me towards freedom. I cannot, alas, leave in such a cowardly fashion. As for you and in particular for your great country, I never believed for a moment that you would have this sentiment of abandoning a people which has chosen liberty. You have refused us your protection and we can do nothing about it. You leave and it is my wish that you and your country will find happiness under the sky. But mark it well that, if I shall die here on the spot and in my country that I love, it is too bad and we all are born and must die one day. I have only committed this mistake of believing in you, the Americans. Please accept, Excellency, my dear friend, my faithful and friendly sentiments.

Sirik Matak

Note from Prince Sirik Matak to U.S. Ambassador, John Gunther Dean, April 12, 1975
 That day, Dean closed down the U.S. Embassy and left the country in a helicopter while the advancing Khmer Rouge rocketed the capital from across the Mekong River and the Tonle Sap. Five days later, the Khmer Rouge took control of the city and Matak sought refuge at the French Embassy with all the Westerners remaining in Phnom Penh. After a few days, the invaders demanded that anyone inside the French Embassy compound, not holding a foreign passport, be turned over to them. Matak, who was high on the Khmer Rouge's enemy list, was likely executed very shortly.
 In 1970, Prince Matak and General Lon Nol had coauthored a coup against Matak's cousin, Prince Norodom Sihanouk. For the following four years, glad to be rid of Sihanouk, America shined its favor on the Lon Nol regime while bombing Vietnamese bases in Cambodia and Laos. Meanwhile, the Khmer Rouge gained strength in the countryside and consolidated control of Cambodia as the North Vietnamese and Viet Cong defeated the American backed government in South Vietnam.

Woman and elephant, Phnom Penh, 1994

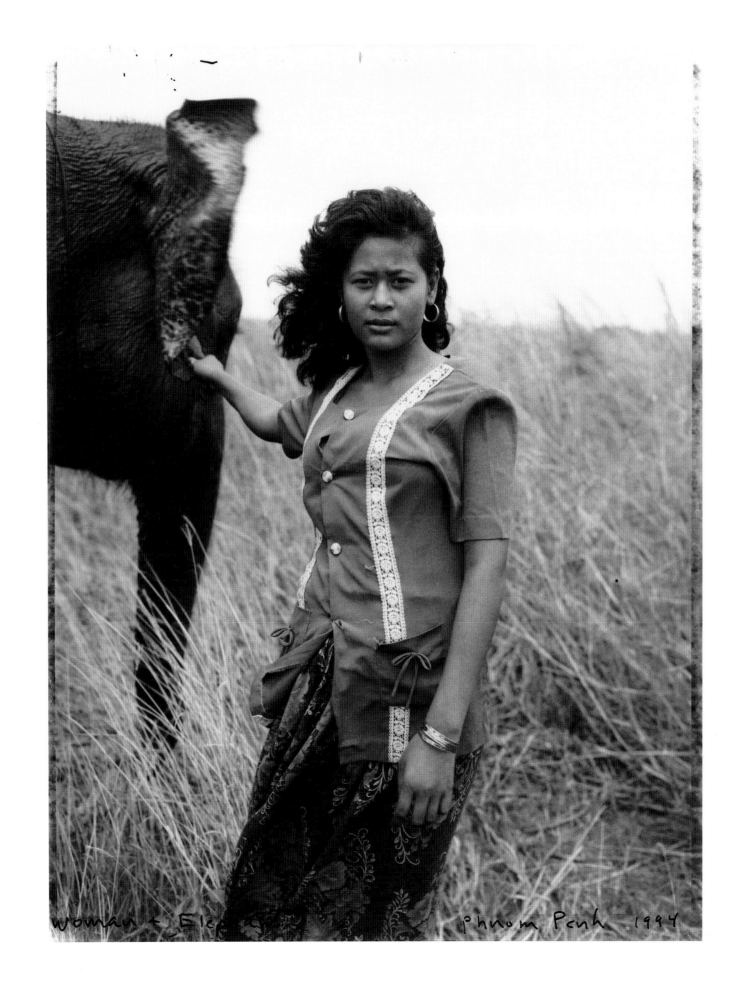

woman + Ele... Phnom Penh 1994

Man with pigs, between Kampong Thom and Siem Riep, 1995

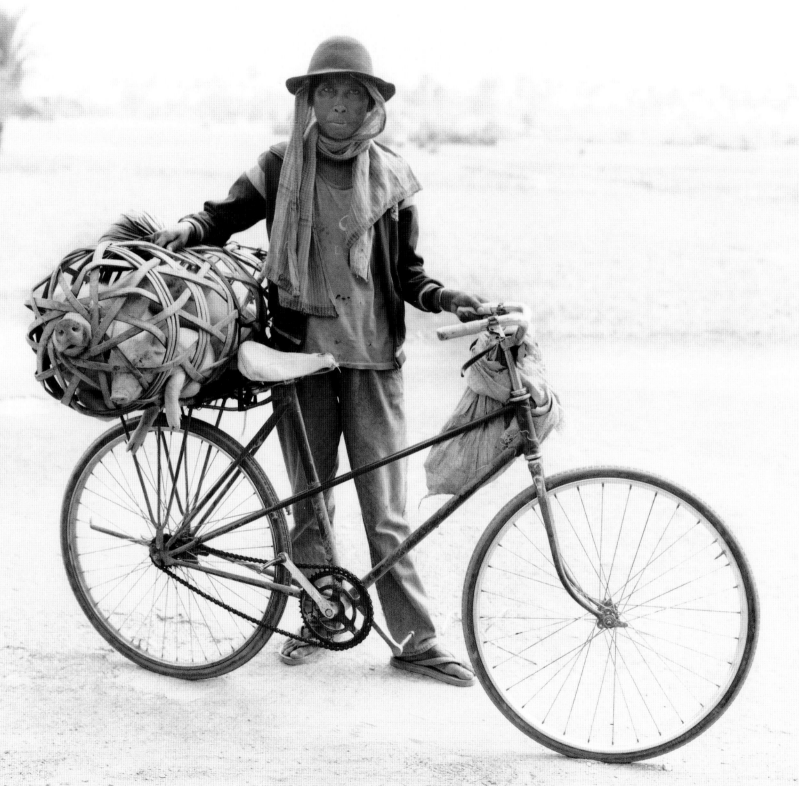

Man with Pigs 1995 between Kampong Thom & Siem Riep

Cooking fuel processor, Hanoi, 1995

Cooking Fuel Processor Hanoi 1995

Brick production, near Hanoi, 1994

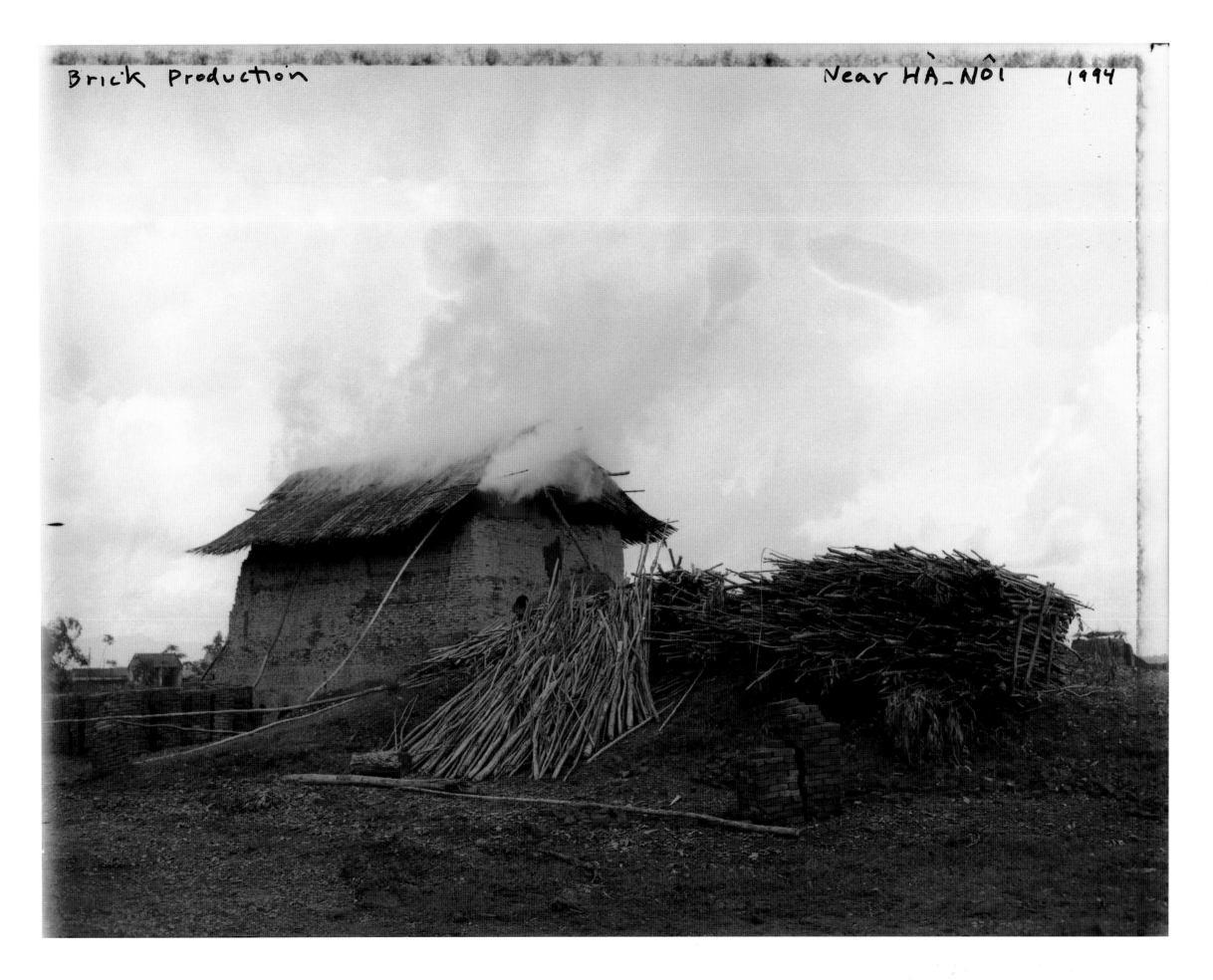

Brick production, Hanoi, 1995

Brick Production Hanoi 1995

Wood house, Vientiane, 1996

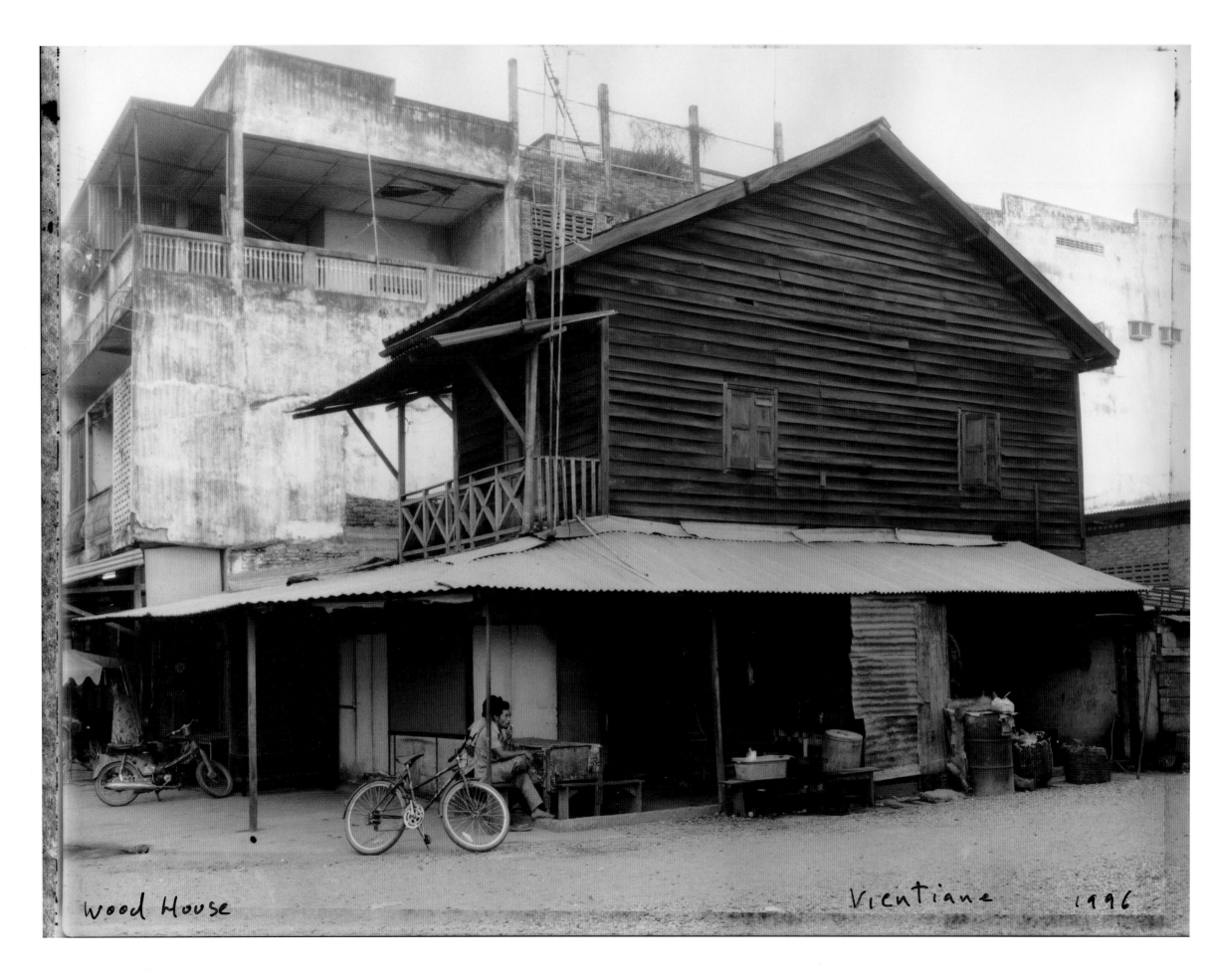

Wood House Vientiane 1996

Brothel, Pailin, 2000

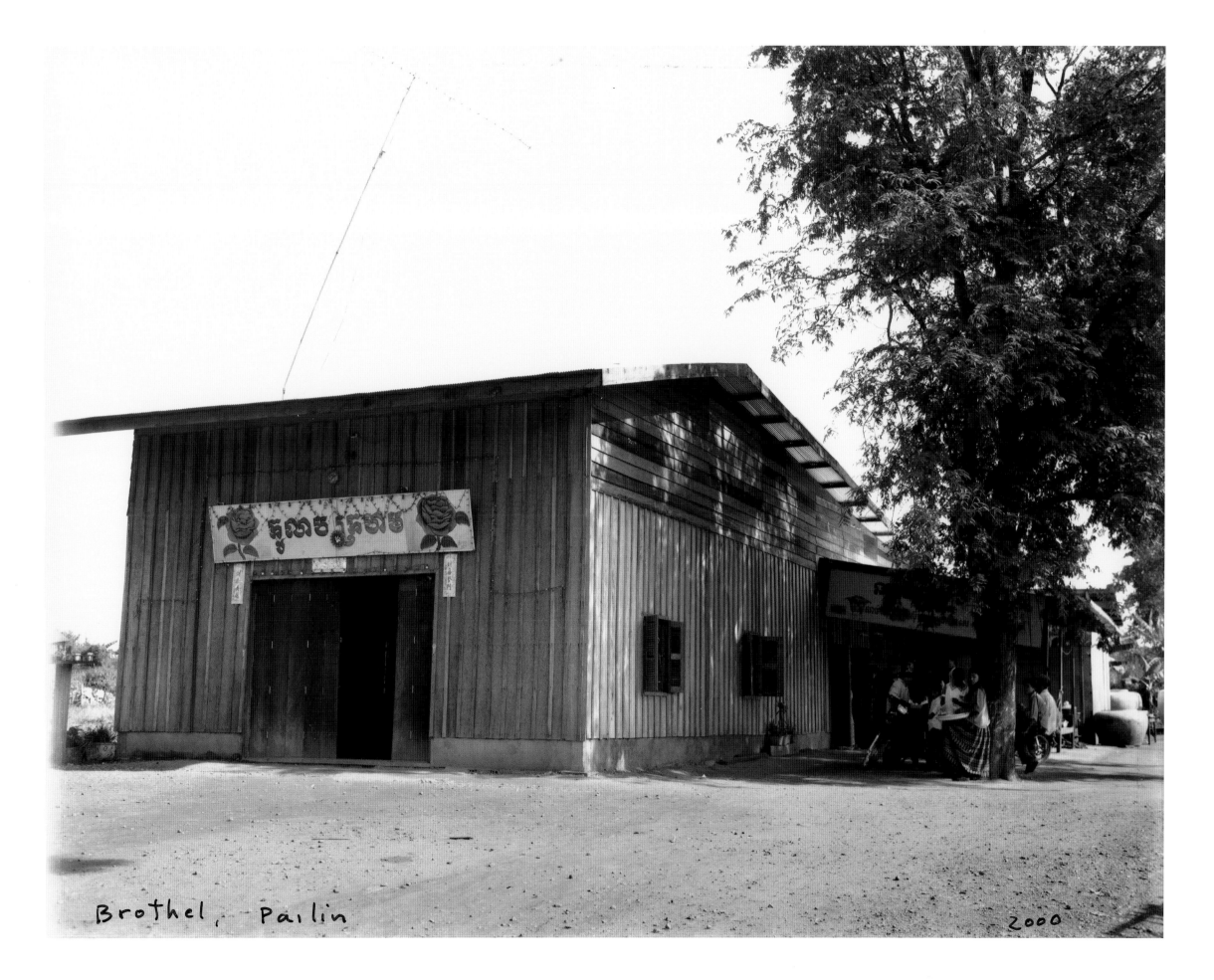

Brothel, Pailin

2000

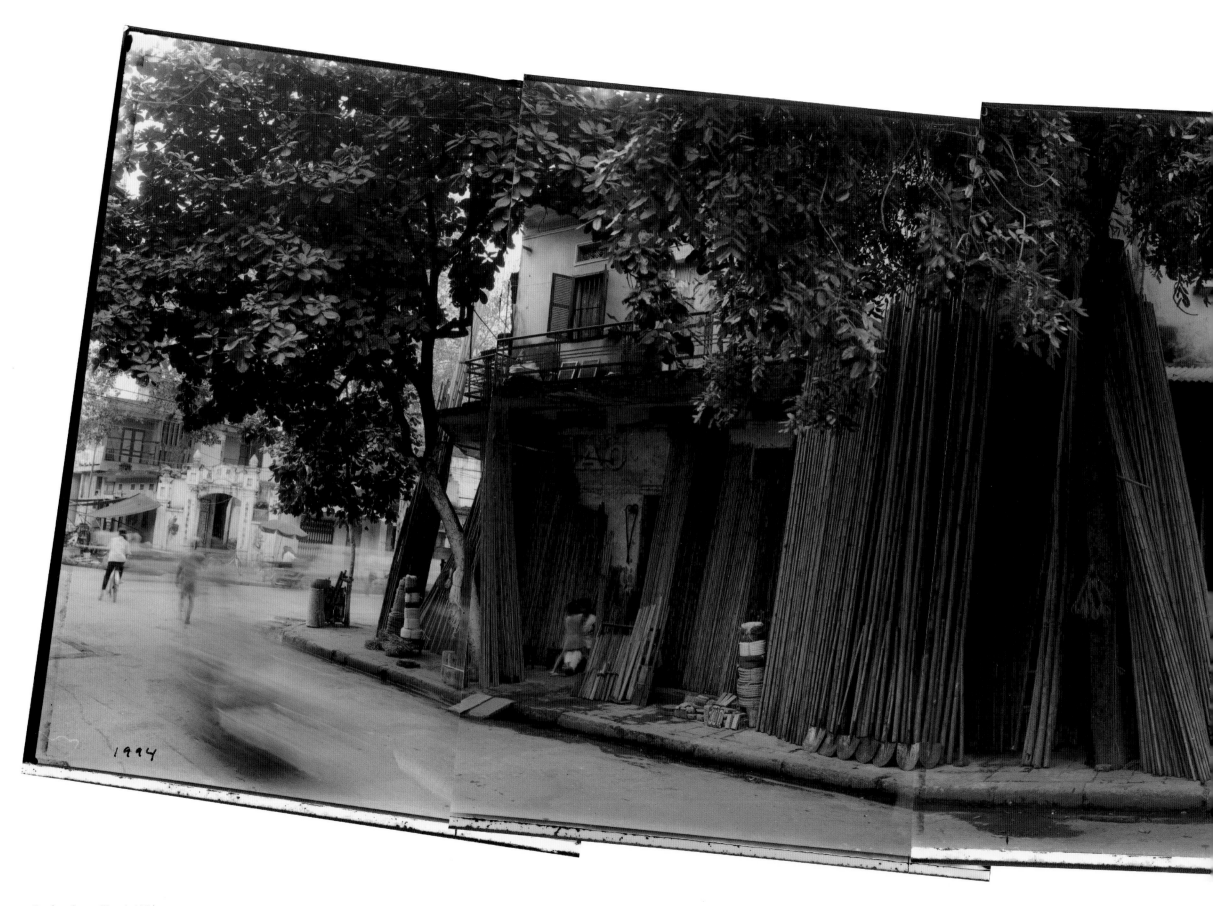

1994

Bamboo Street, Hanoi, 1994

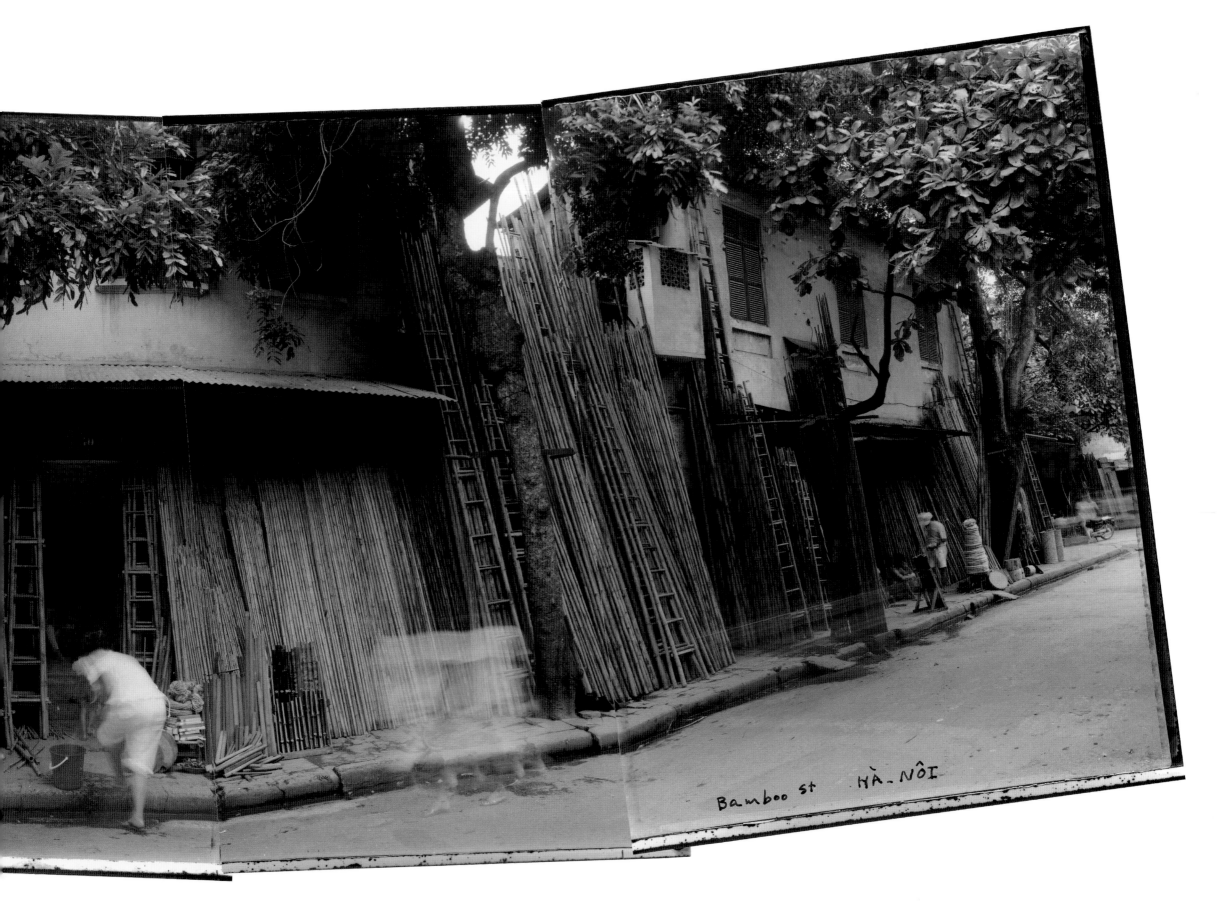

Bamboo St HÀ-NÔI

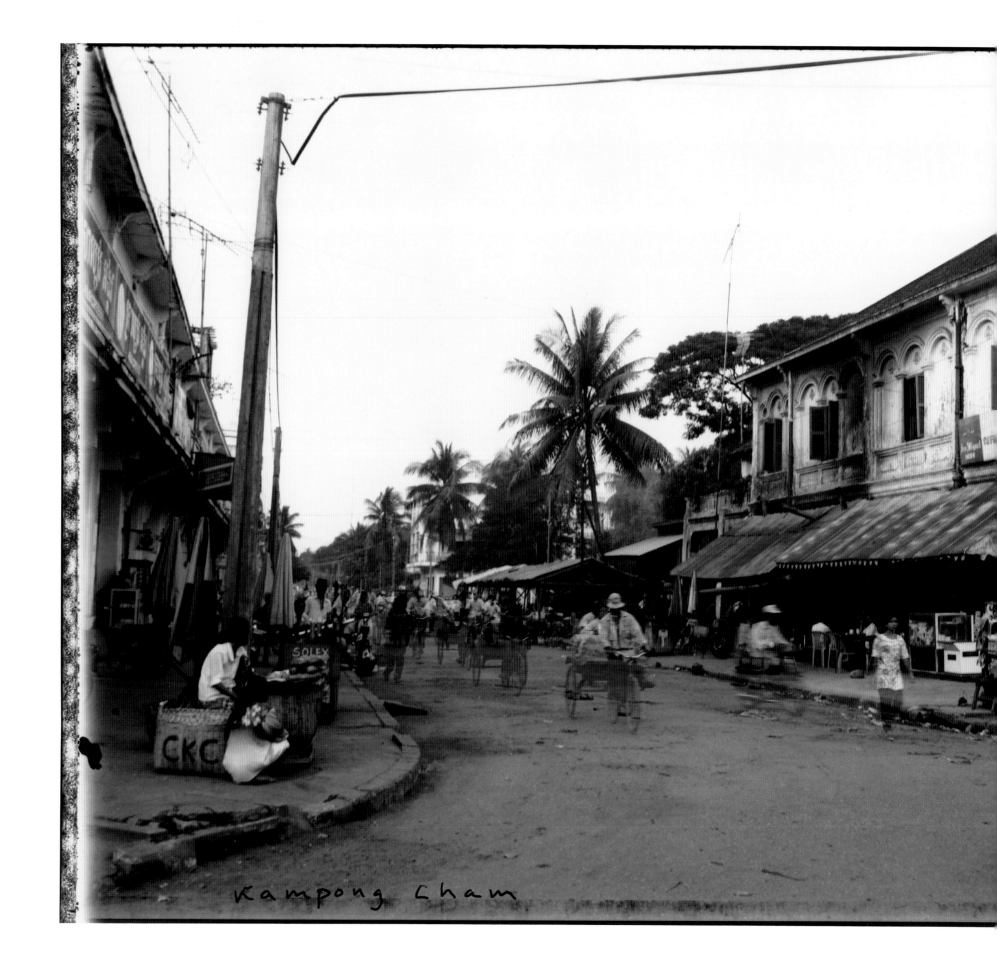

Kampong Cham

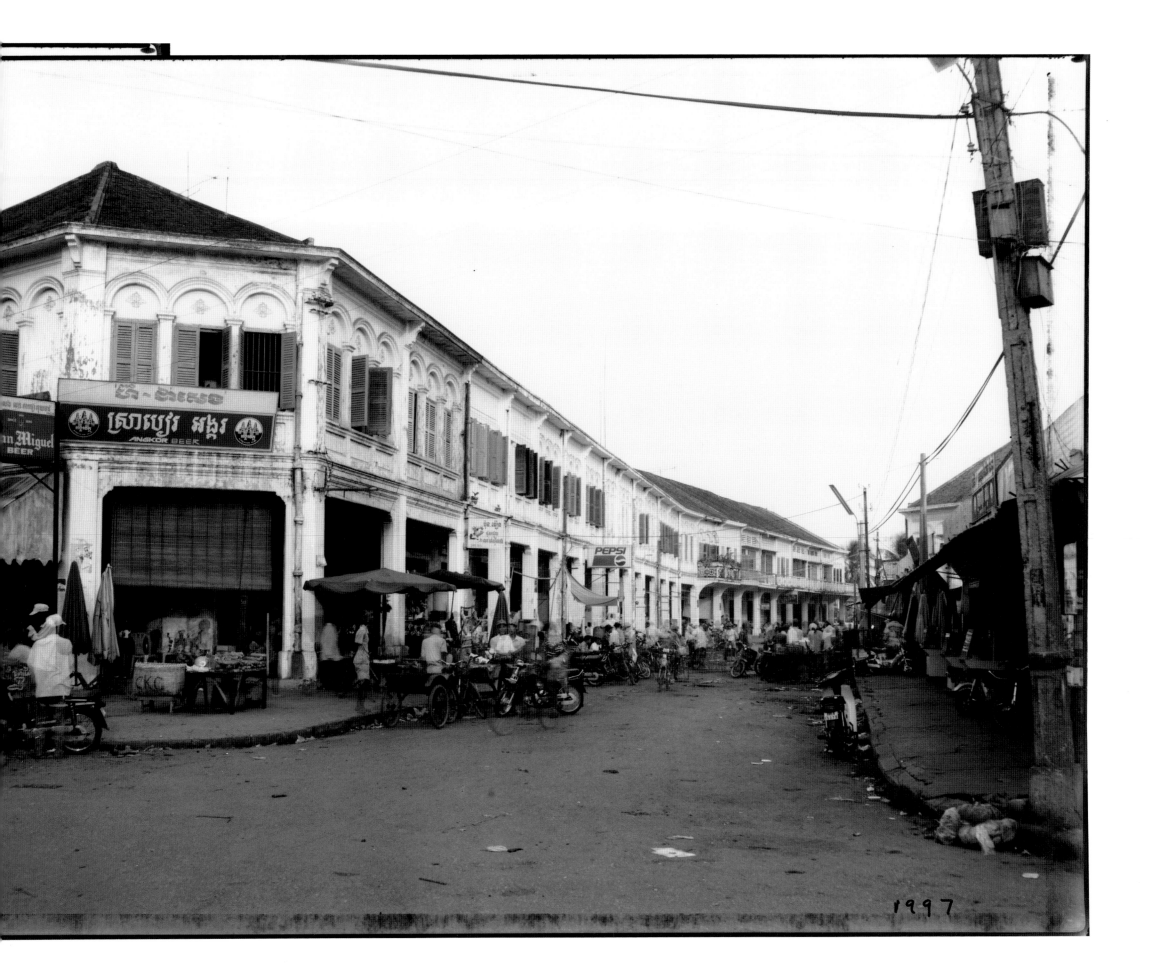
1997

Ministry of Finance, originally built as the office of the Resident Superior, the highest ranking French official in Cambodia, Phnom Penh, 1995

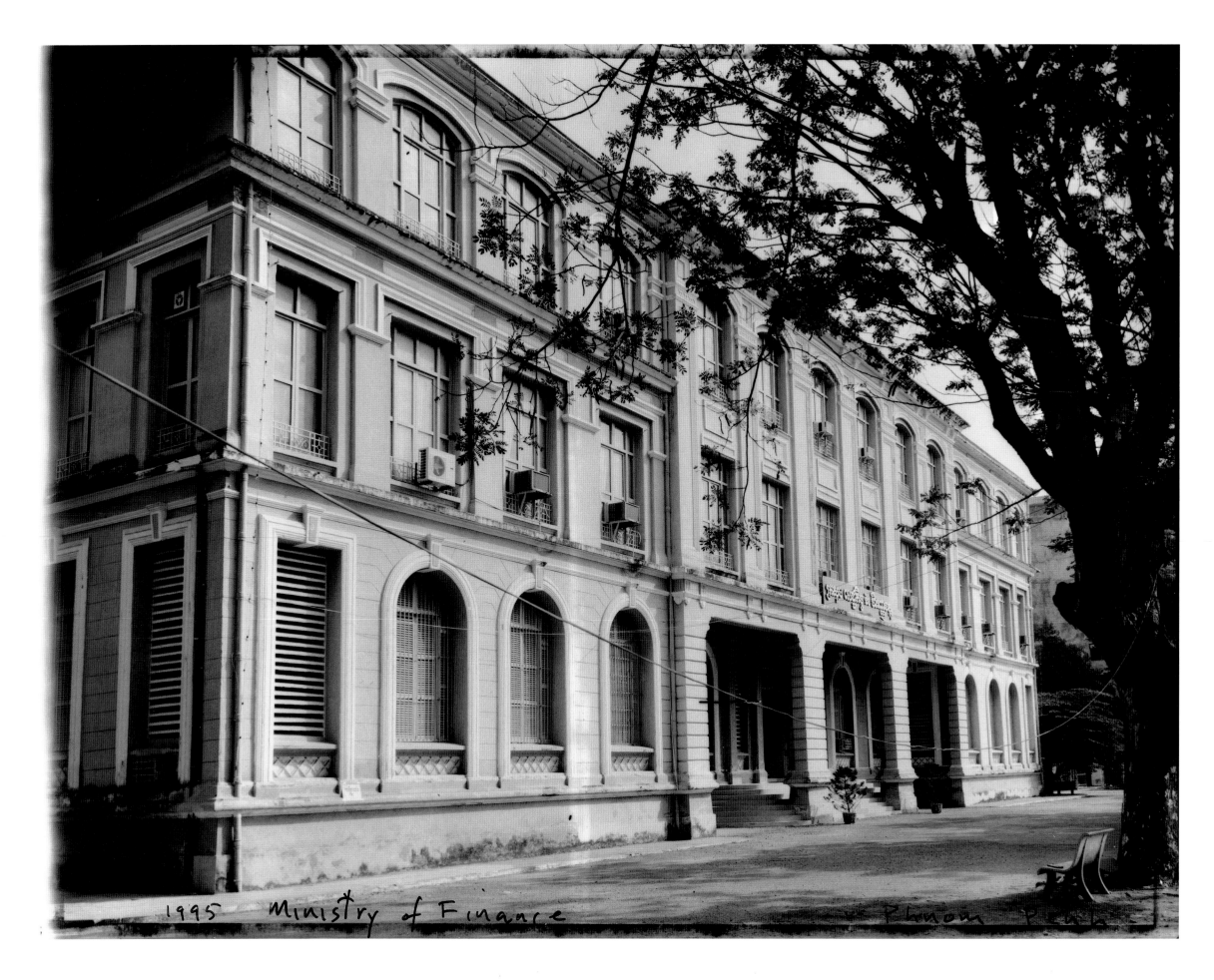

1995 Ministry of Finance Phnom Penh

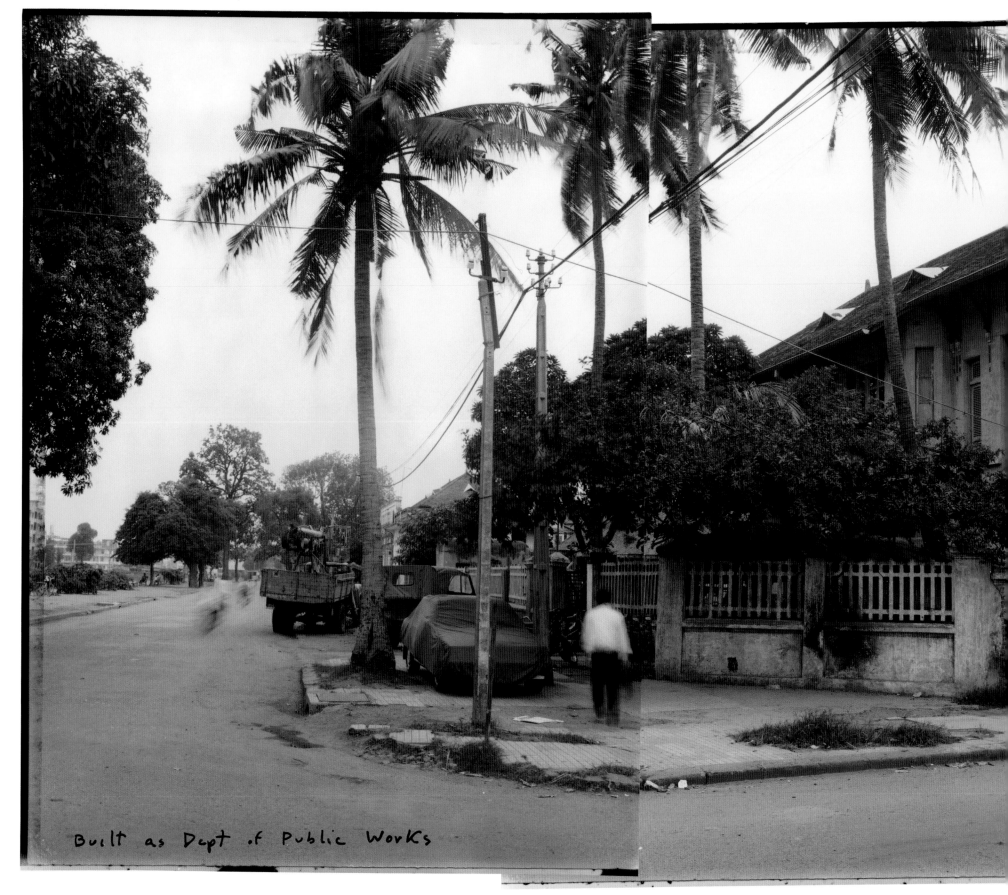

Built as Dept of Public Works

Headquarters of Military Police, originally built as the Department of Public Works, 1994

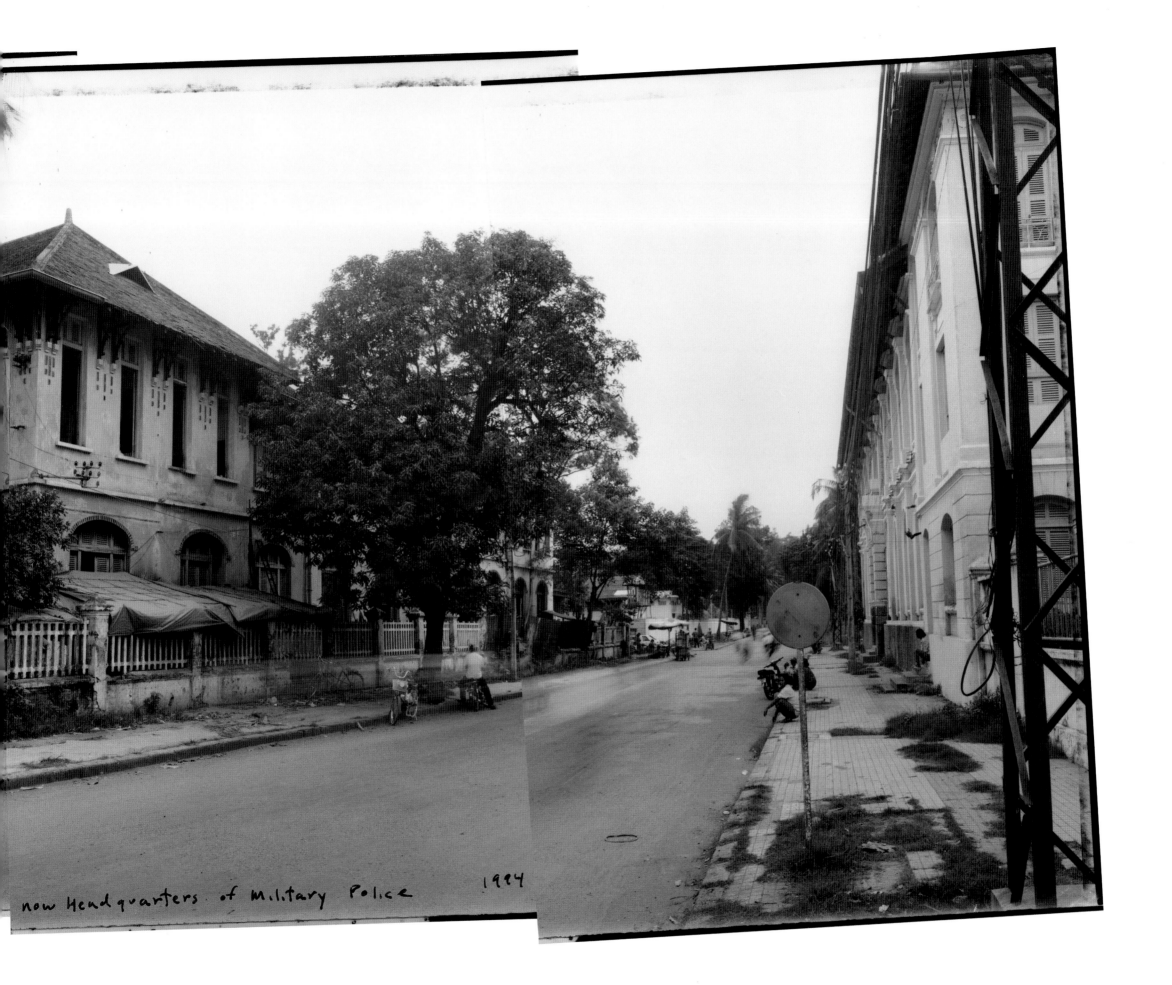

now Headquarters of Military Police 1994

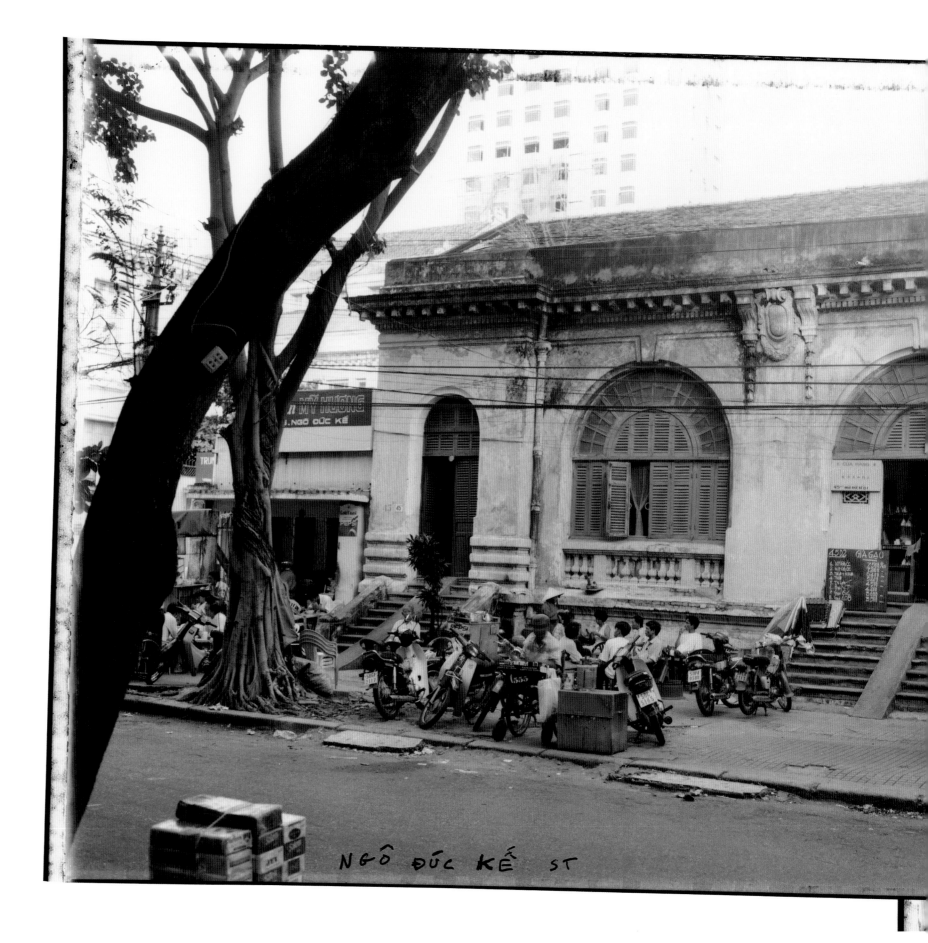

NGÔ ĐÚC KẾ ST

Ngo Duc Ke Street, Saigon, 1996

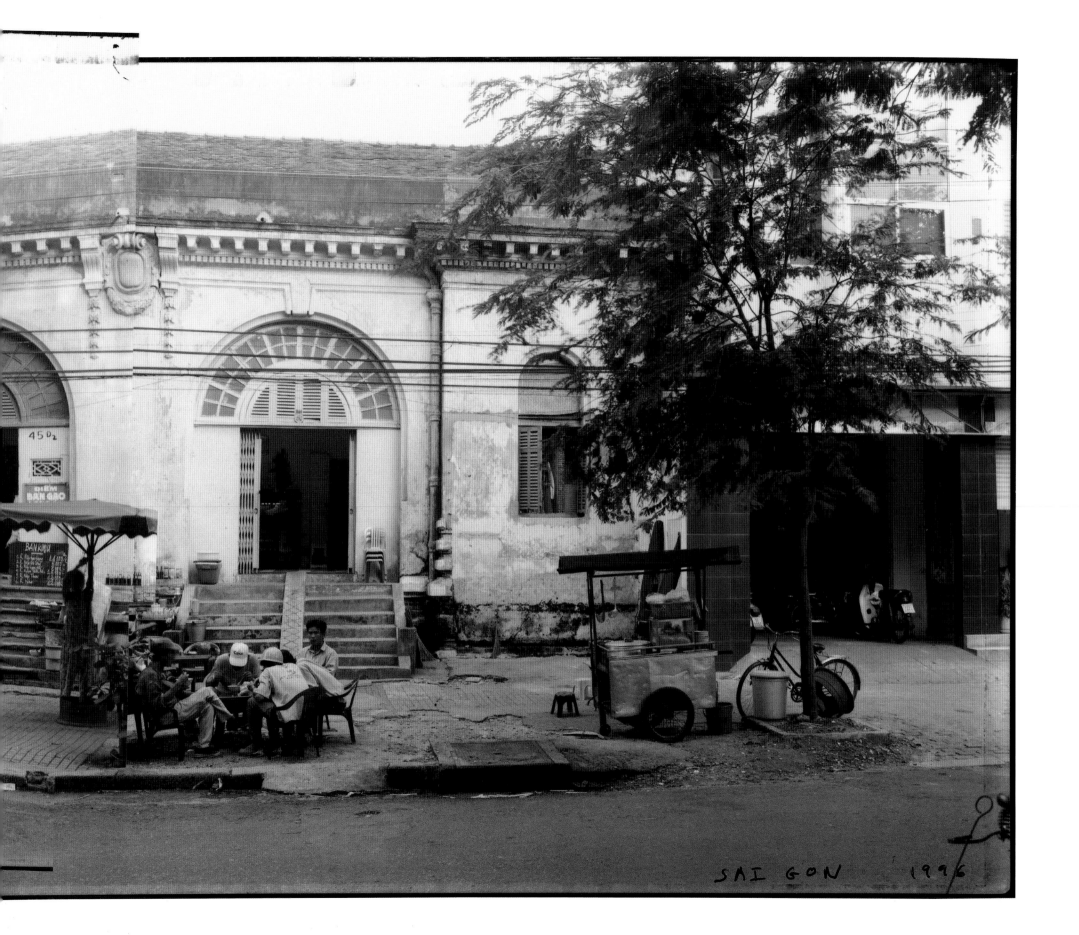

SAI GON 1996

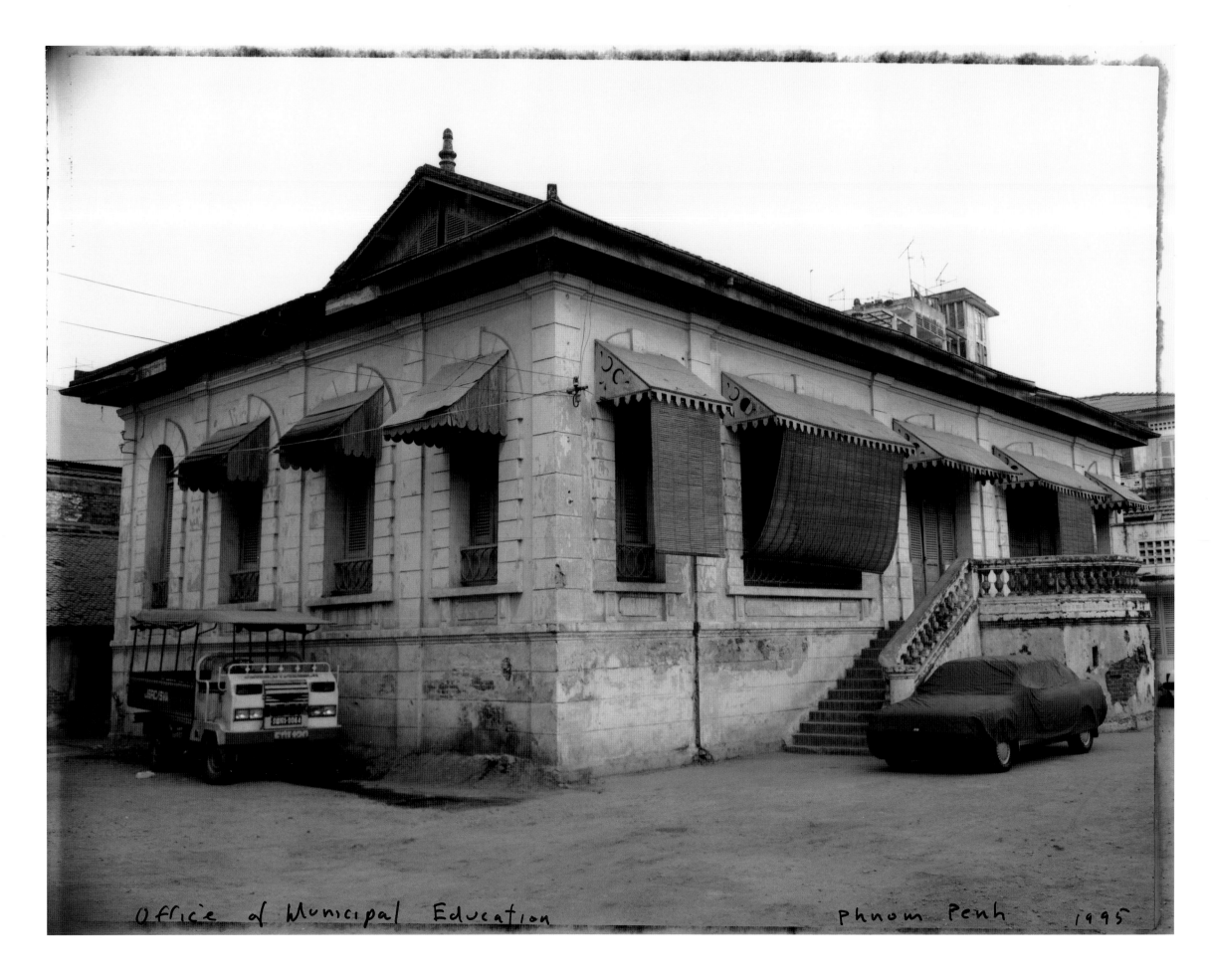

Office of Municipal Education Phnom Penh 1995

Quoc Hoc School, Hue, 1995
Ho Chi Minh, Ngo Dinh Diem, and Vo Nguyen Giap are among the school's graduates.

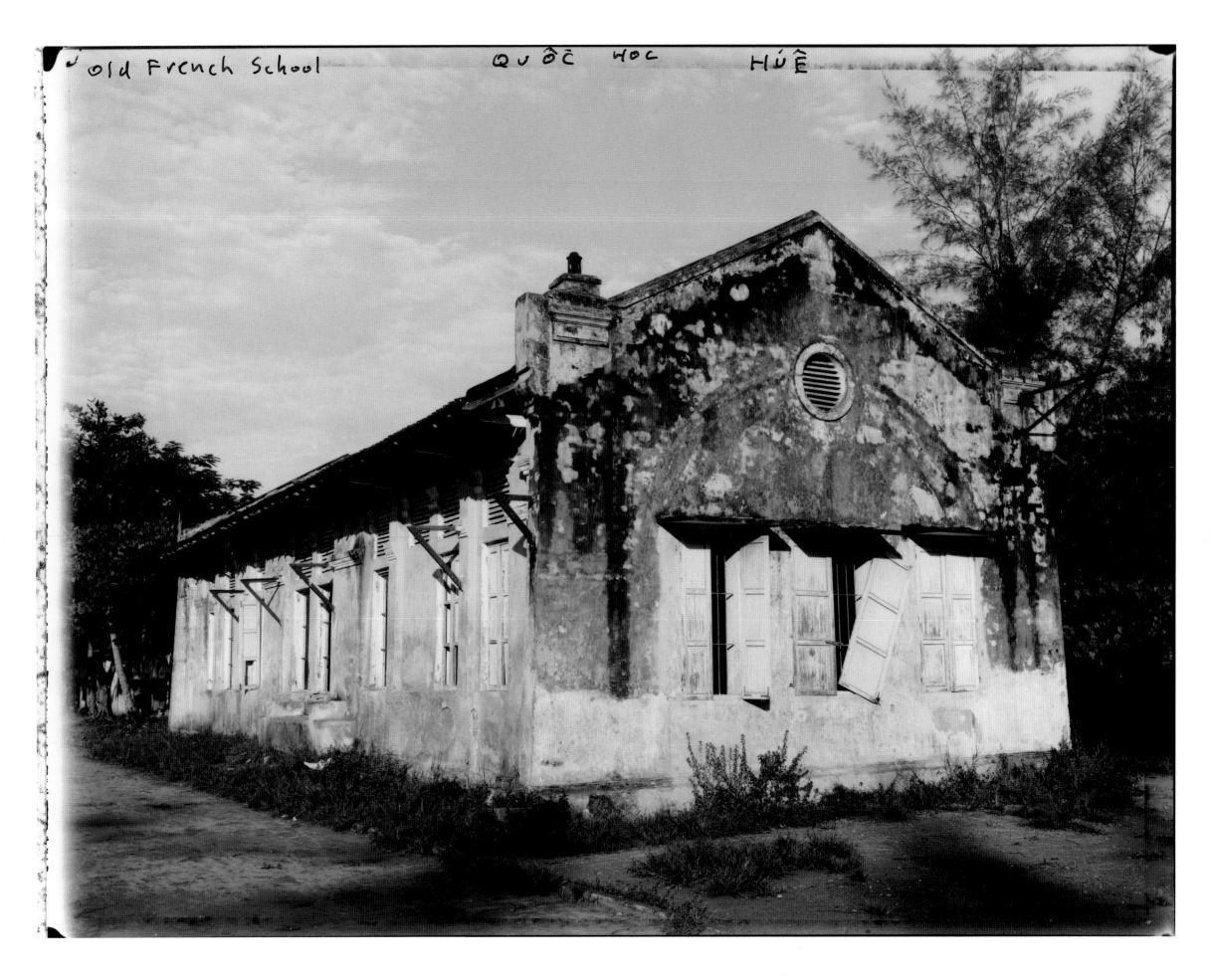

Old French School Quôc Hoc Húê

Sports club for Party Youth, originally built as a Catholic School, Hue, 1995

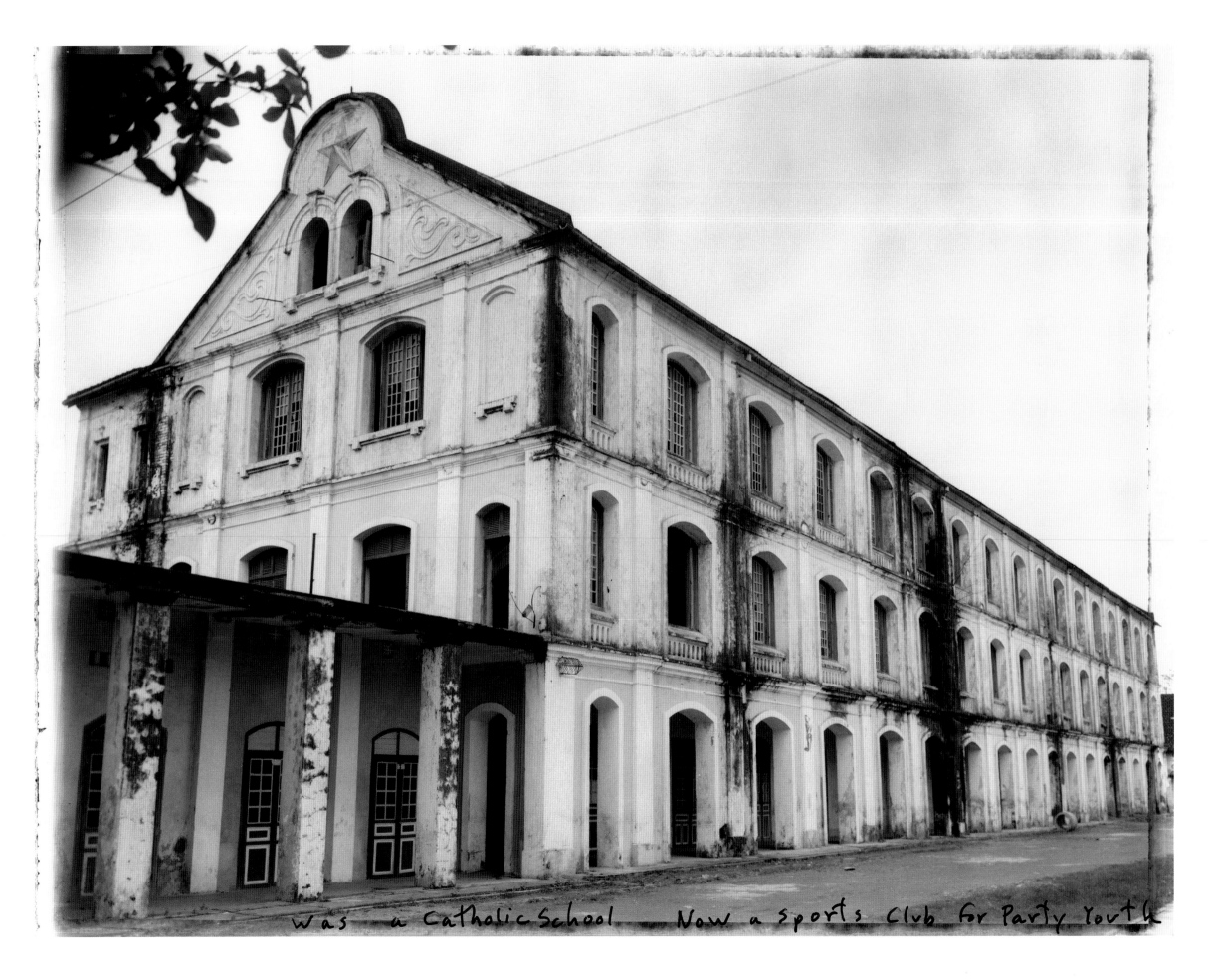

Was a catholic School — Now a sports Club for Party Youth

Olympic Stadium, Hue, 1997

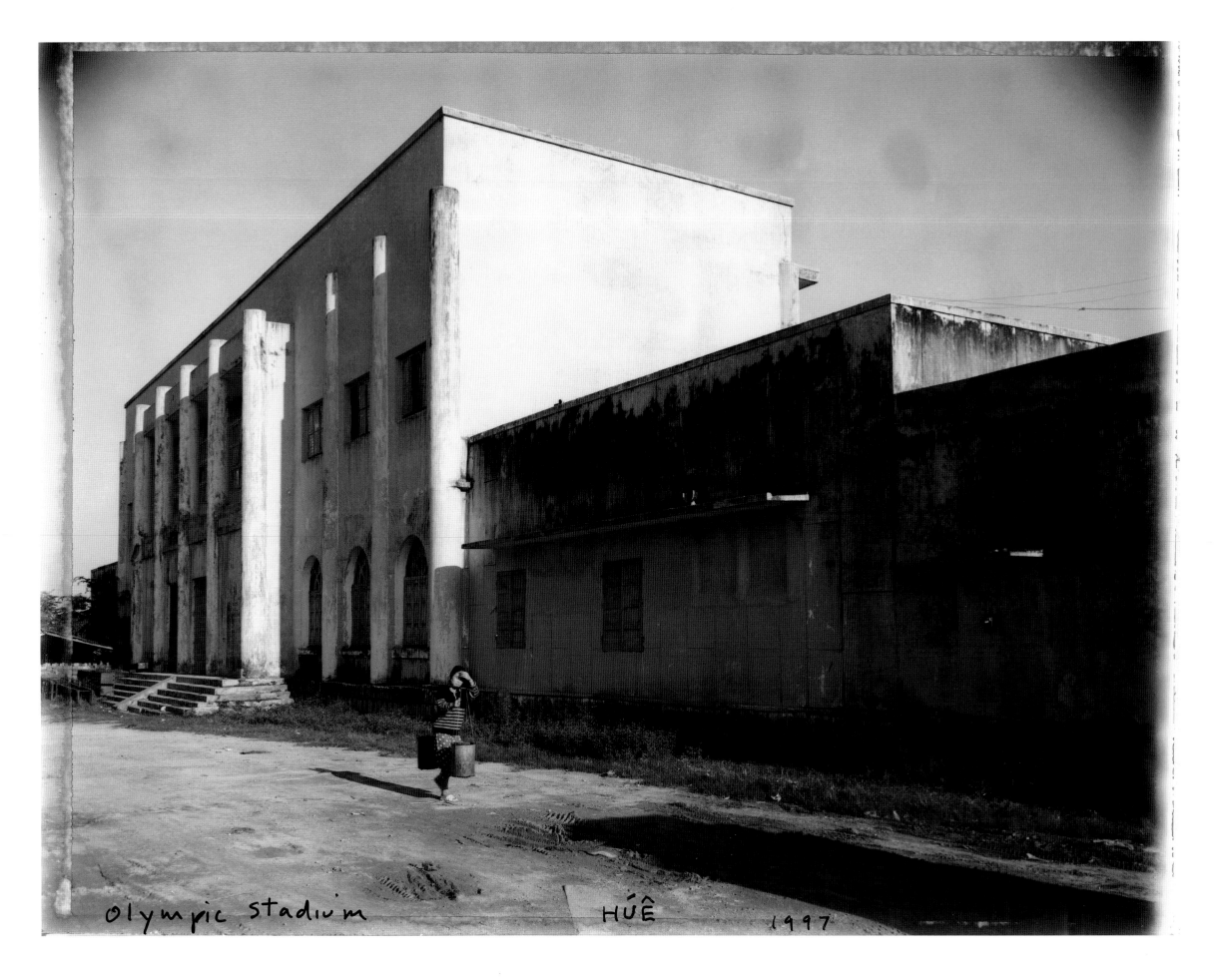

Olympic Stadium HÚÊ 1997

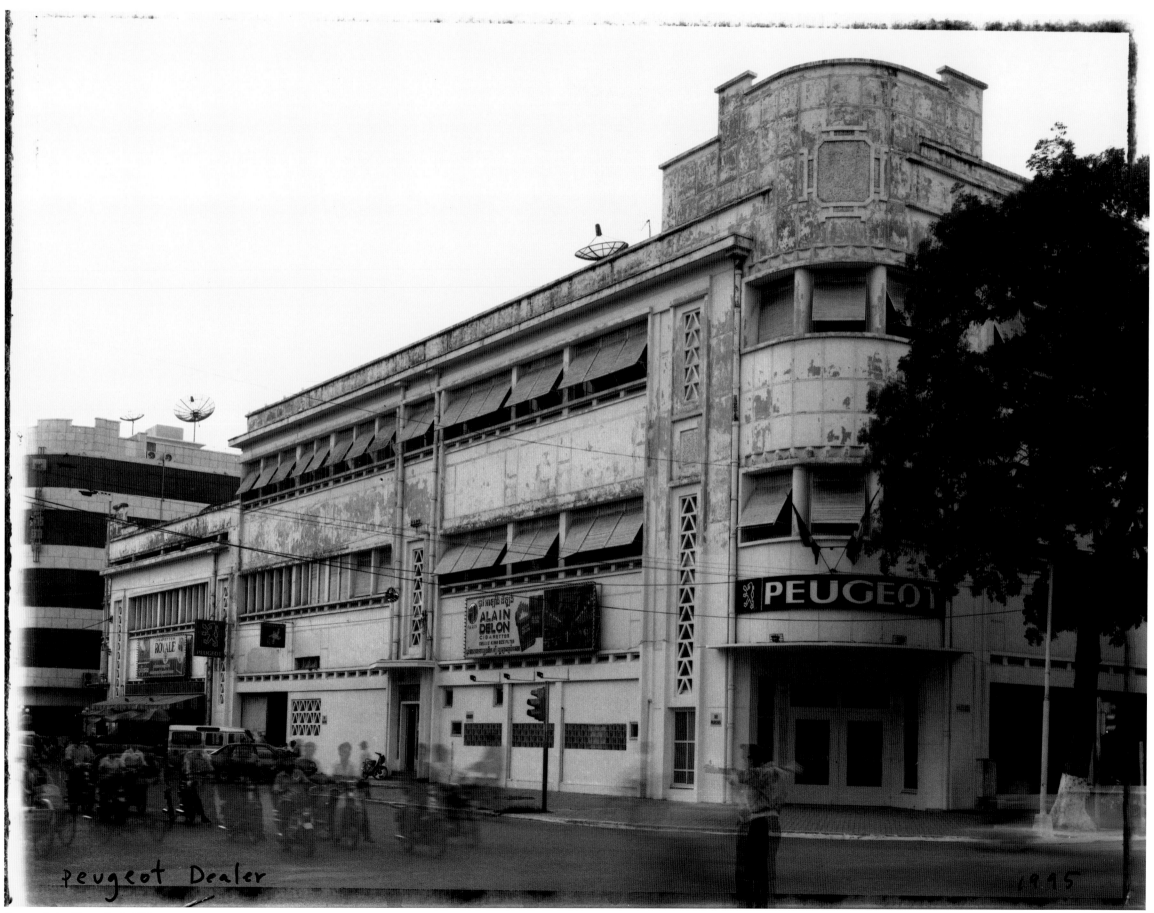

Peugeot Dealer

1995

Peugeot dealer, Phnom Penh, 1995

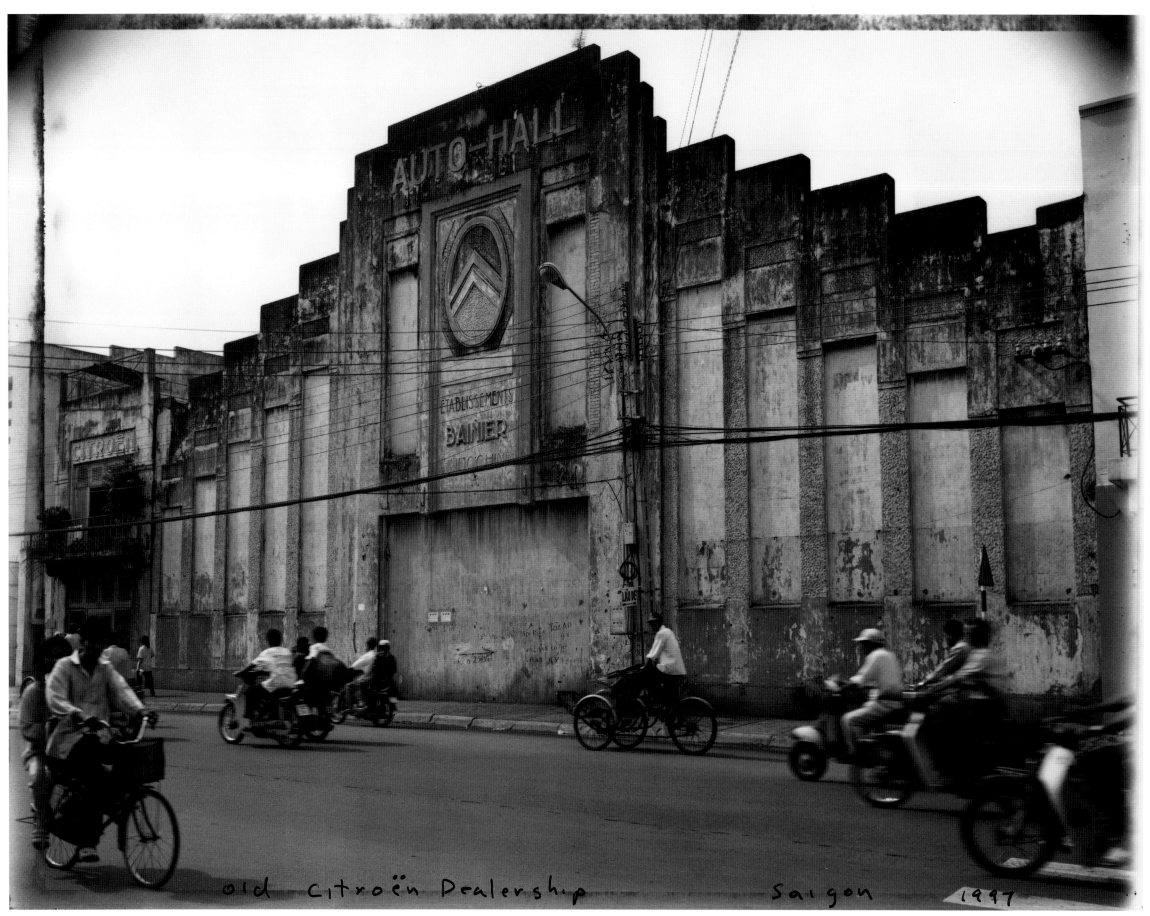

Old Citroën Dealership Saigon 1997

Old Citroën dealership, Saigon, 1997

Steel warehouse and barber, Haiphong, 1998

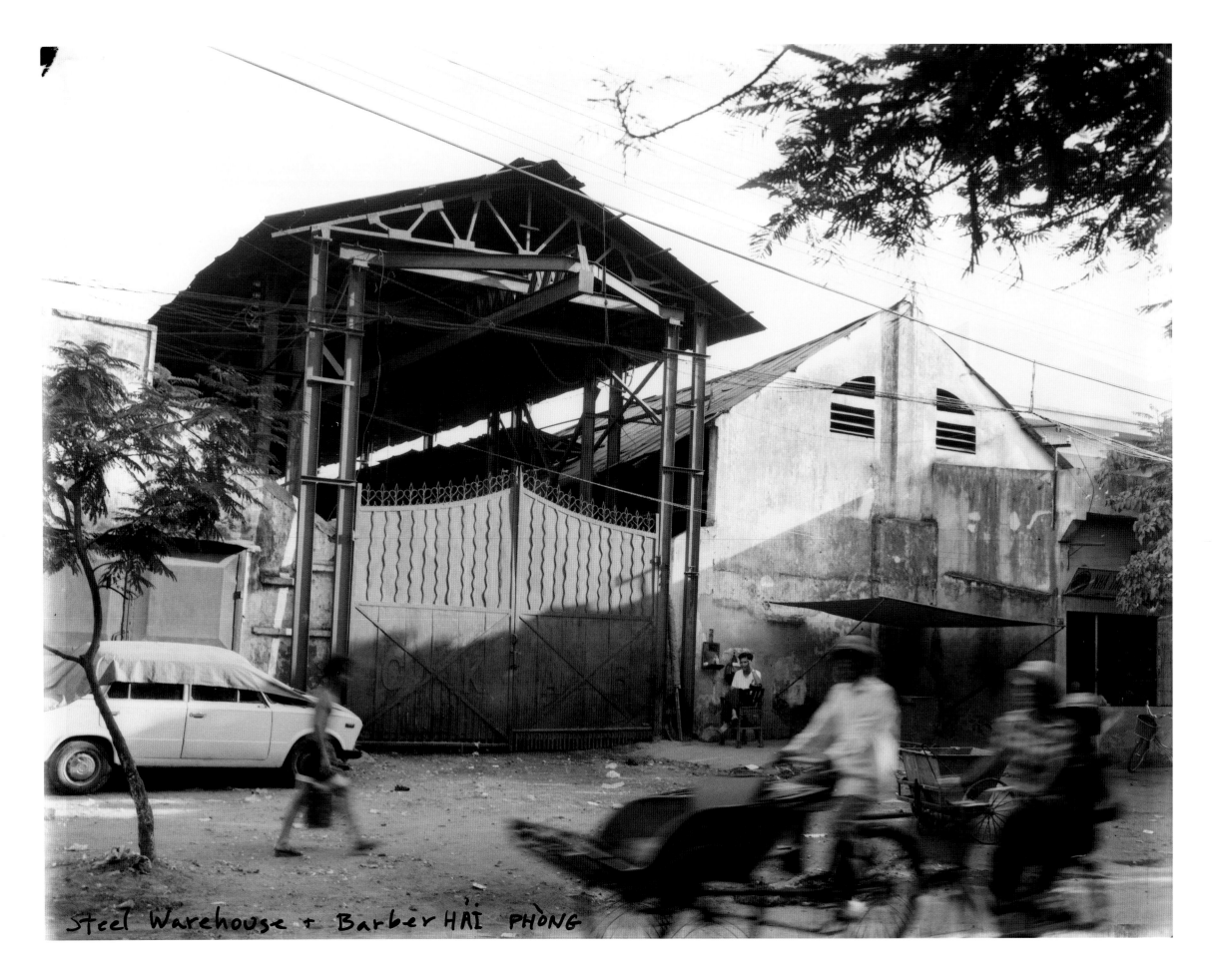

Steel Warehouse + Barber HẢI PHÒNG

Factory, Phnom Penh, 1998

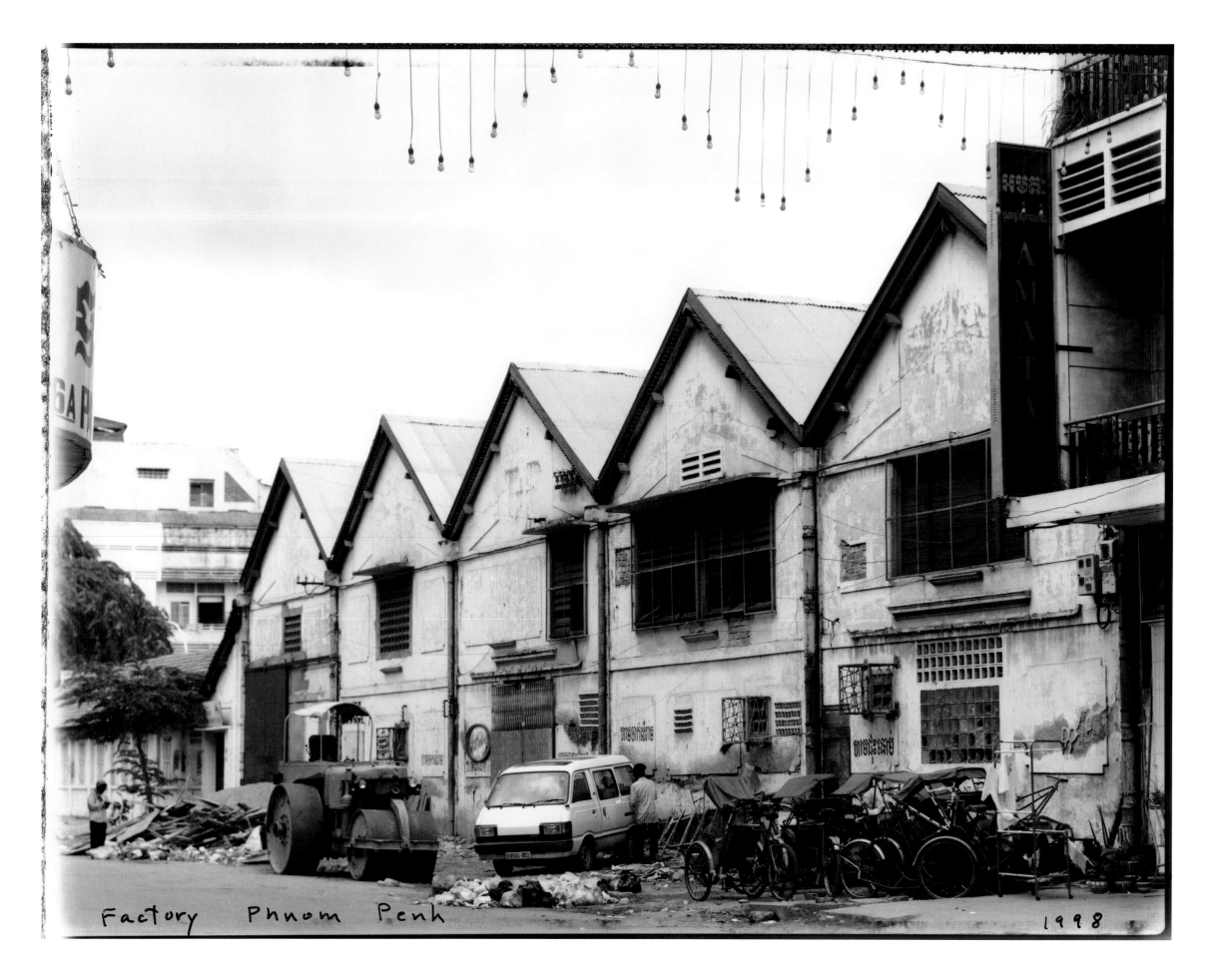

Factory Phnom Penh 1998

Factory, Kampot, 1997

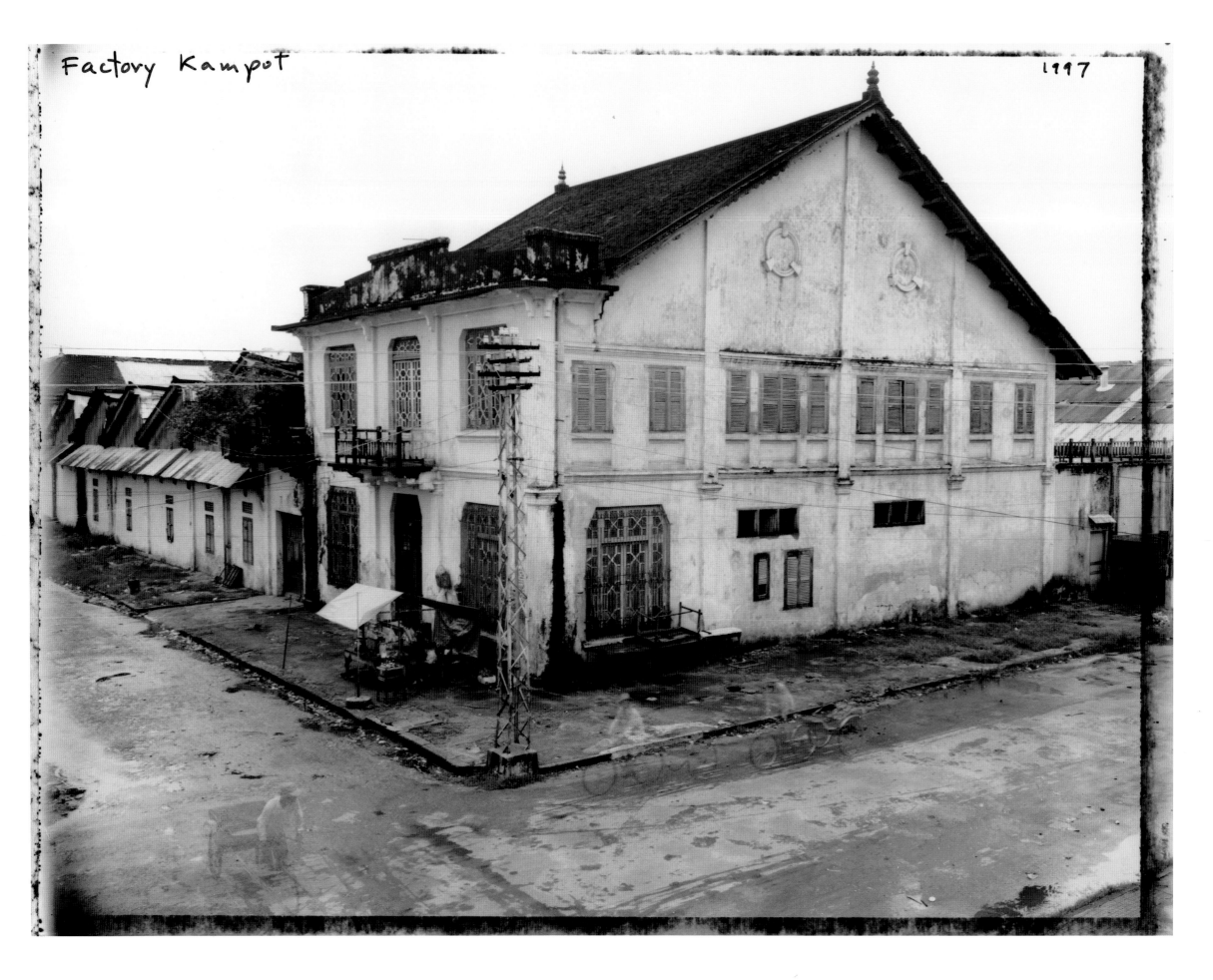

Factory Kampot

1997

Inner tube factory, Tay Ninh, 1995

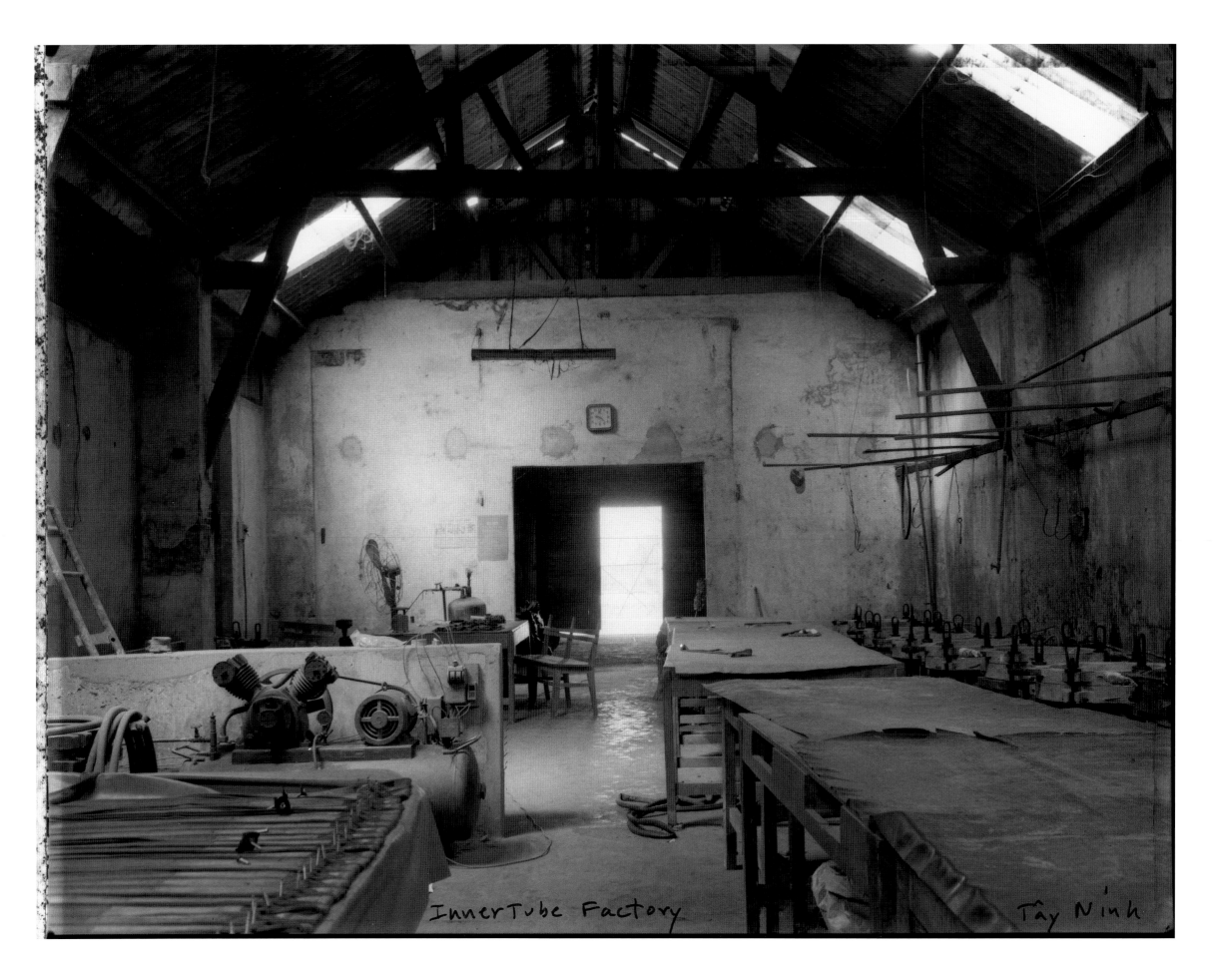

InnerTube Factory Tây Ninh

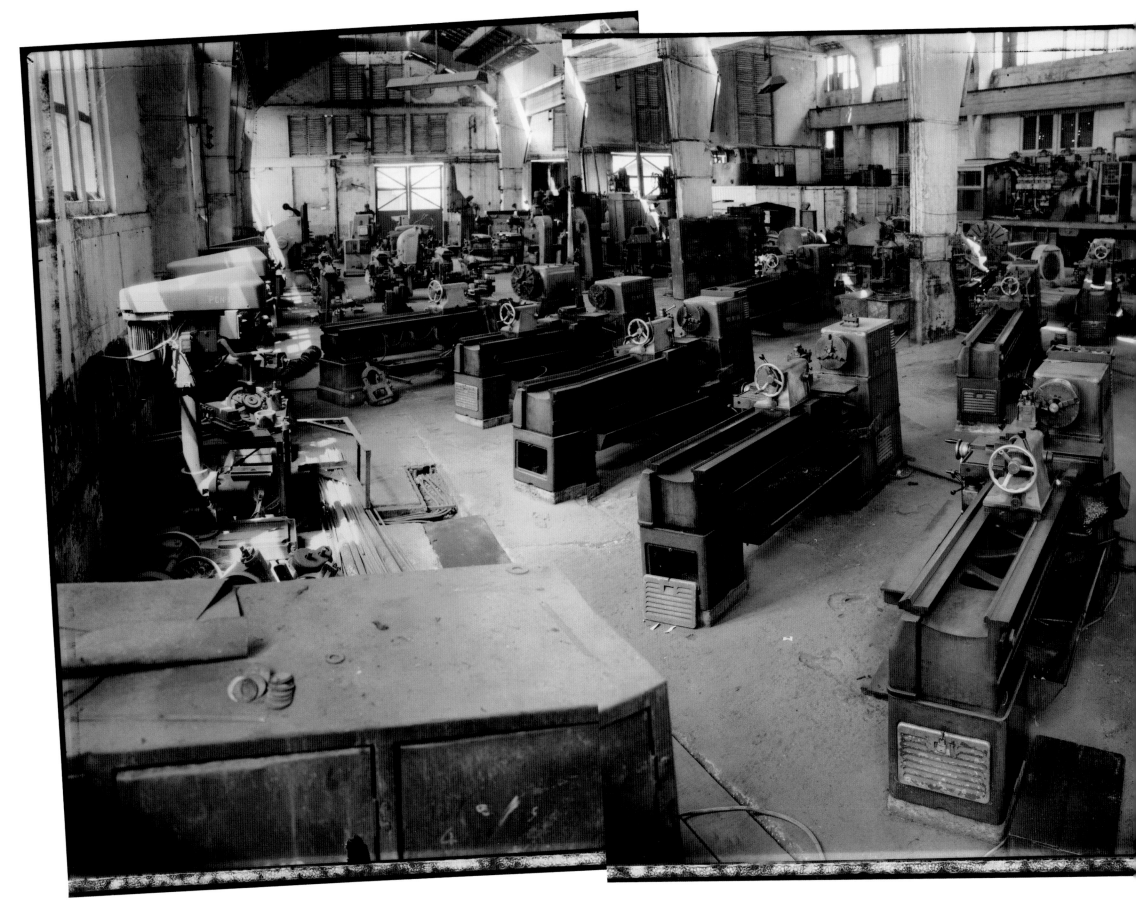

Locomotive repair shop, Phnom Penh, 1995

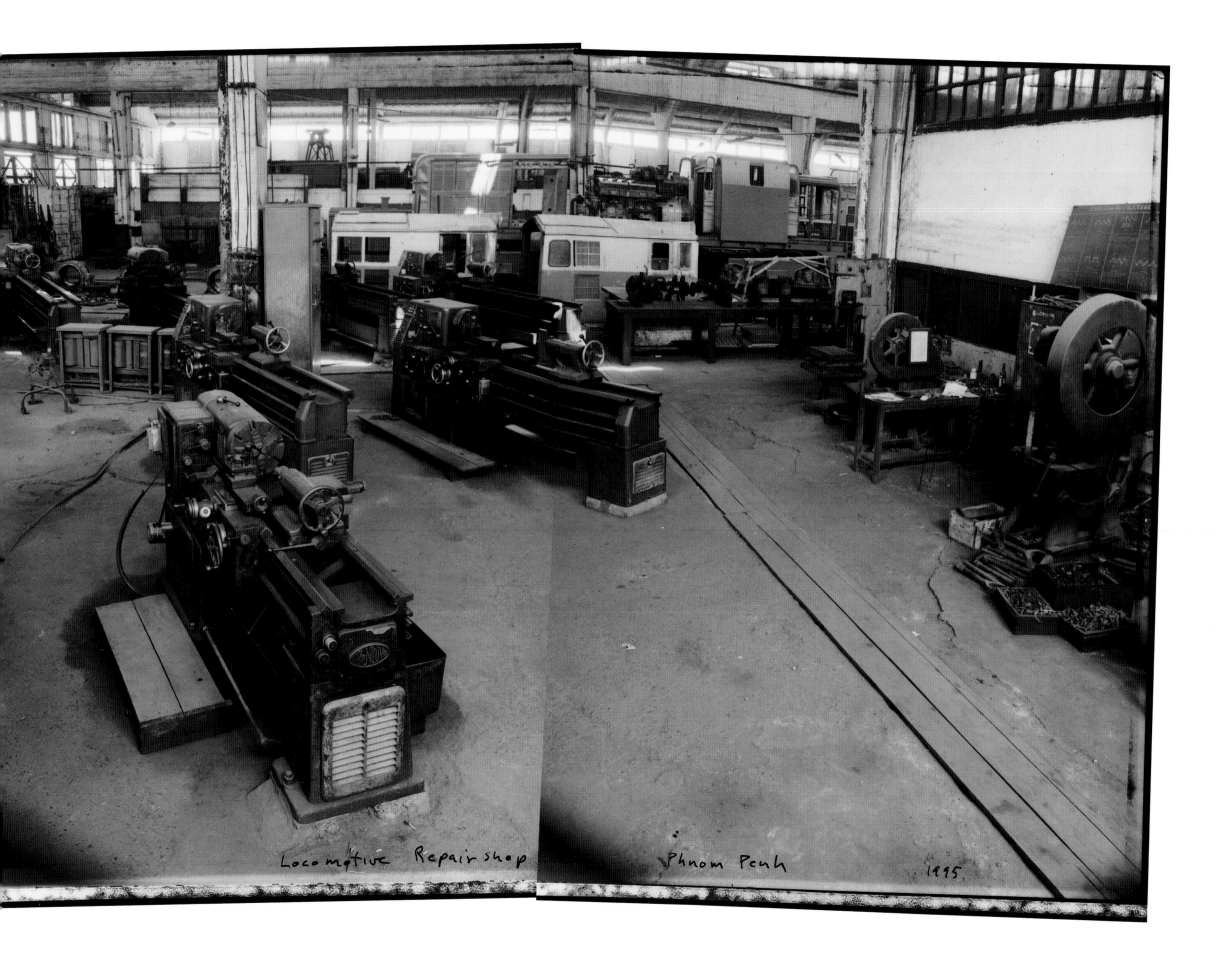

Locomotive Repair shop Phnom Penh 1995.

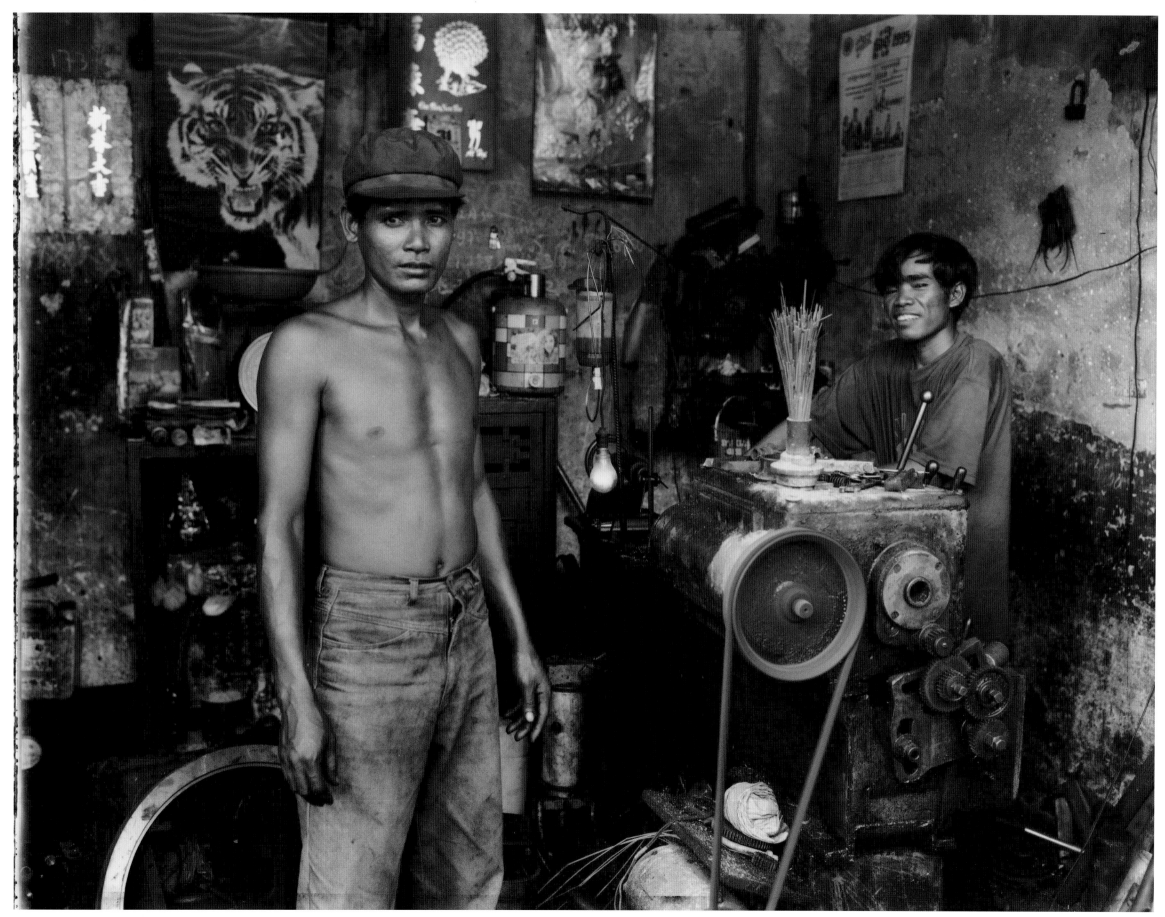

Machinist, Phnom Penh, 1997

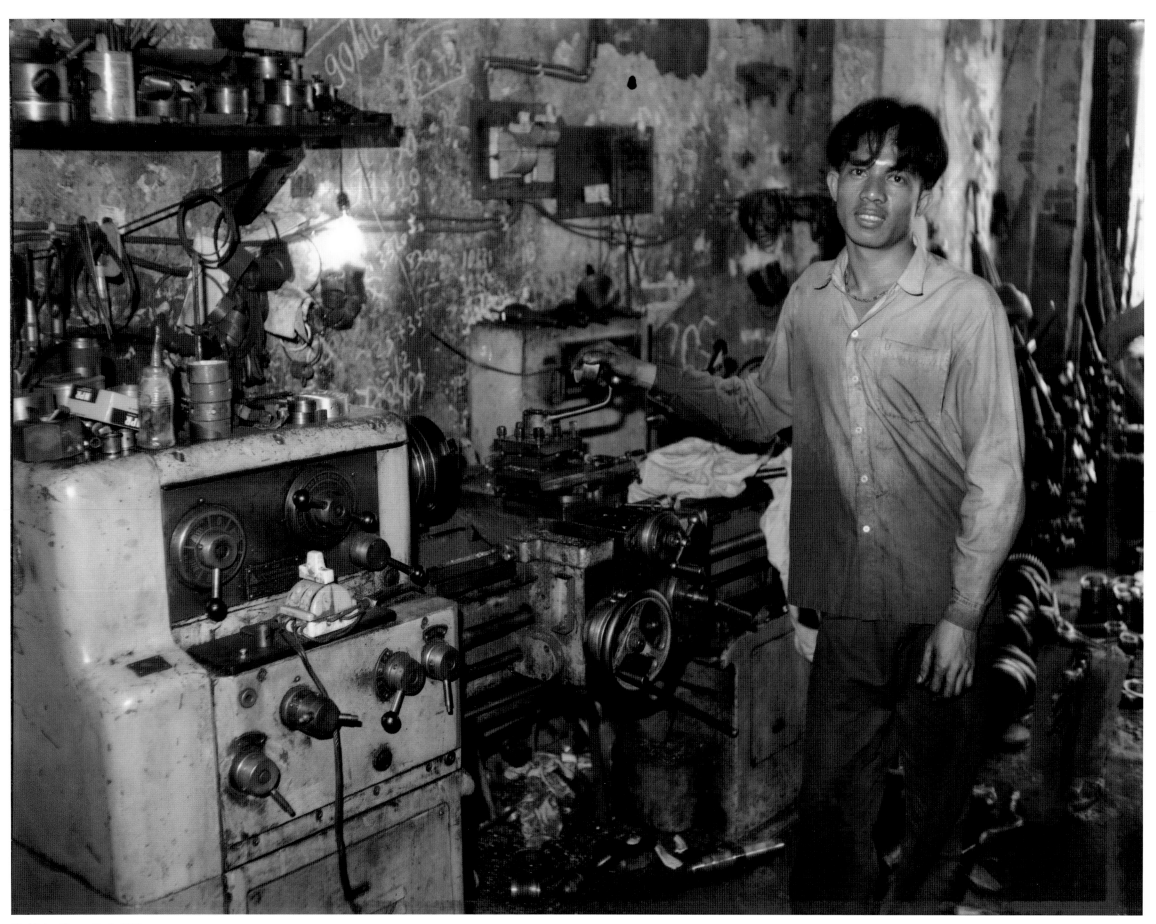

Machinist, Phnom Penh, 1995

Drill press operator, Phnom Penh, 1995

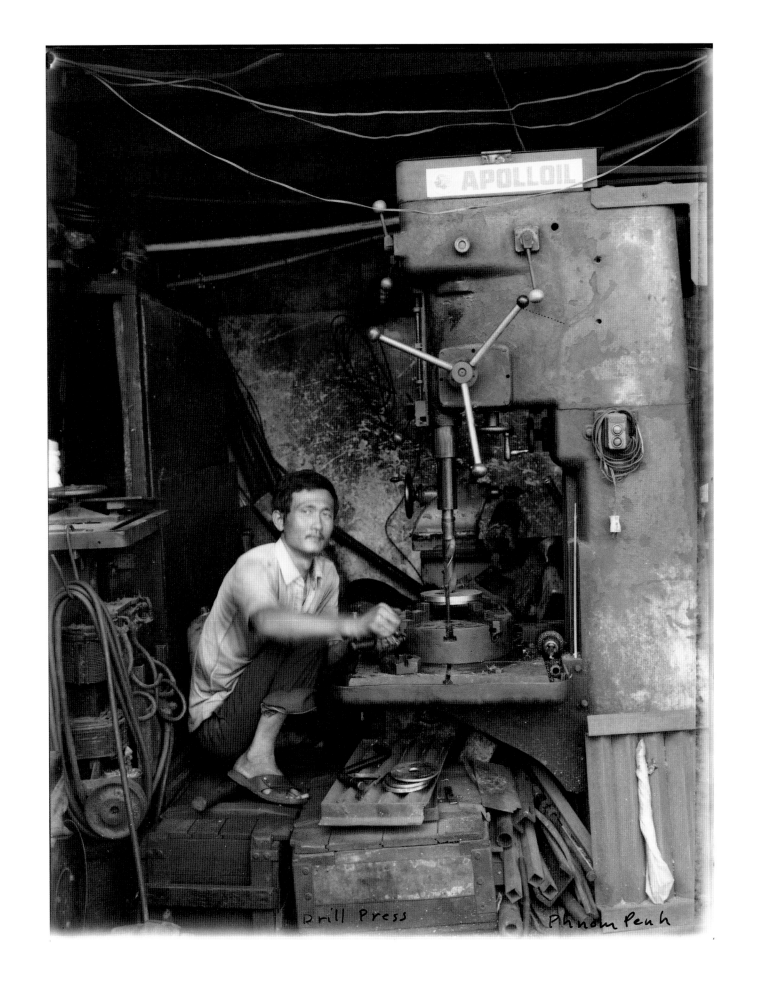

Drill Press Phnom Penh

Engine rebuilders, Phnom Penh, 1997

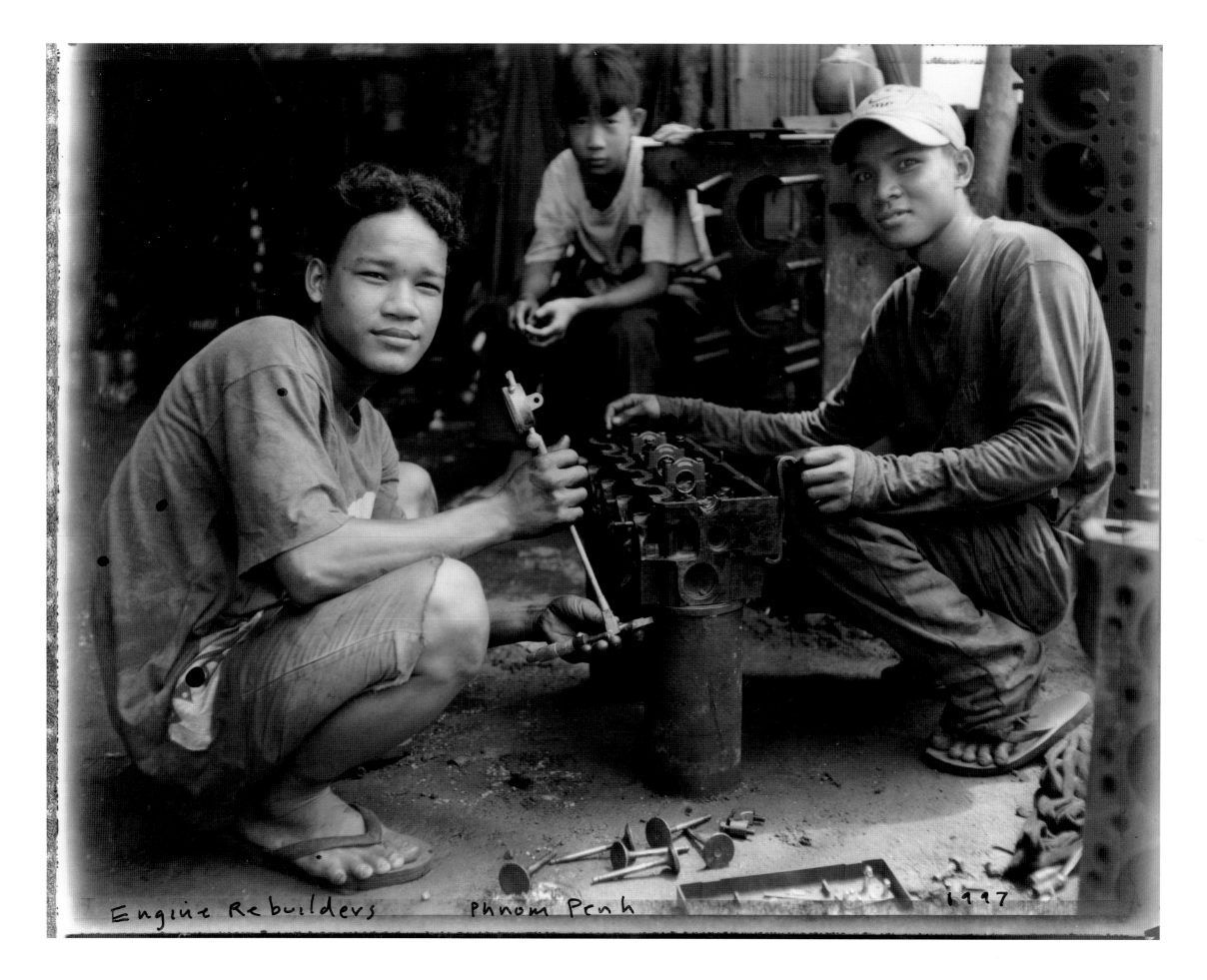

Engine Rebuilders Phnom Penh 1997

Typewriter workers, Phnom Penh, 1994

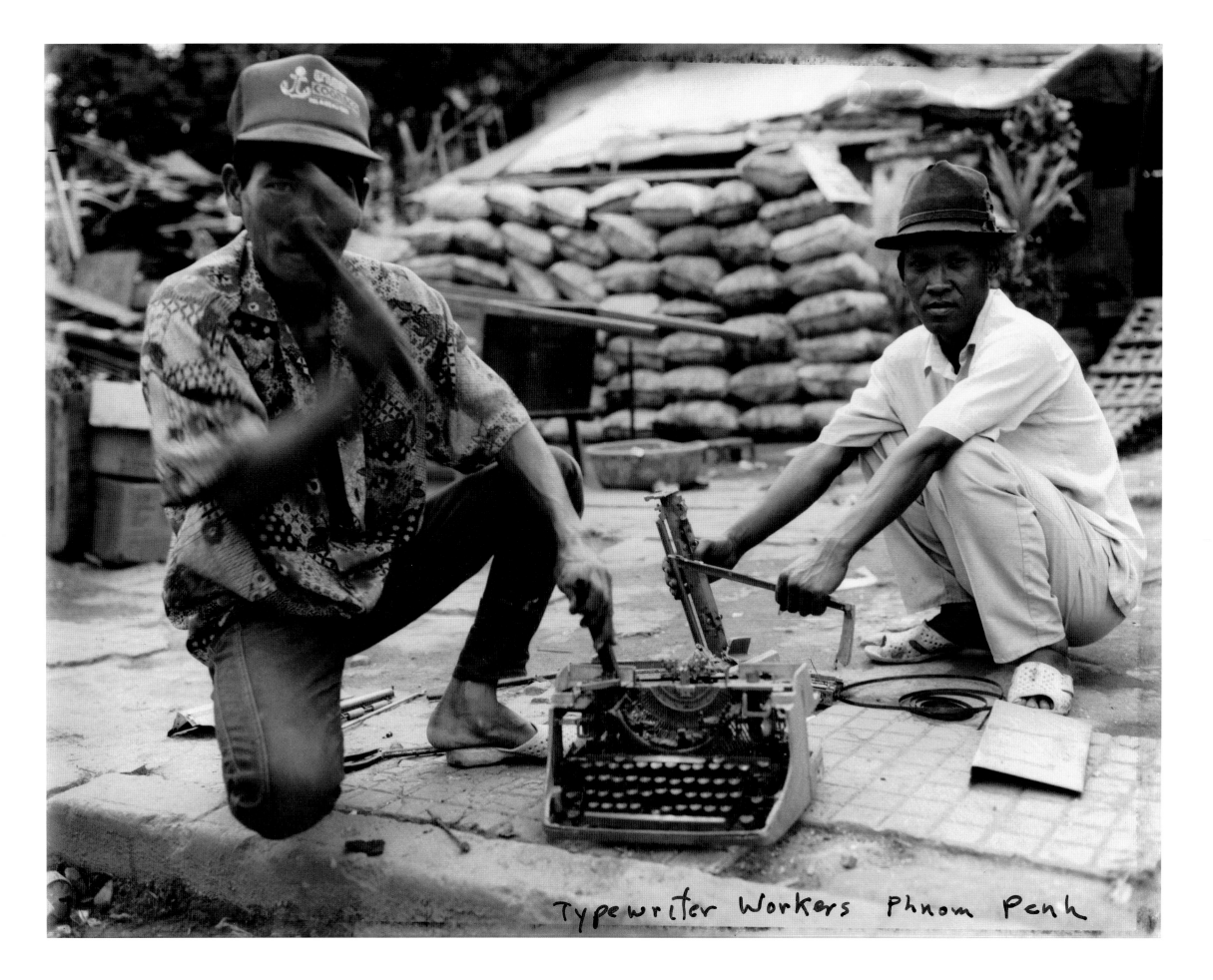

Typewriter Workers Phnom Penh

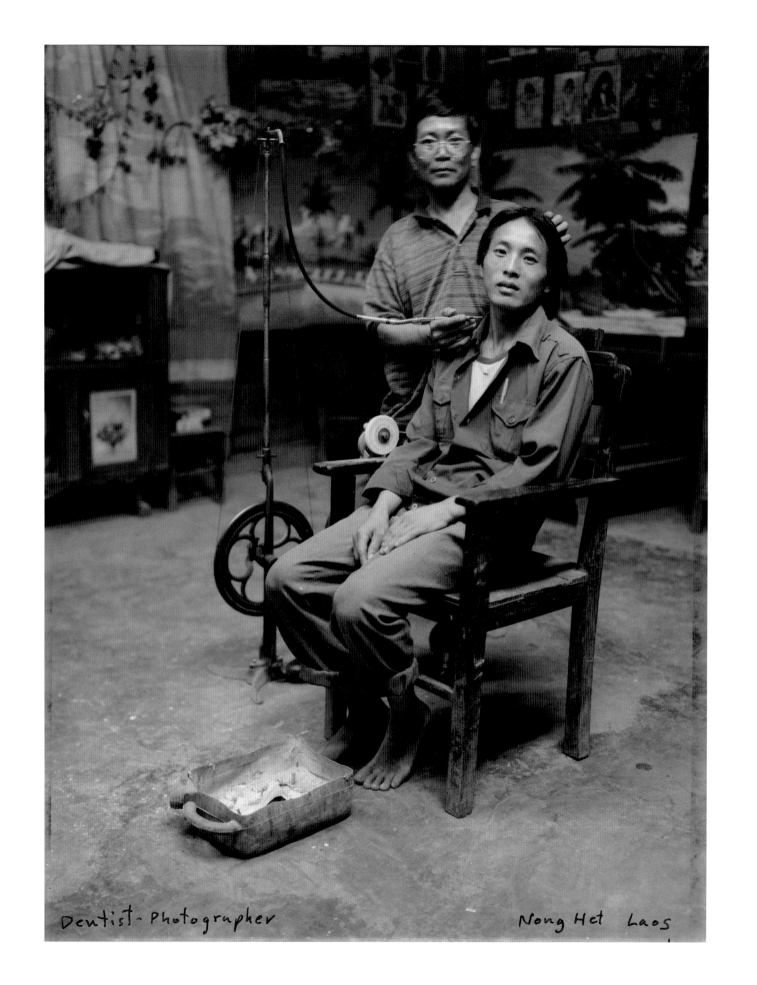

Dentist-Photographer

Nong Het Laos

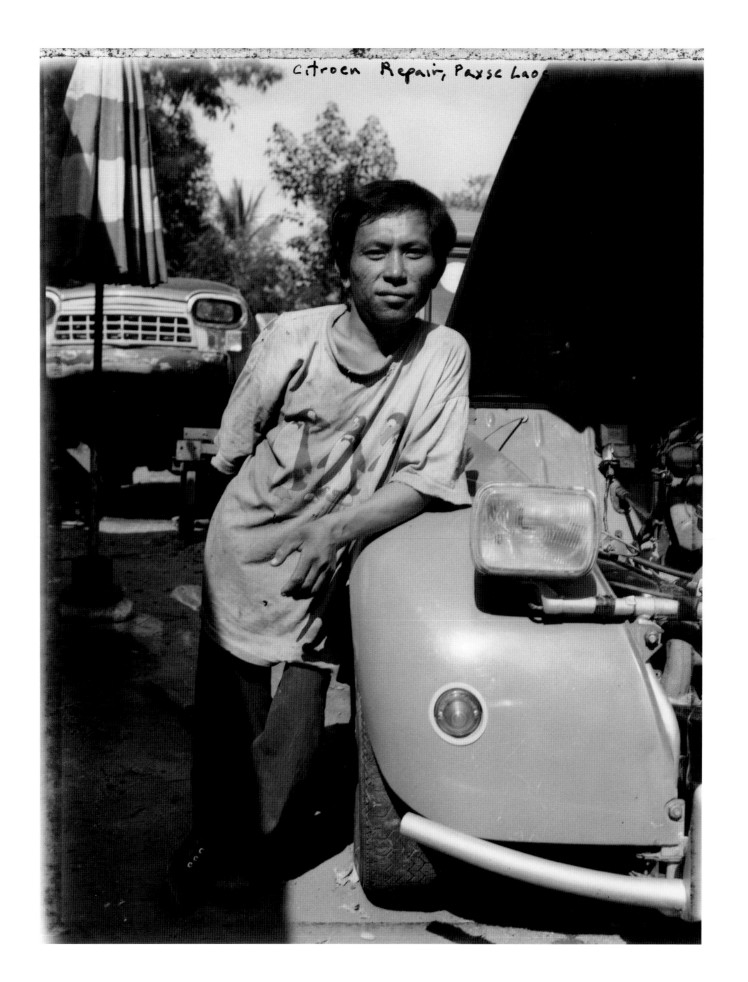

Citroën repairman, Paxse, 1997

Barbershop, railroad station, Phnom Penh, 1993

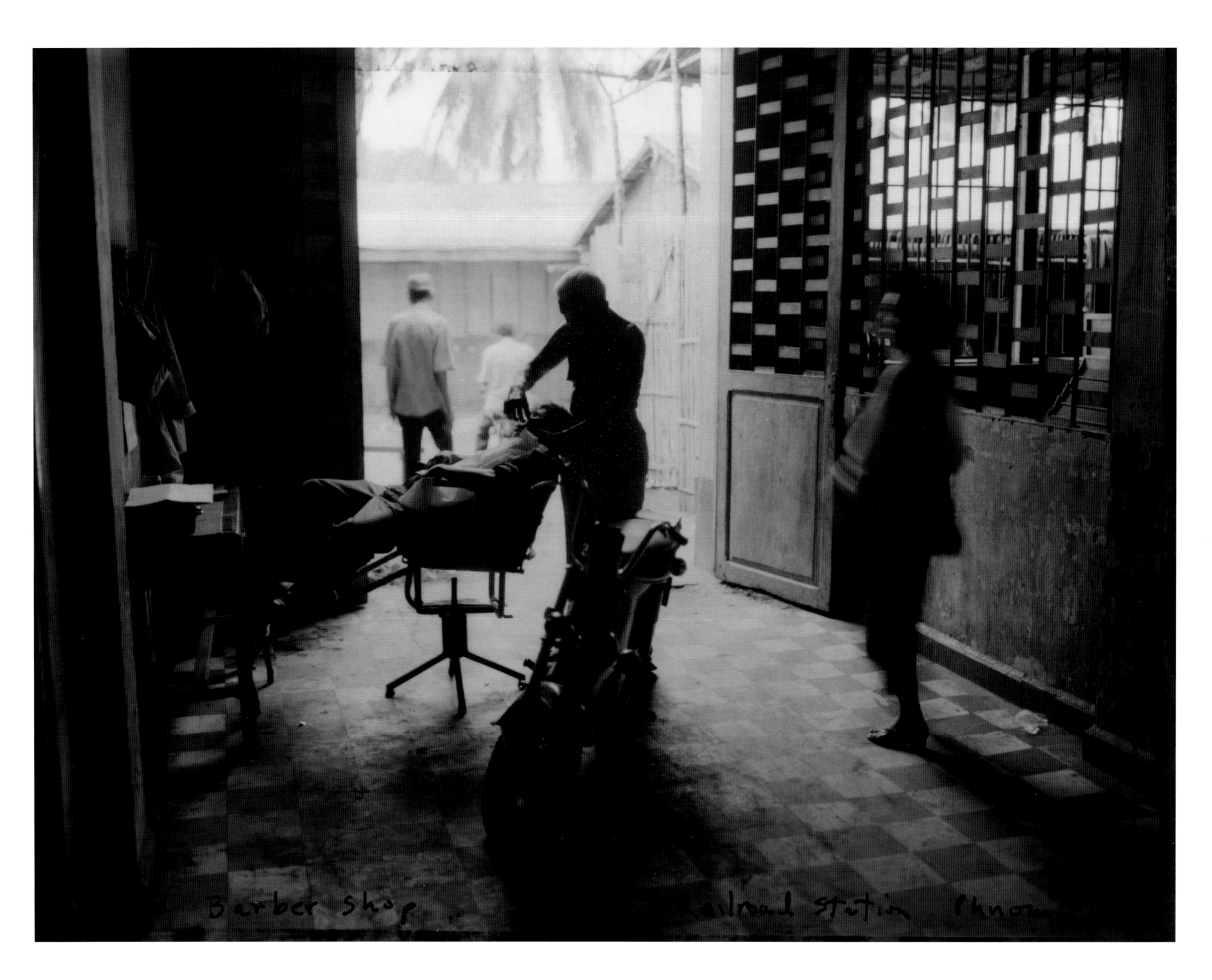

Barber Shop Railroad Station Phnom

Military hospital, Phnom Penh, 1995

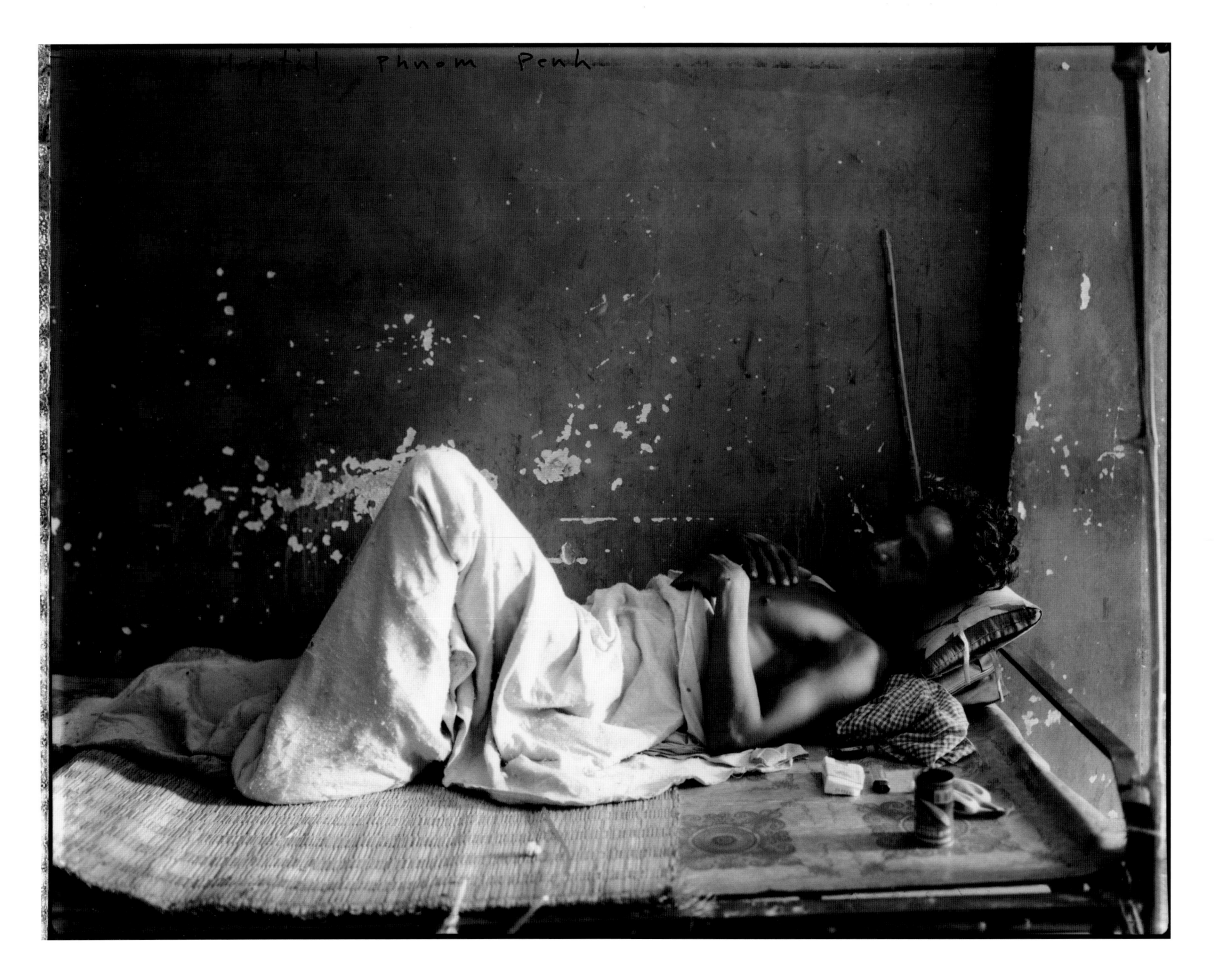

Shell Petroleum headquarters, Phnom Penh, 1996

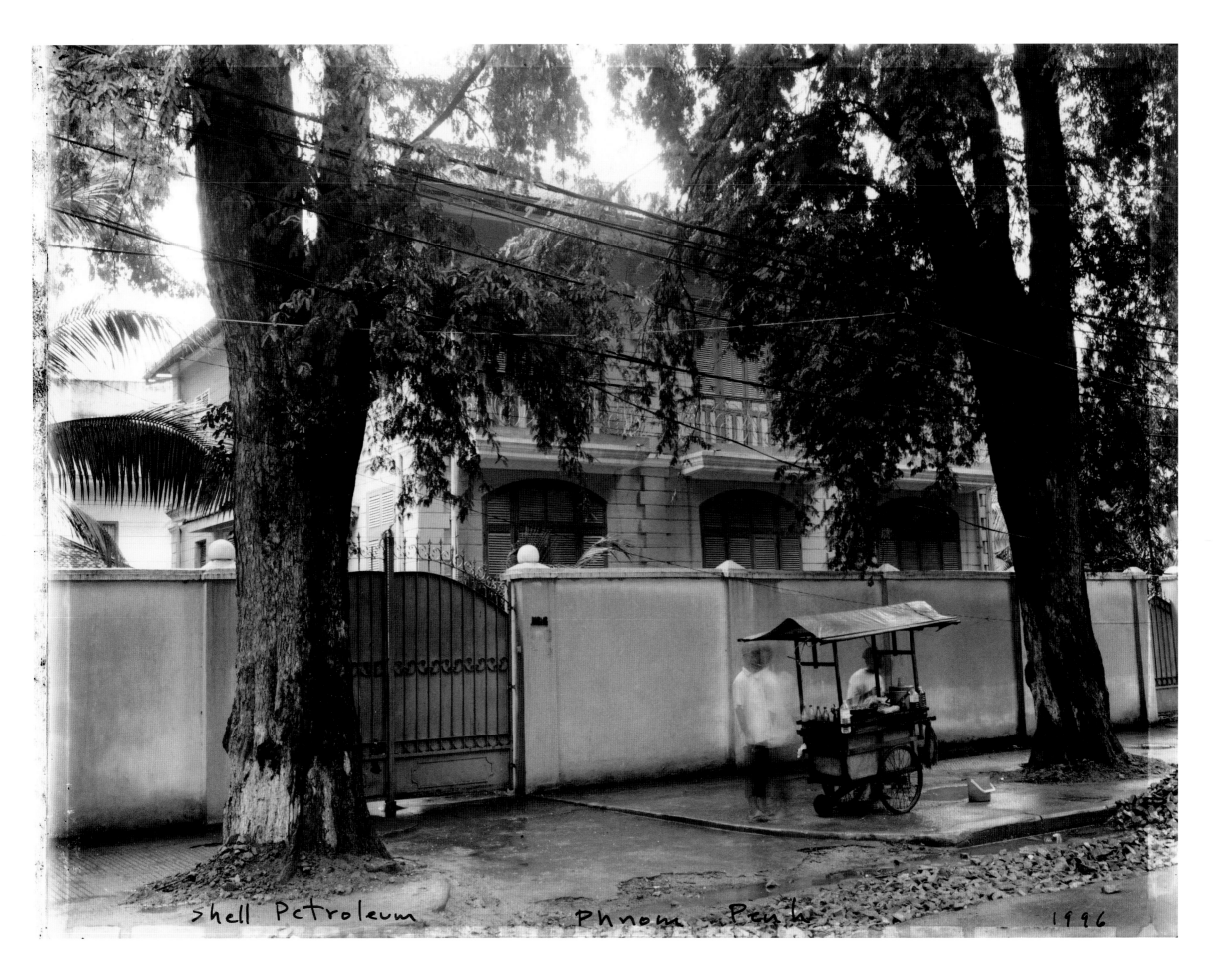

Shell Petroleum Phnom Penh 1996

Hoi Vu Street, Hanoi, 1998

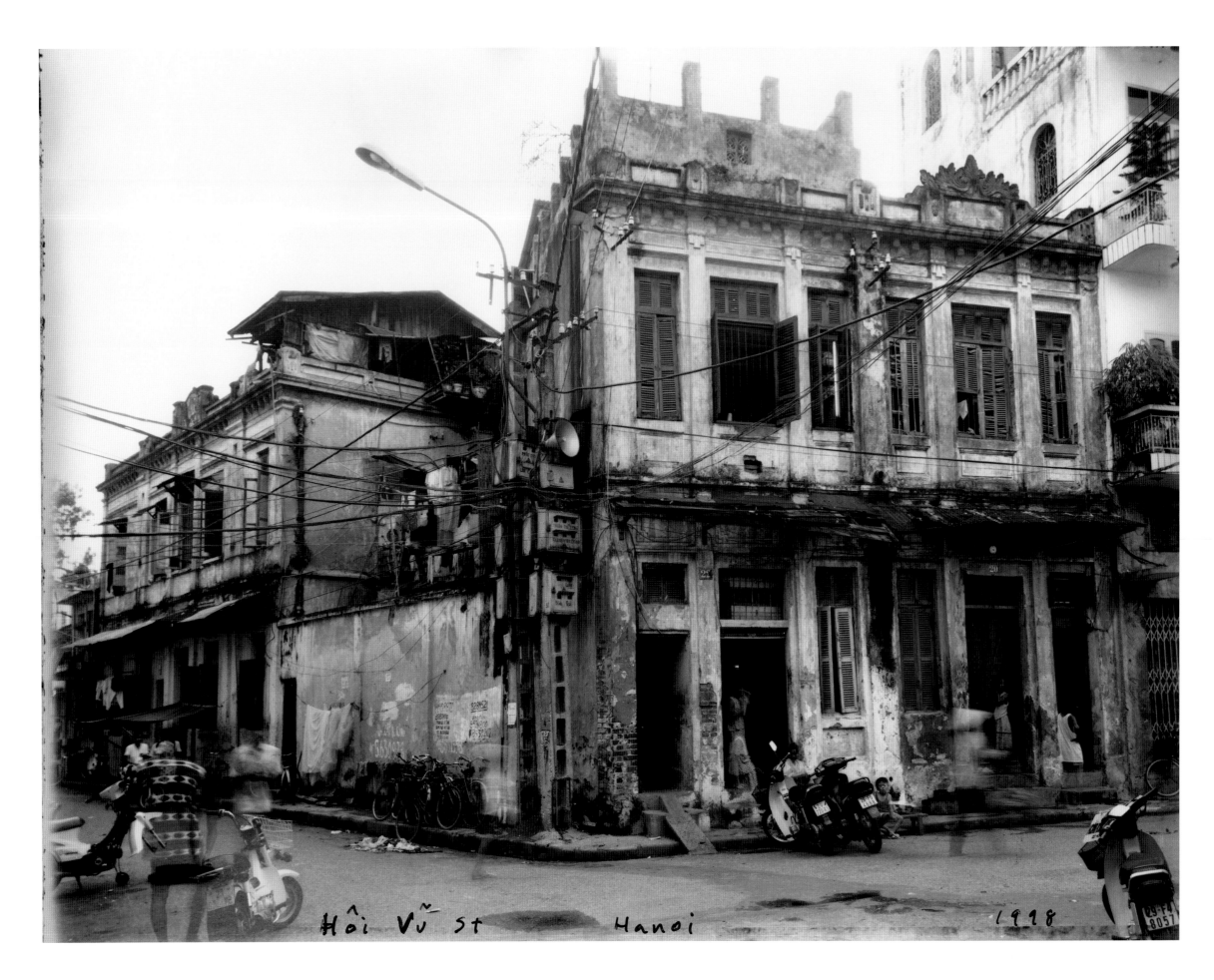

Hôi Vũ St Hanoi 1998

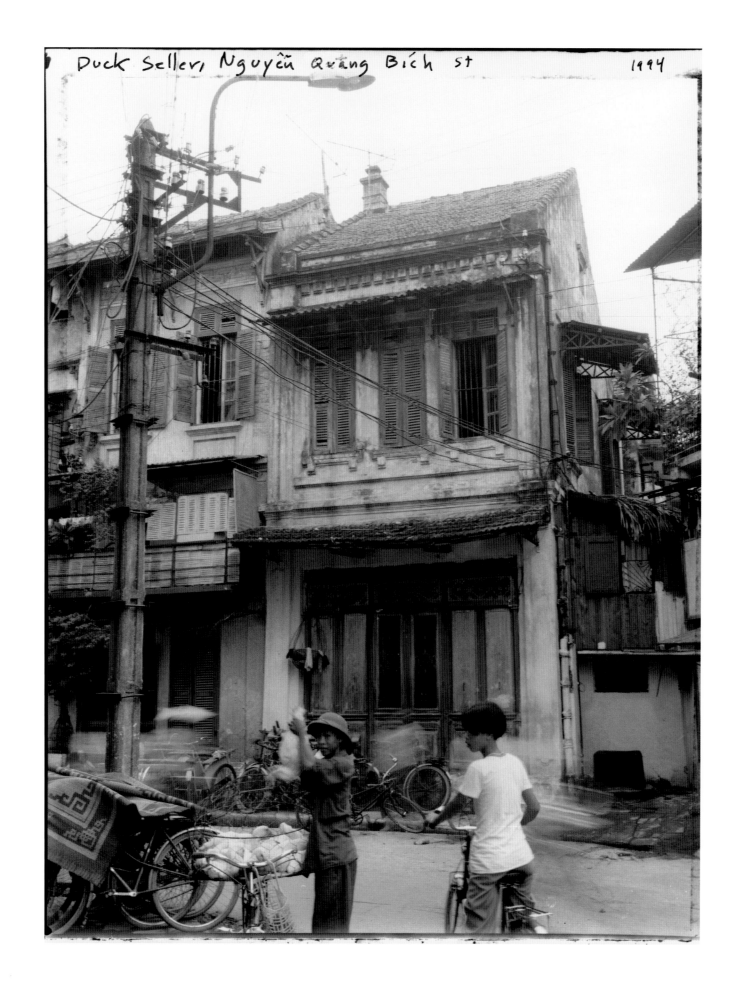

Duck seller,
Nguyen Quang Bich Street,
Hanoi, 1994

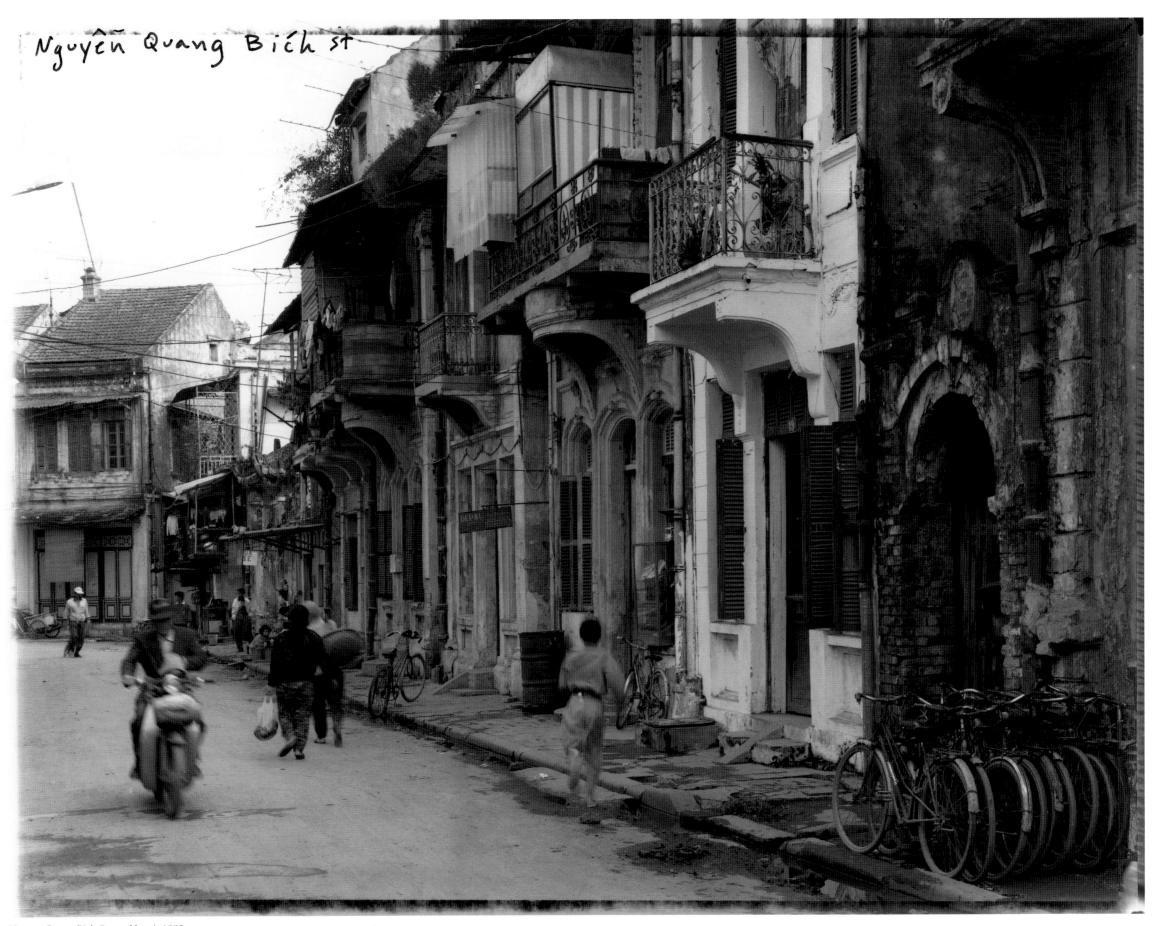

Nguyễn Quang Bích st

Nguyen Quang Bich Street, Hanoi, 1995

Yet Kien Street, Hanoi, 1994

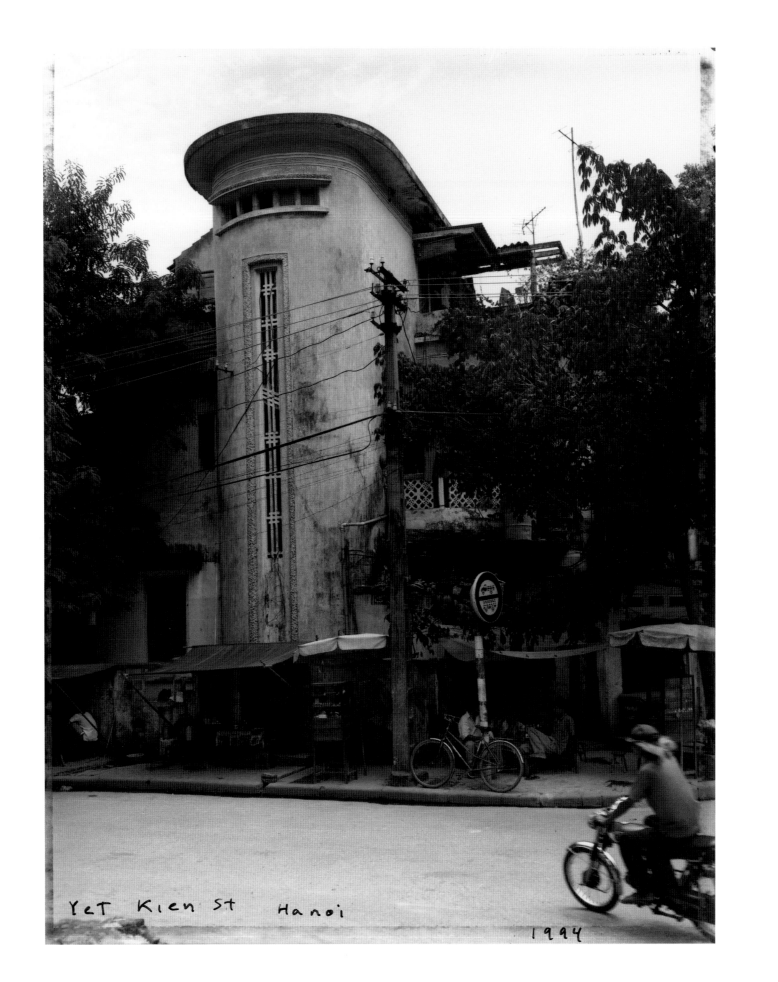

Yet Kien St Hanoi

1994

Apartments Lux, Street 144, Lux Parfumerie at the corner, Phnom Penh, 1994

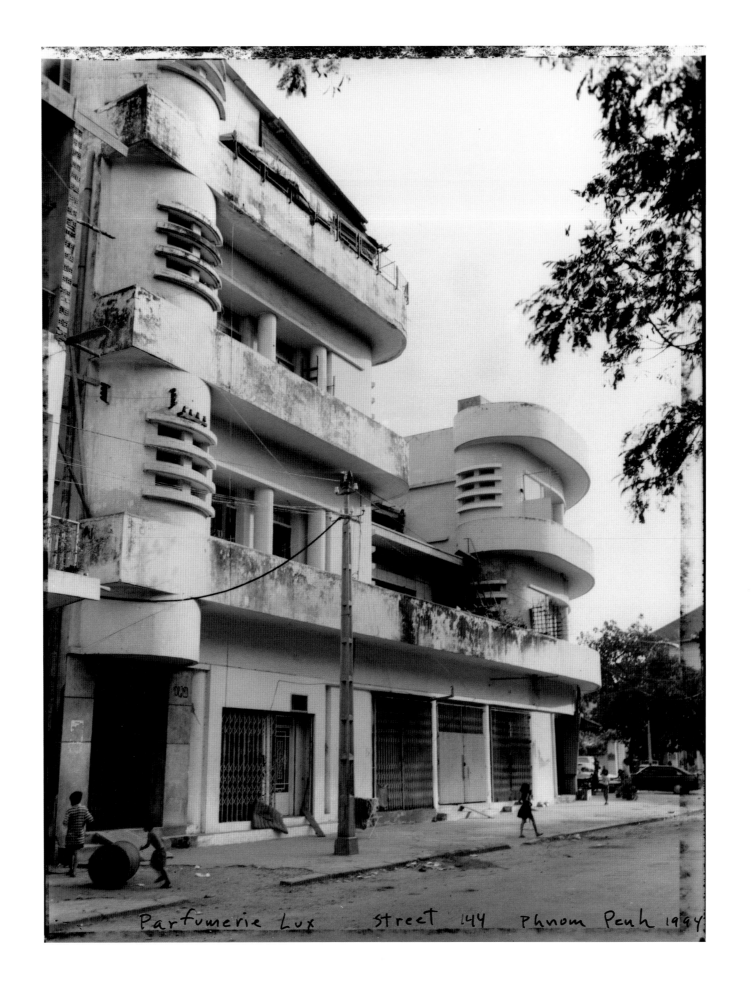

Parfumerie Lux Street 144 Phnom Penh 1994

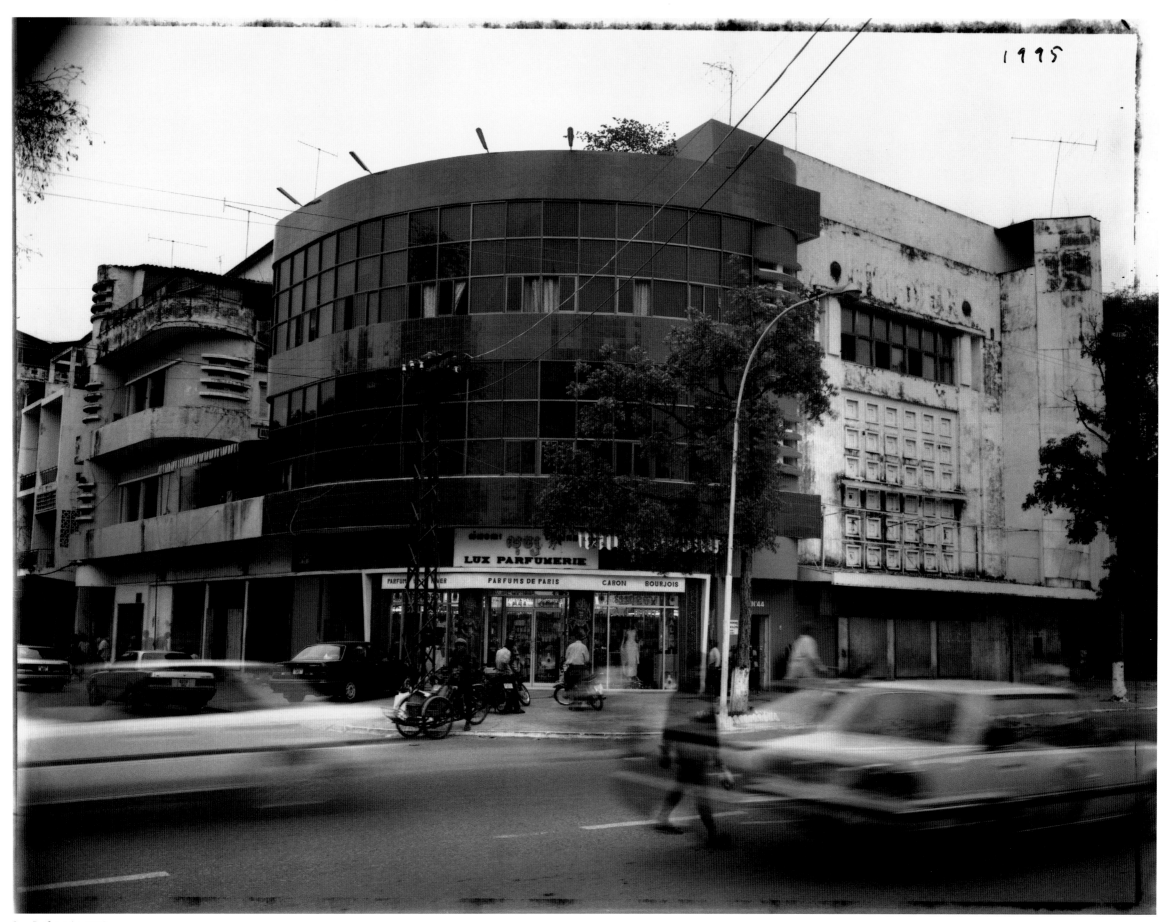

1995

Lux Parfumerie, 1995

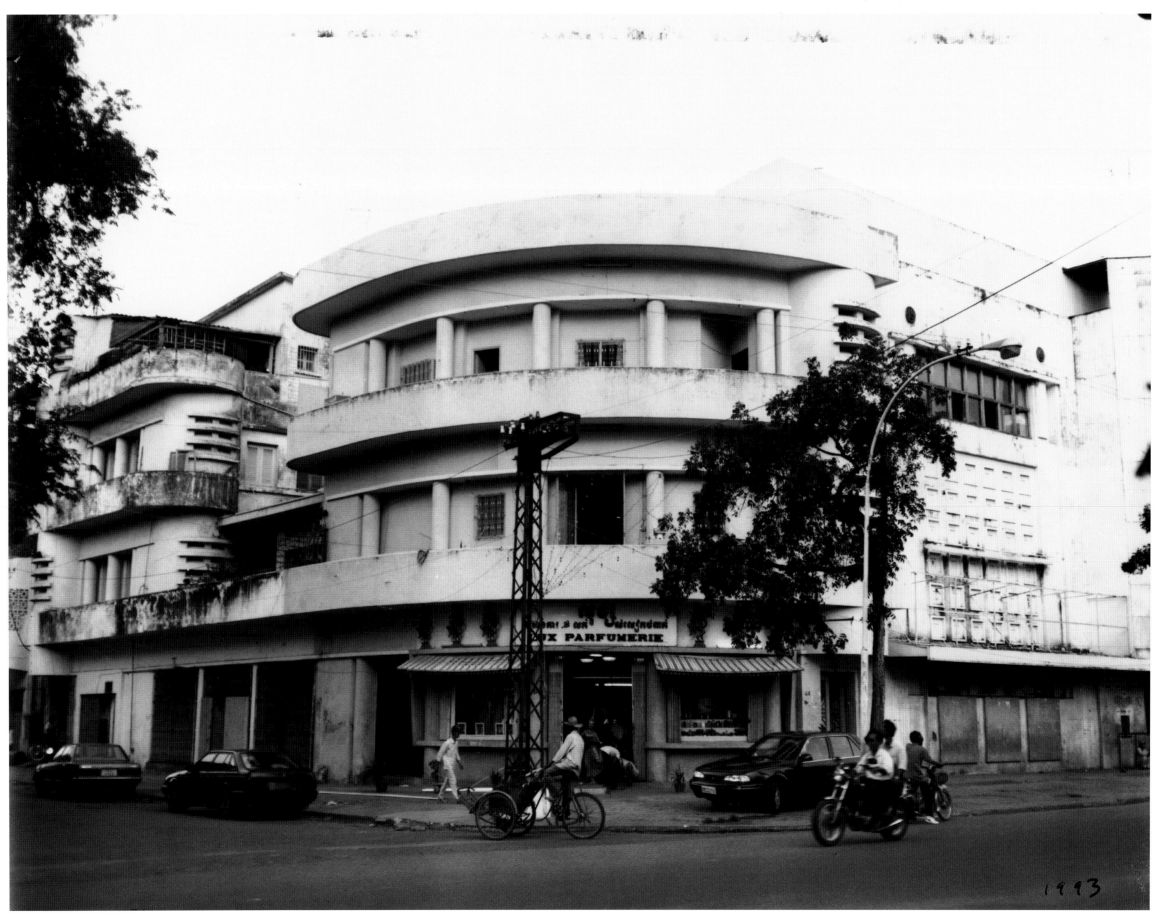

1993

Lux Parfumerie, 1993

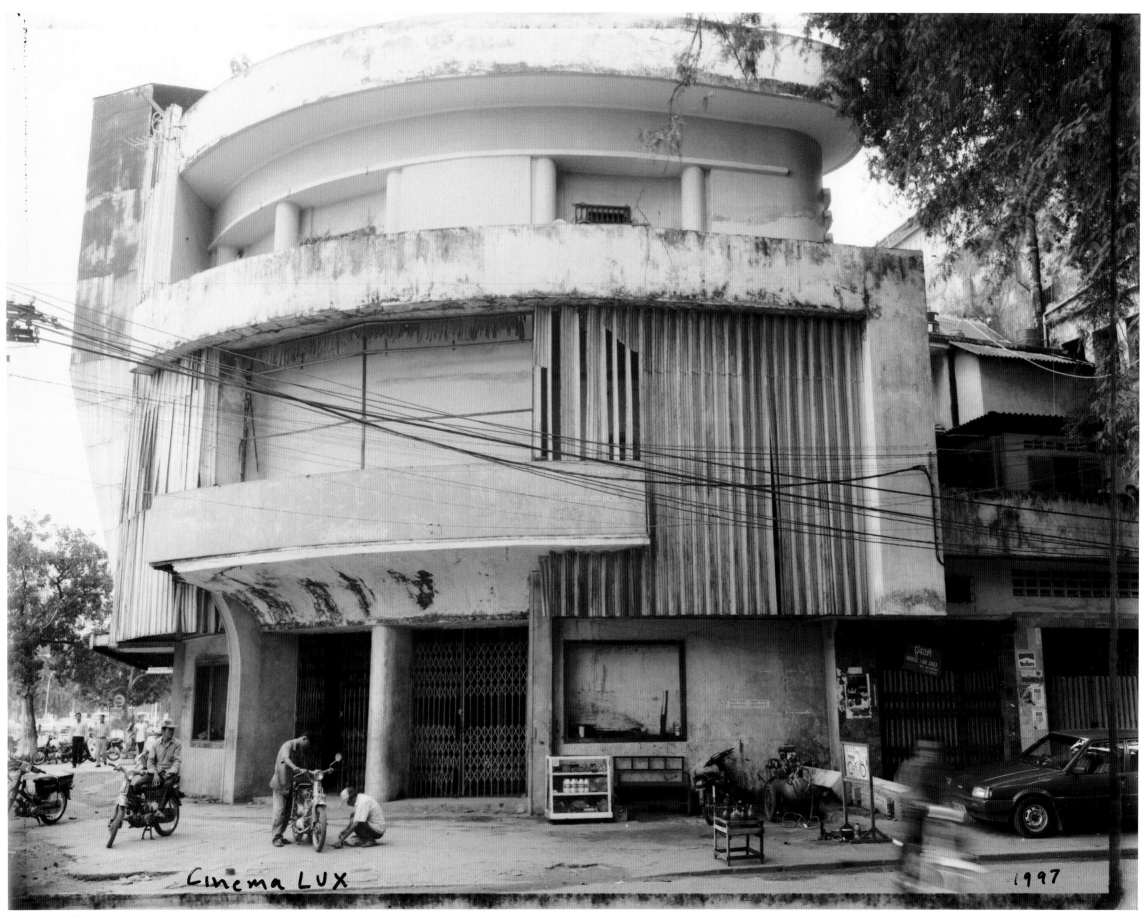

Cinema LUX 1997

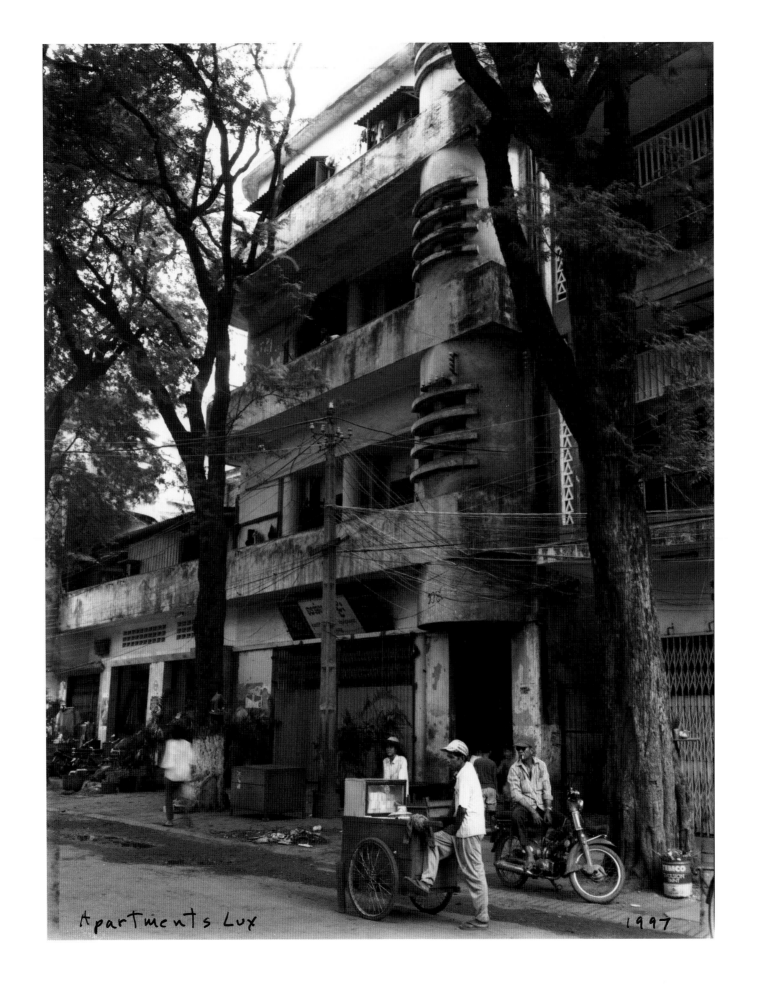

Apartments Lux 1997

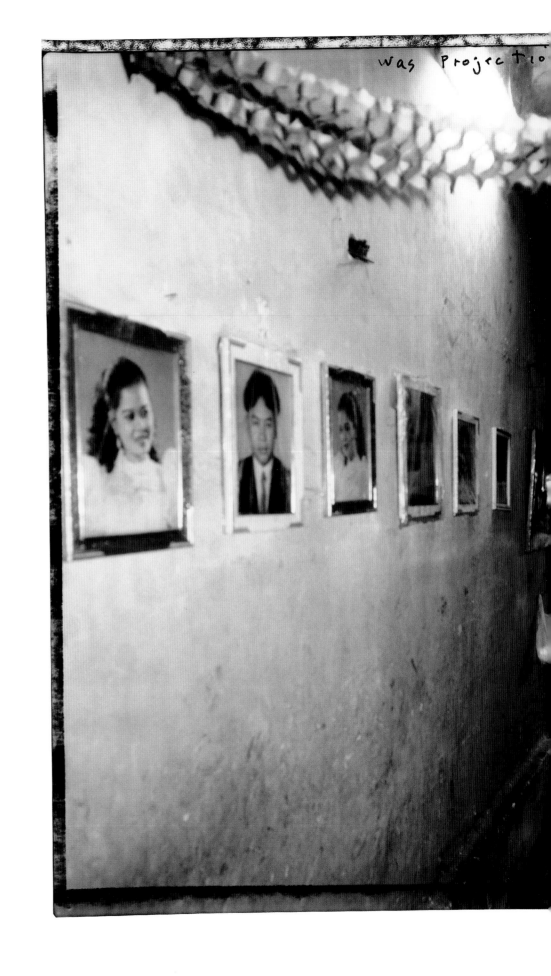

Cinema Lux, projection booth, 1997

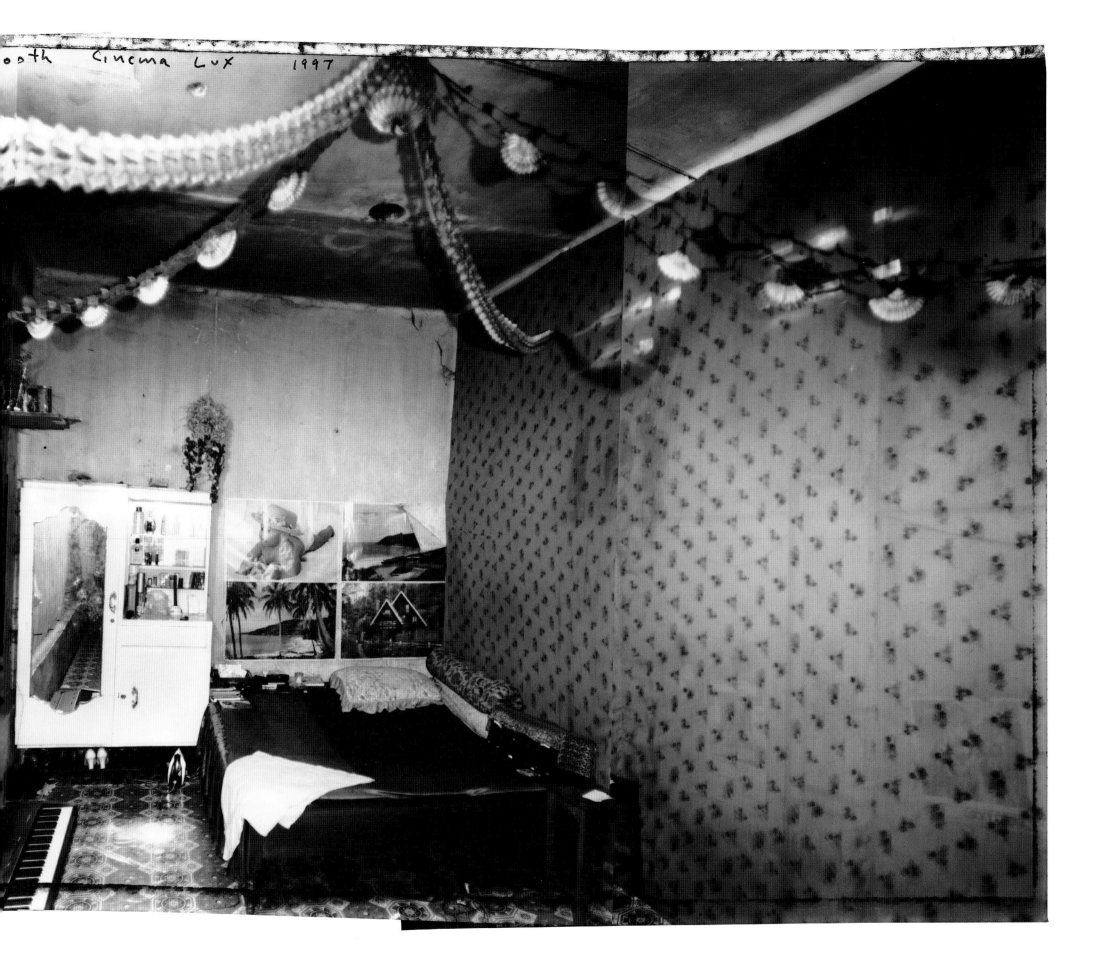

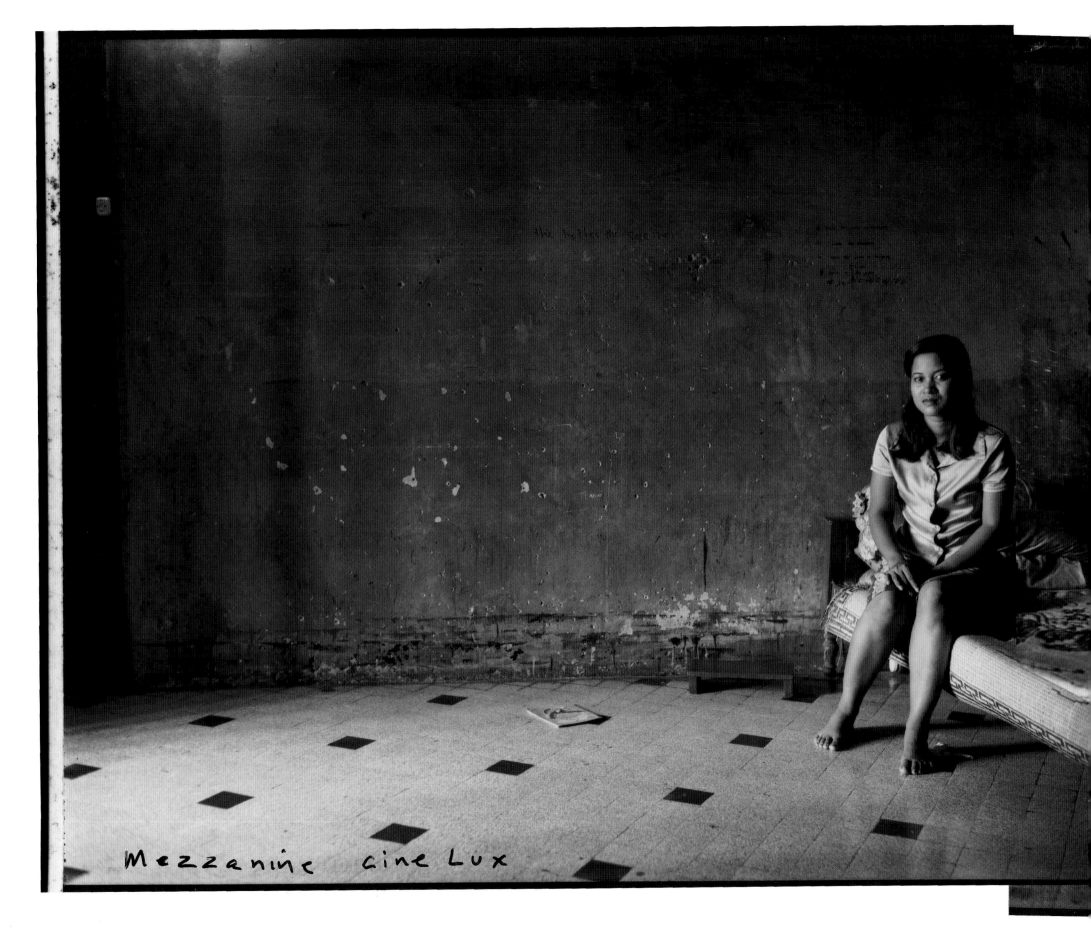

Mezzanine cine Lux

Cinema Lux, mezzanine, 2000

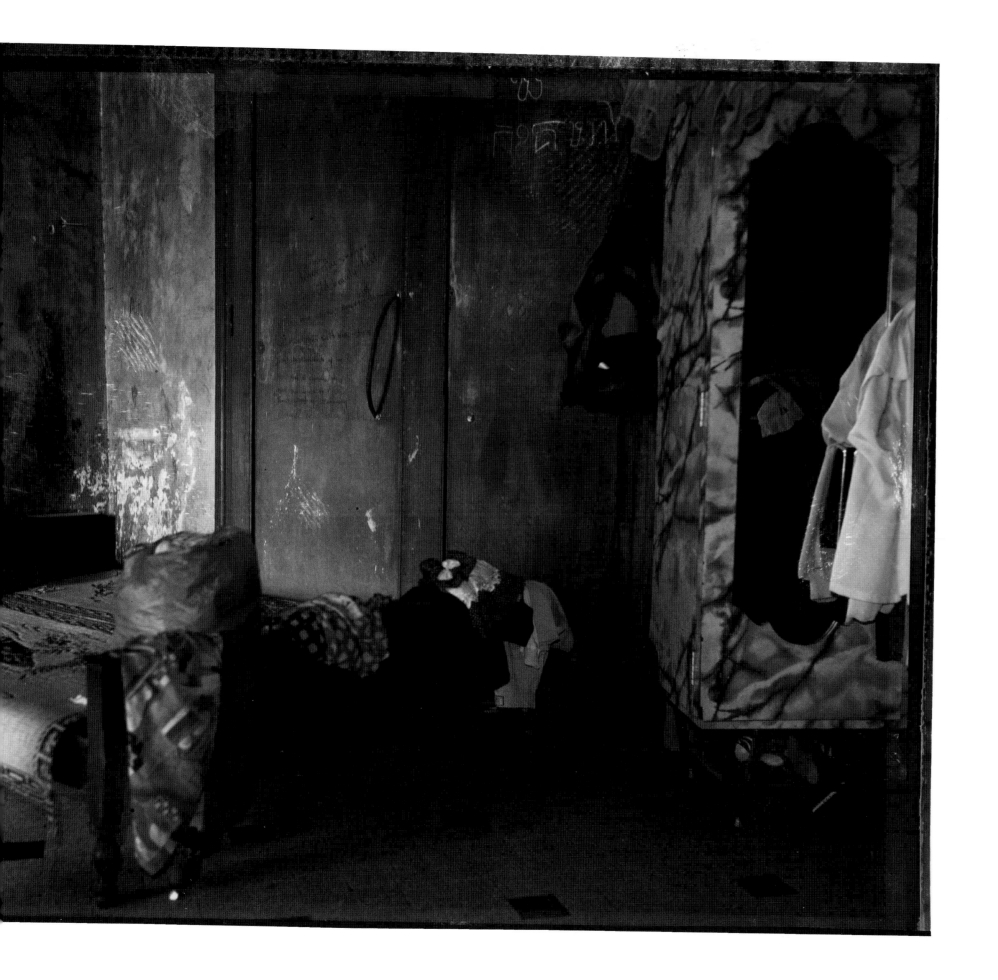

Woman in a restaurant, Phnom Penh, 1994

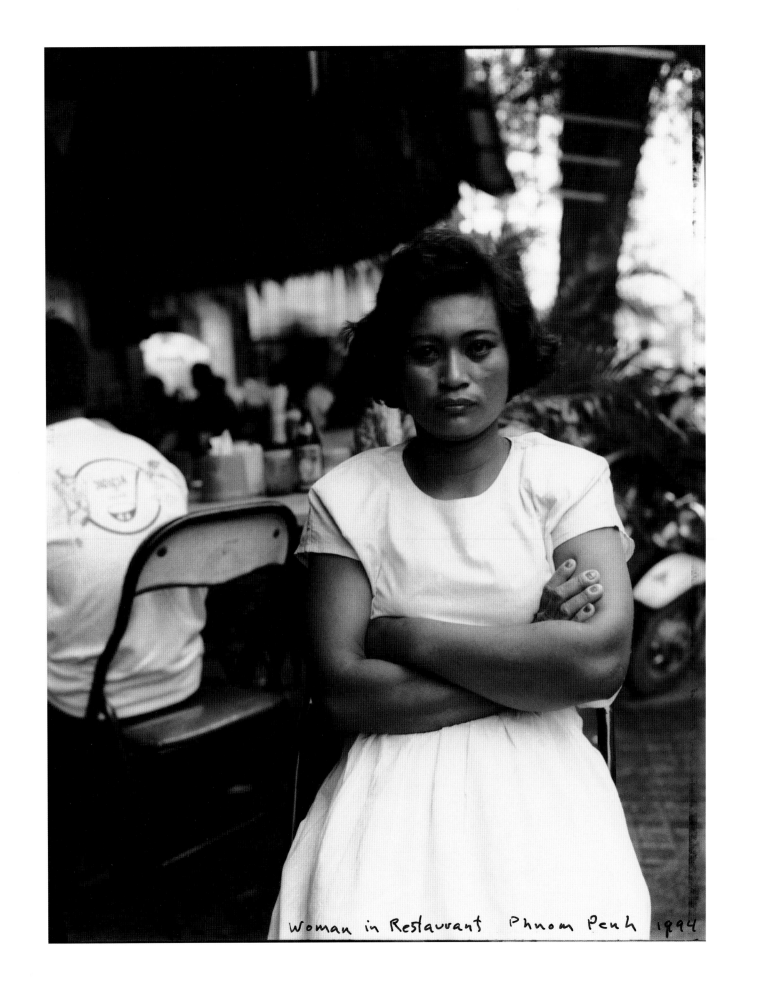

Woman in Restaurant Phnom Penh 1994

Smoking, drinking biologist, Hanoi, 1995

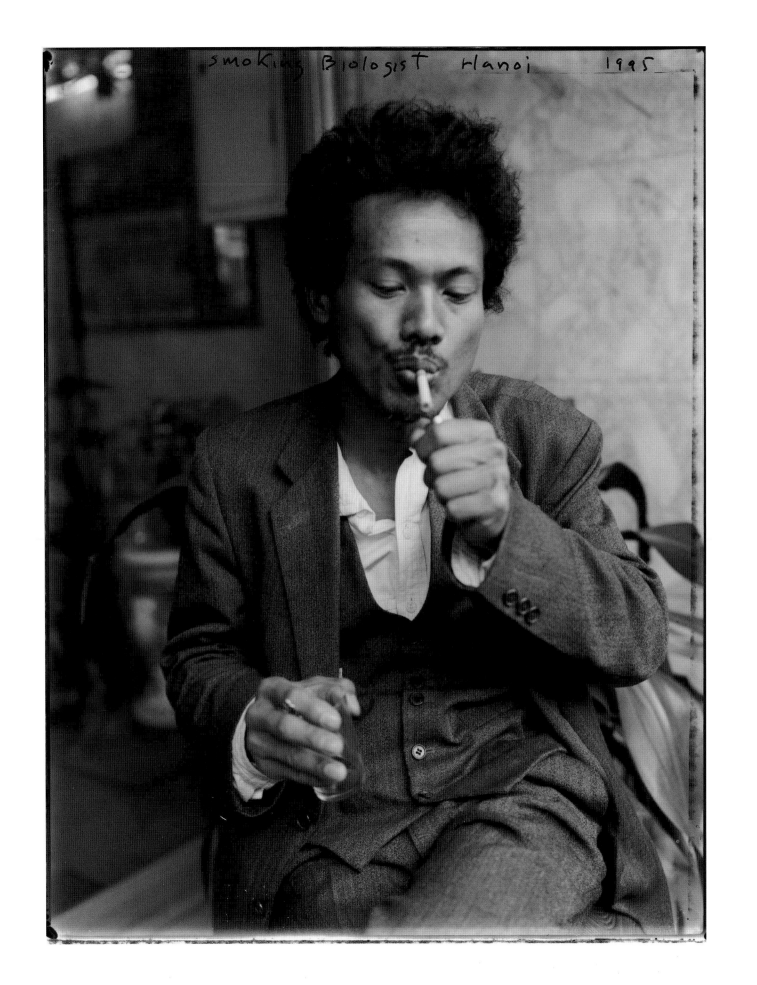

smoking Biologist Hanoi 1995

Balloon man, Phnom Penh, 1994

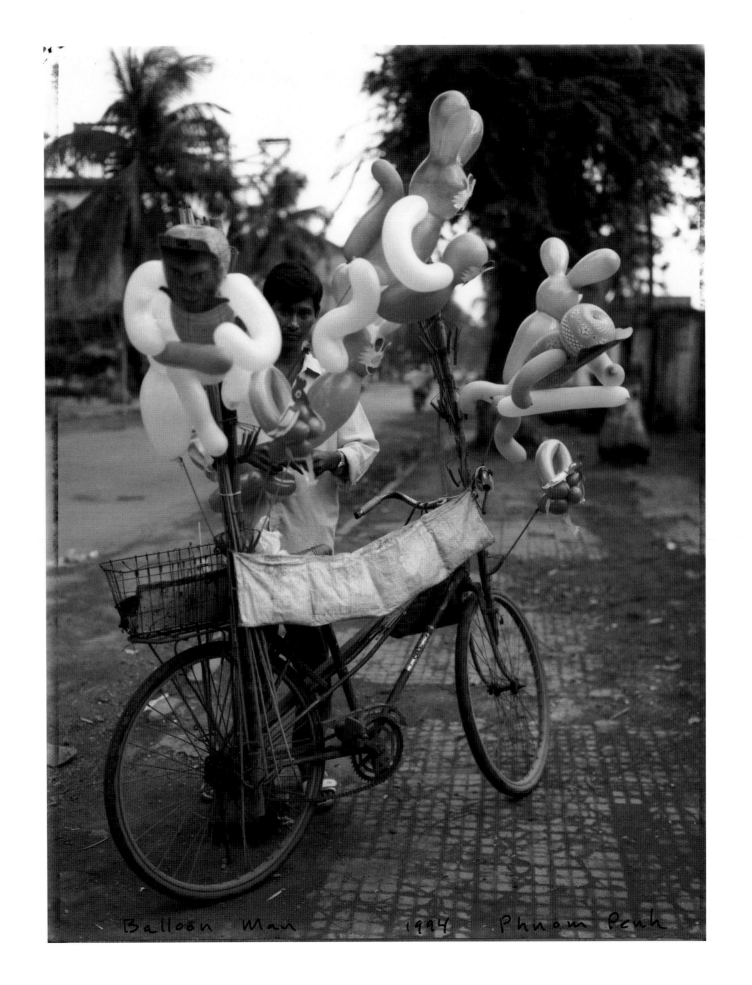

Balloon Man 1994 Phnom Penh

Beauty shop, Phnom Penh, 1995

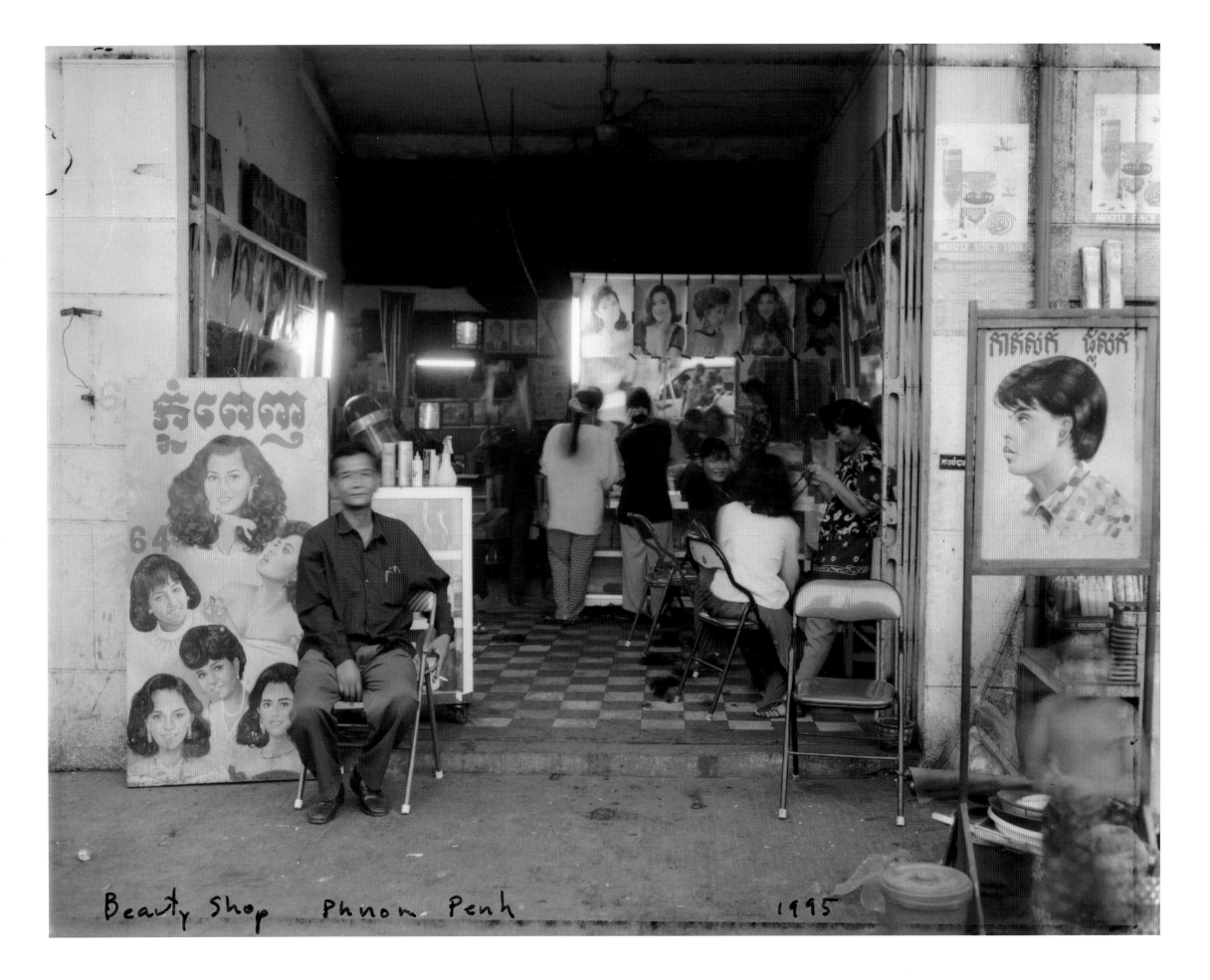

Beauty Shop Phnom Penh 1995

Key maker, shoe fixer, lighter filler, Kampong Cham, 1997

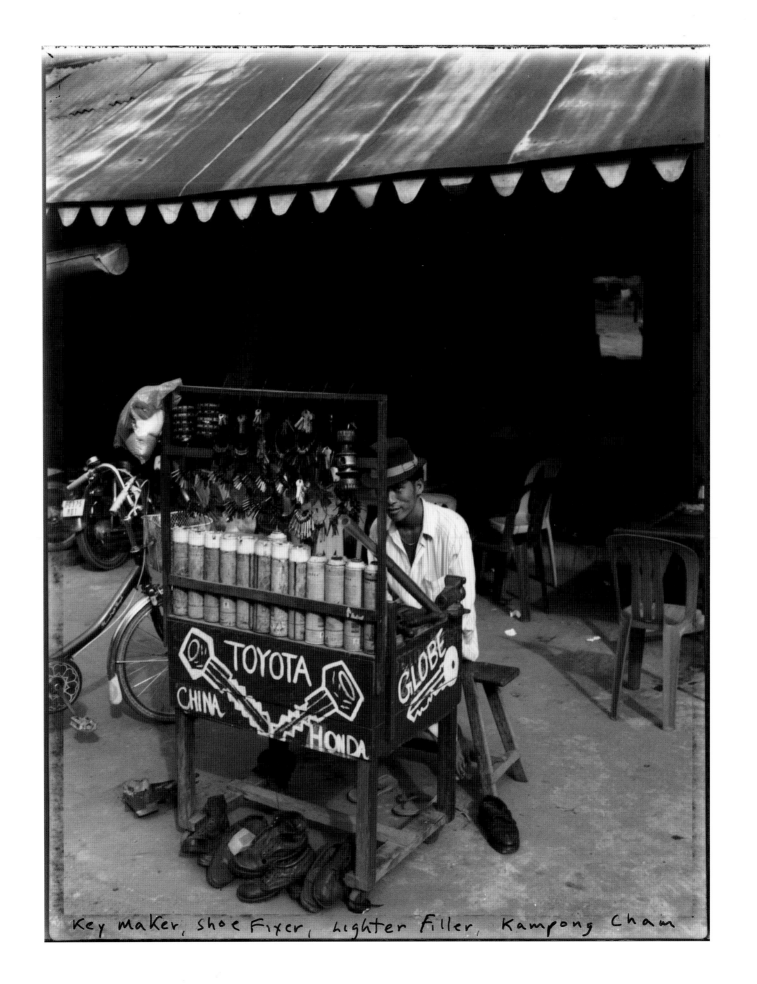

Key maker, Shoe fixer, Lighter Filler, Kampong Cham

Gas station, Hue, 2000

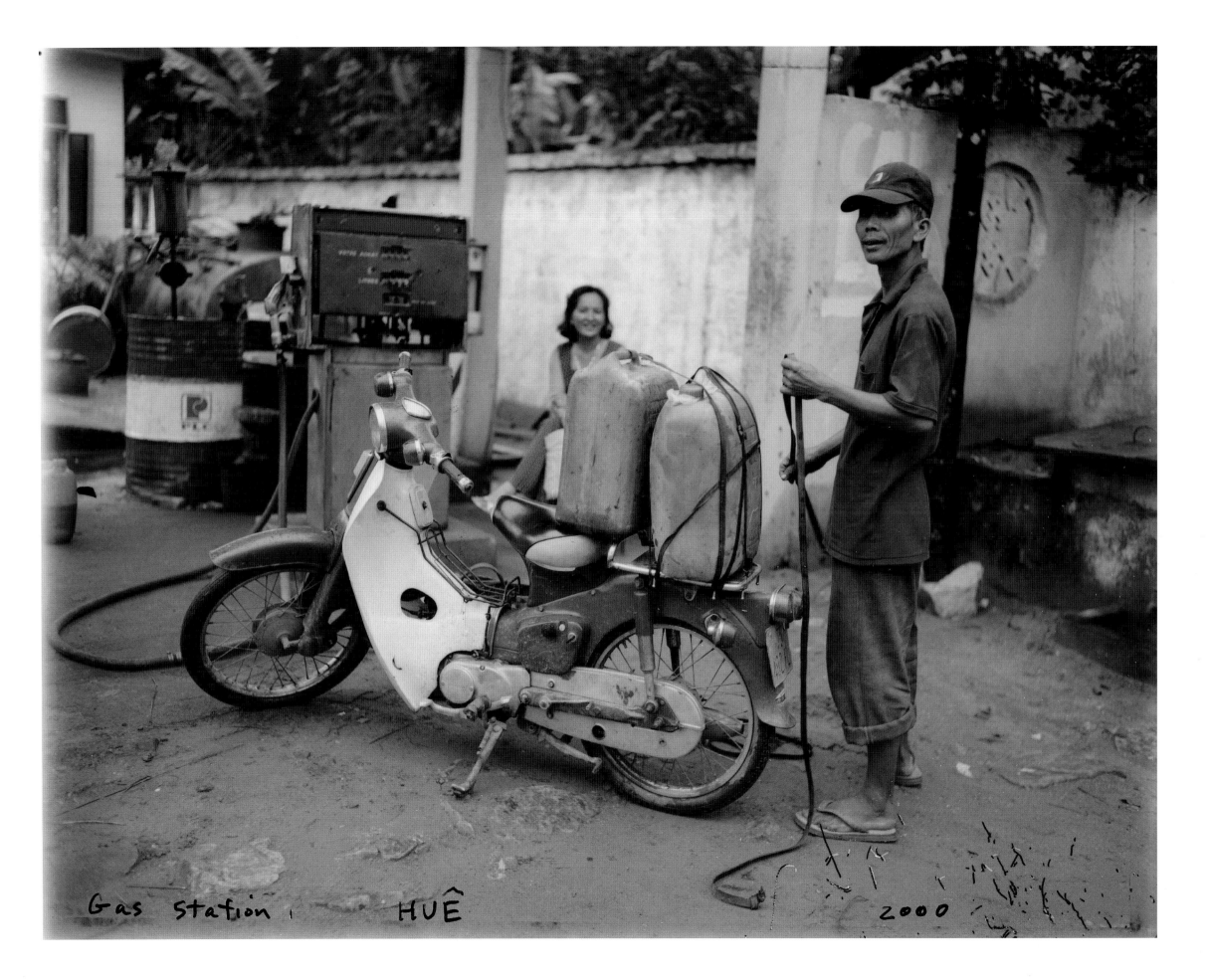

Gas Station, HUÊ 2000

Shell station, Siem Riep, 1995

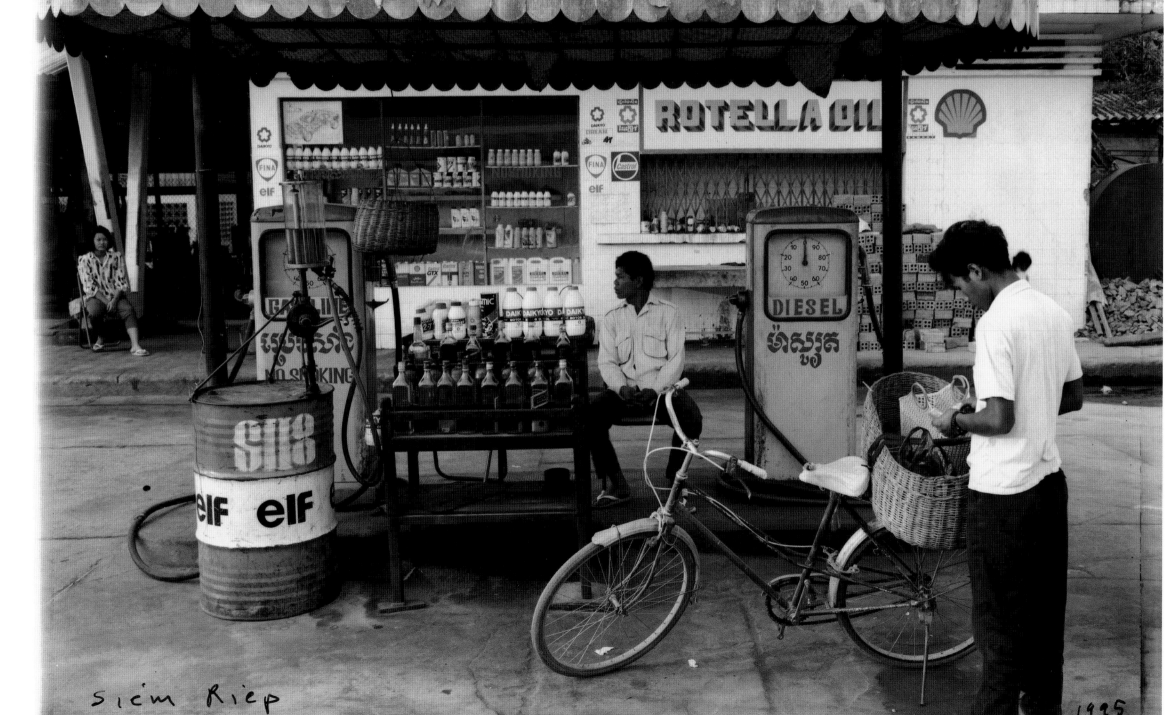

ស្ថានីយប្រេងឥន្ធនៈ
FILLING. STATION

ROTELLA OIL

Siem Riep

1995.

Total station, Nha Trang, 1995

TOTAL Dầu nhớt PHÁP tuyệt hảo

TOTAL STATION 1995

NHA TRANG

Newsstand, Phnom Penh, 1995

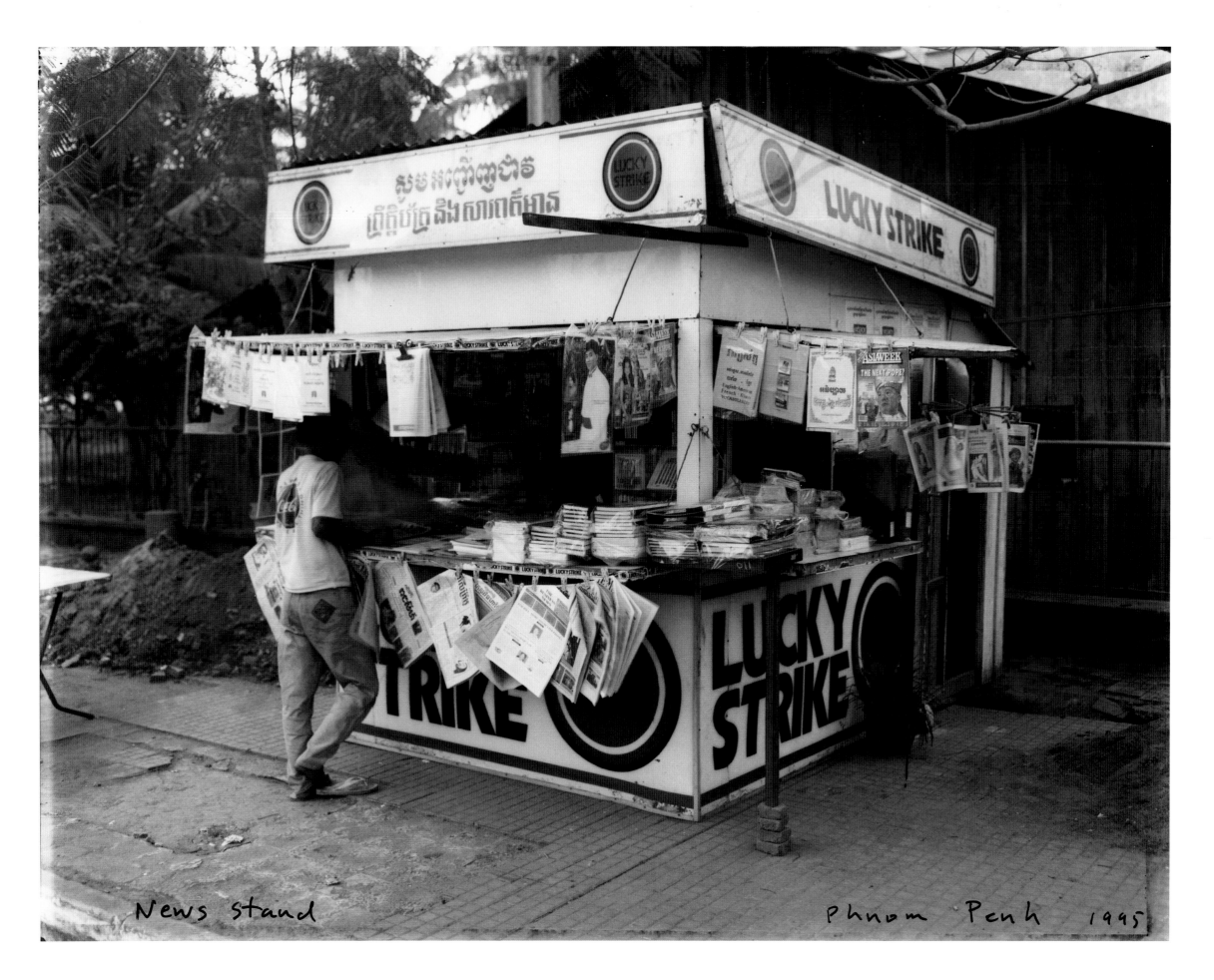

News Stand

Phnom Penh 1995

Phnom Penh, 1995

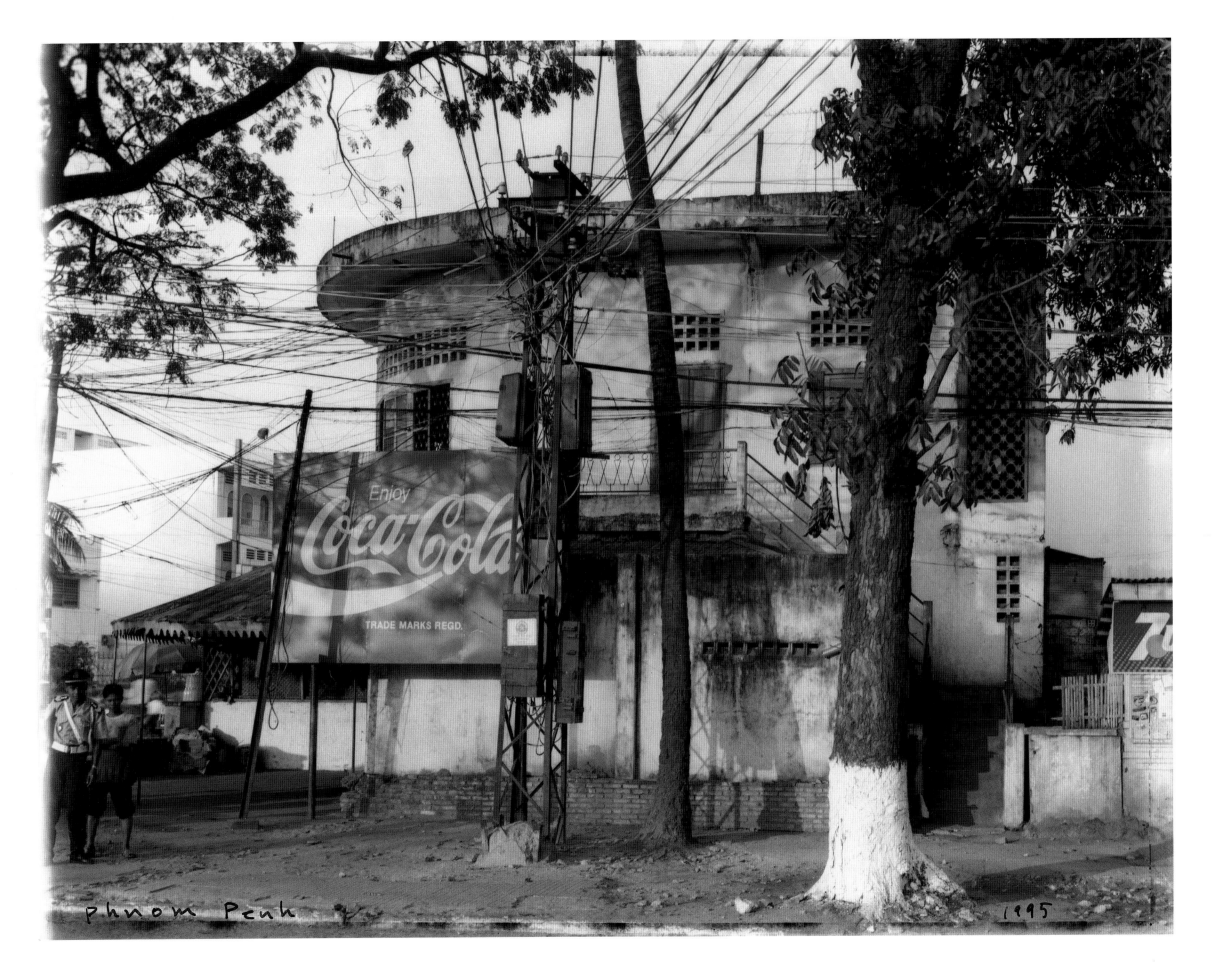

phnom Penh 1995

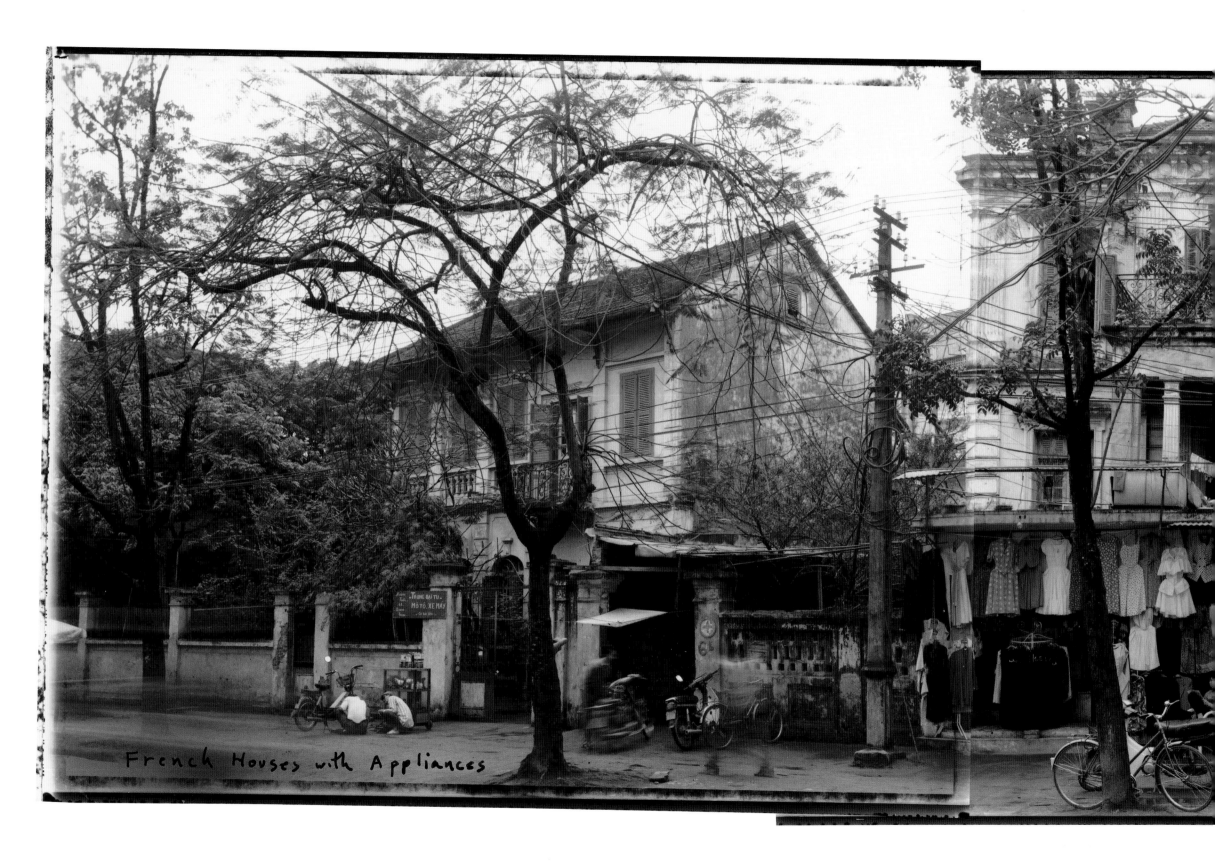

French houses with appliances, Quang Trung Street, Hanoi, 1995

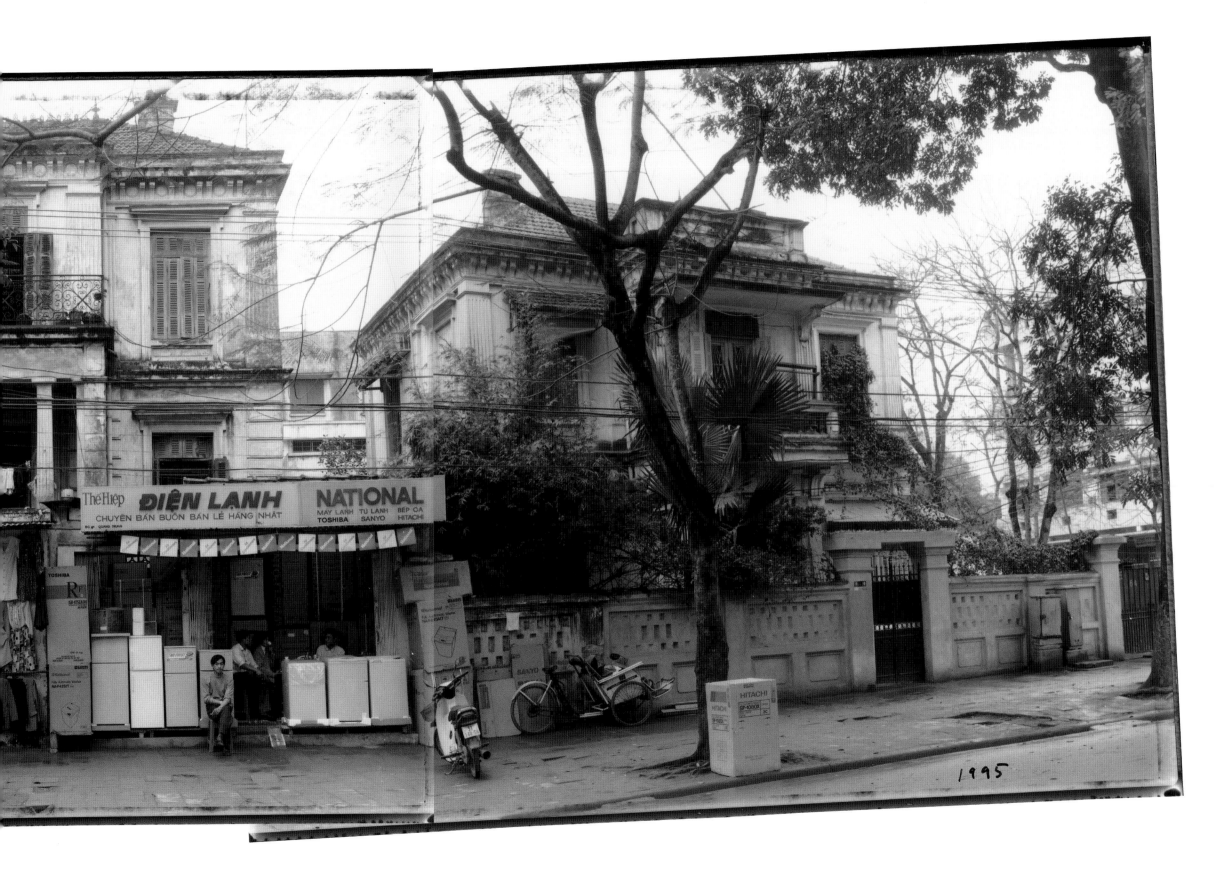

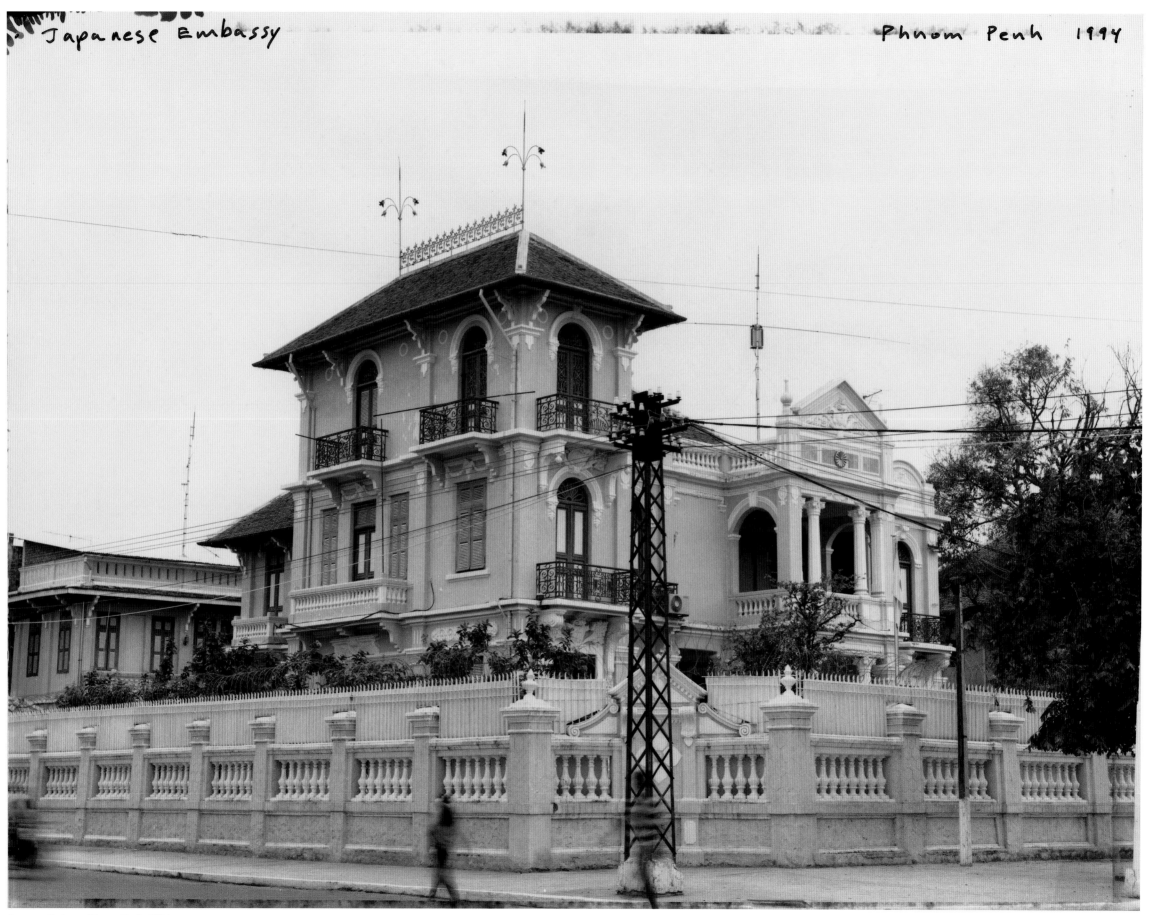

Japanese Embassy, Phnom Penh, 1994

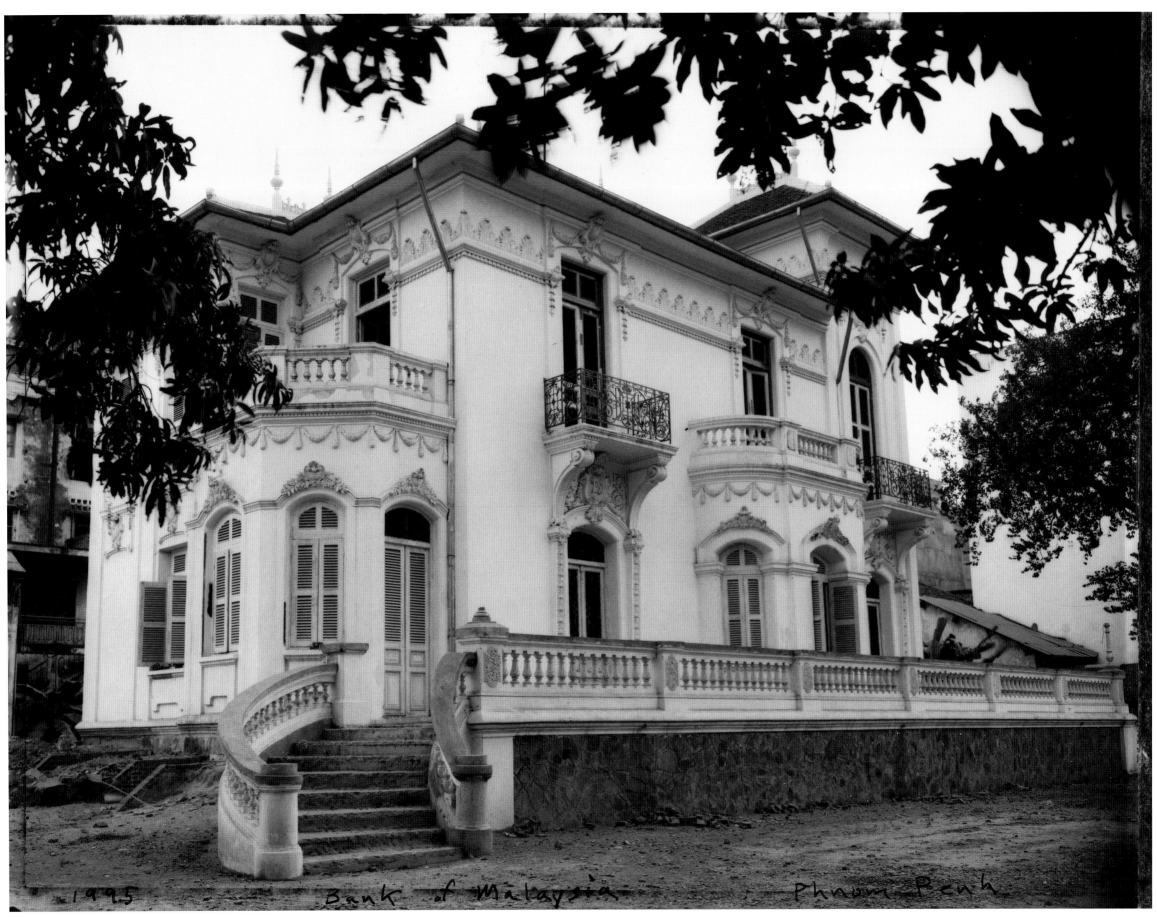

1995 Bank of Malaysia Phnom Penh

Bank of Malaysia, Phnom Penh, 1995

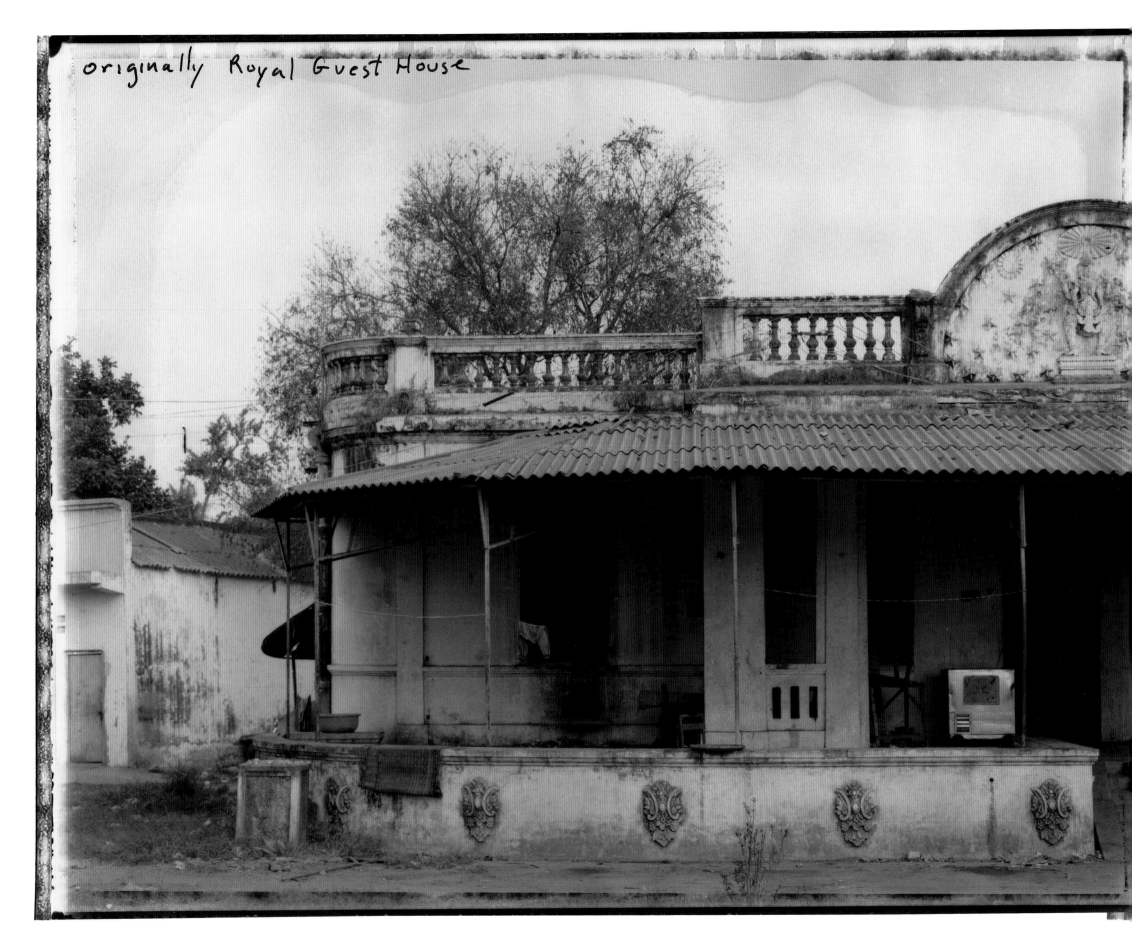

originally Royal Guest House

Police station, originally built as a royal guest house, Phnom Penh, 1995

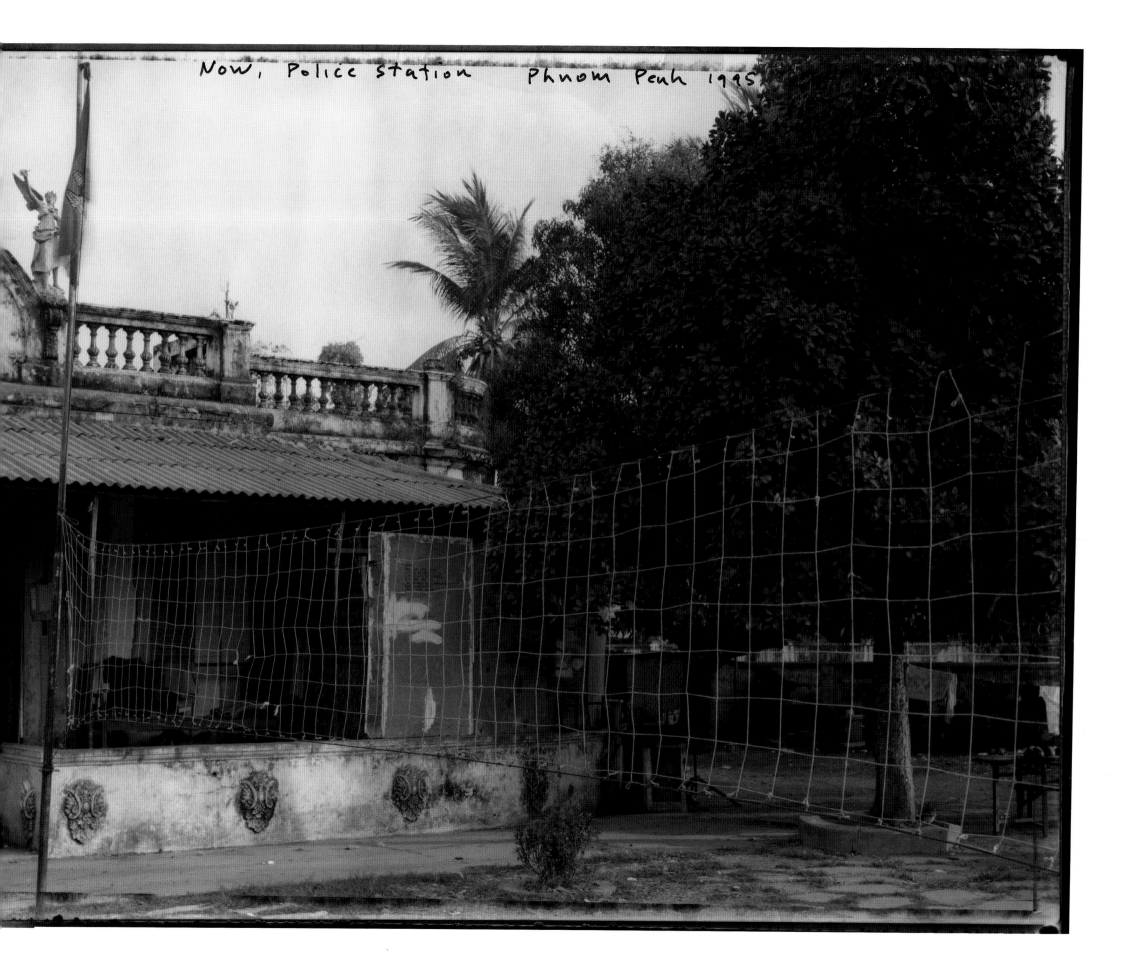

Now, Police Station Phnom Penh 1995

French house, Phnom Penh, 1995; demolished 1996

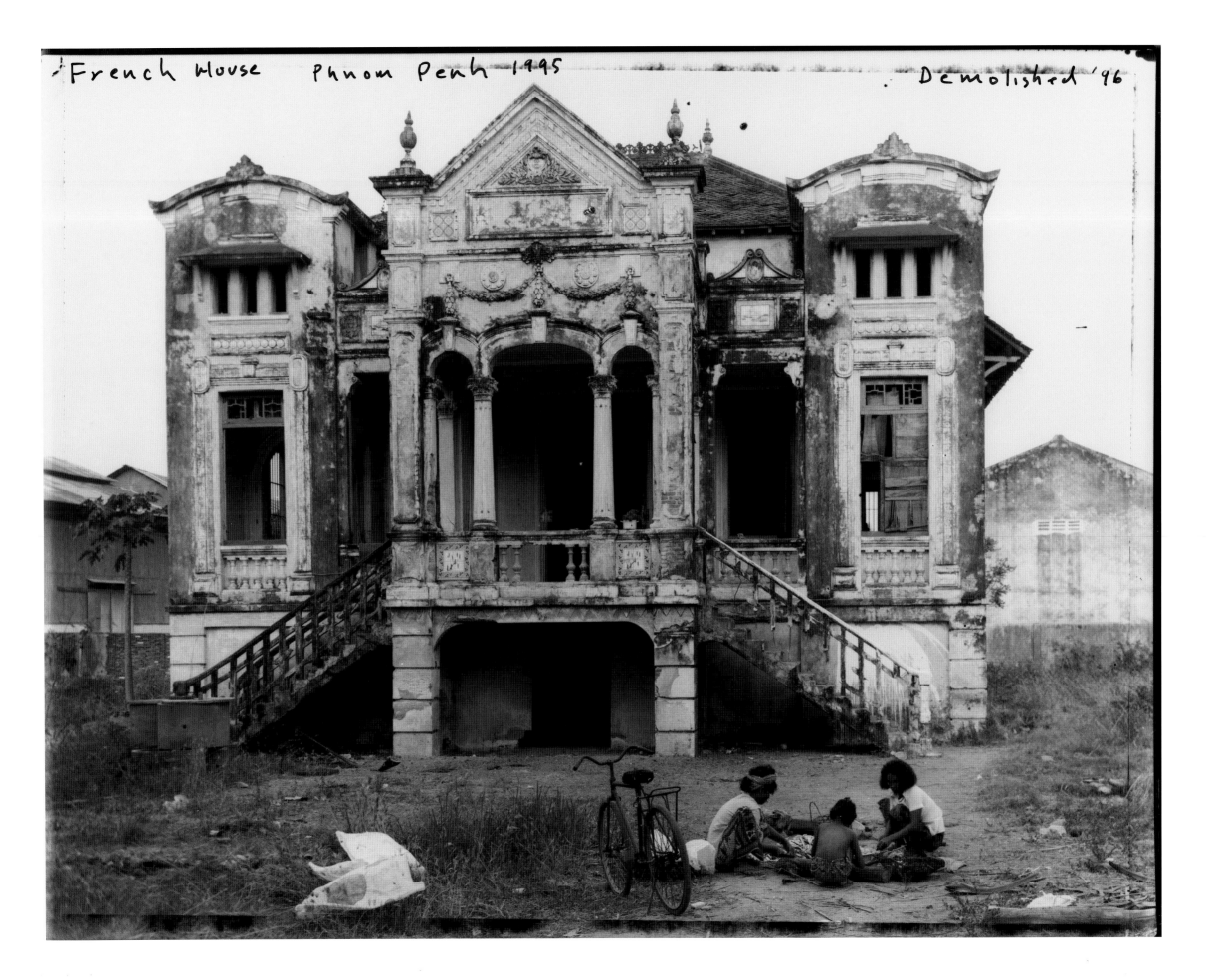

'French House Phnom Penh 1995 . Demolished '96

Hanoi, 1995

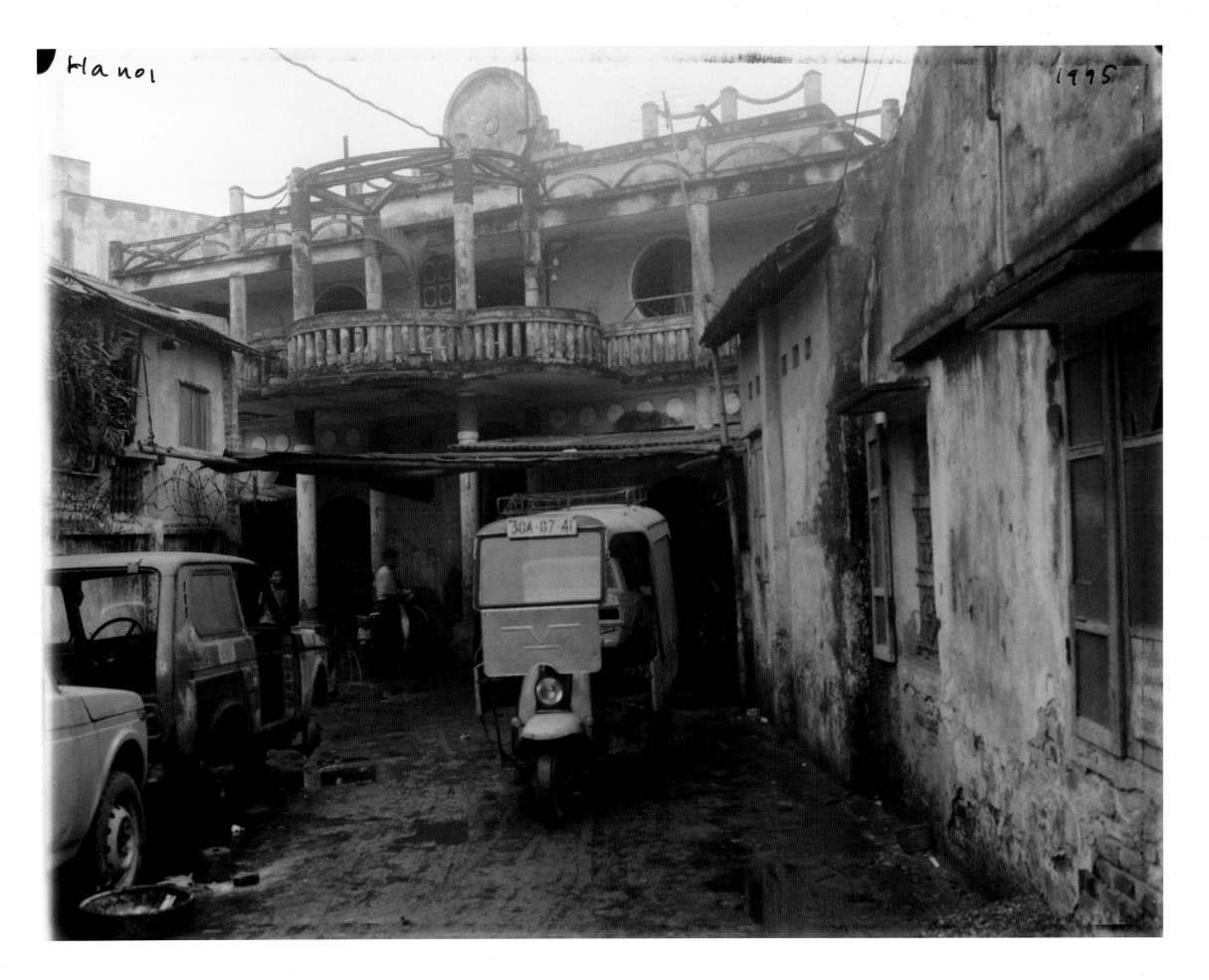

Hoa Binh Cinema, inhabited by poor people, Danang, 1995; demolished 1998

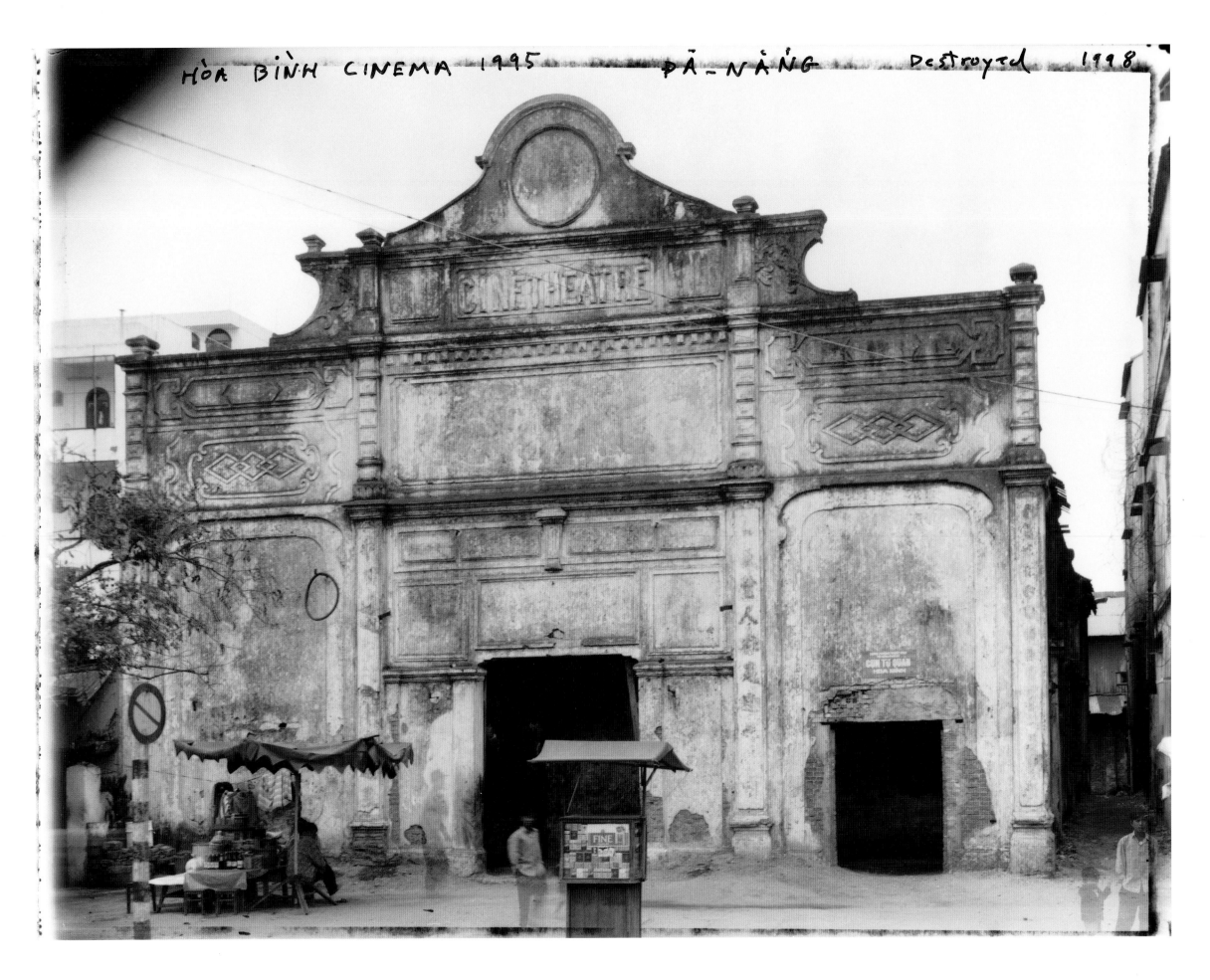
HÒA BÌNH CINEMA 1995 ĐÀ-NẴNG Destroyed 1998

Cinema-Video, inhabited by old and poor, Danang, 2000

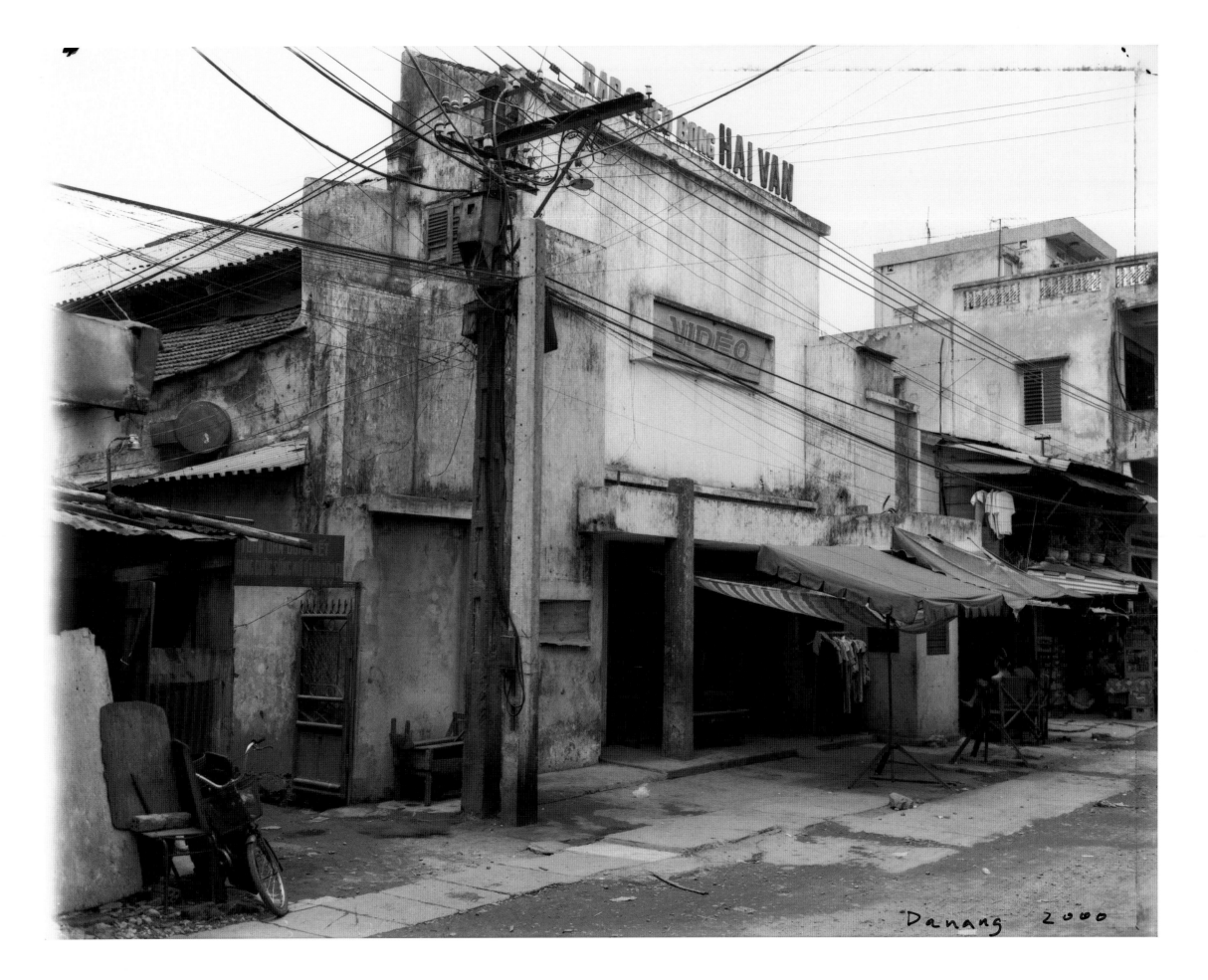

Danang 2000

Bandstand with resident, Phnom Penh, 1993

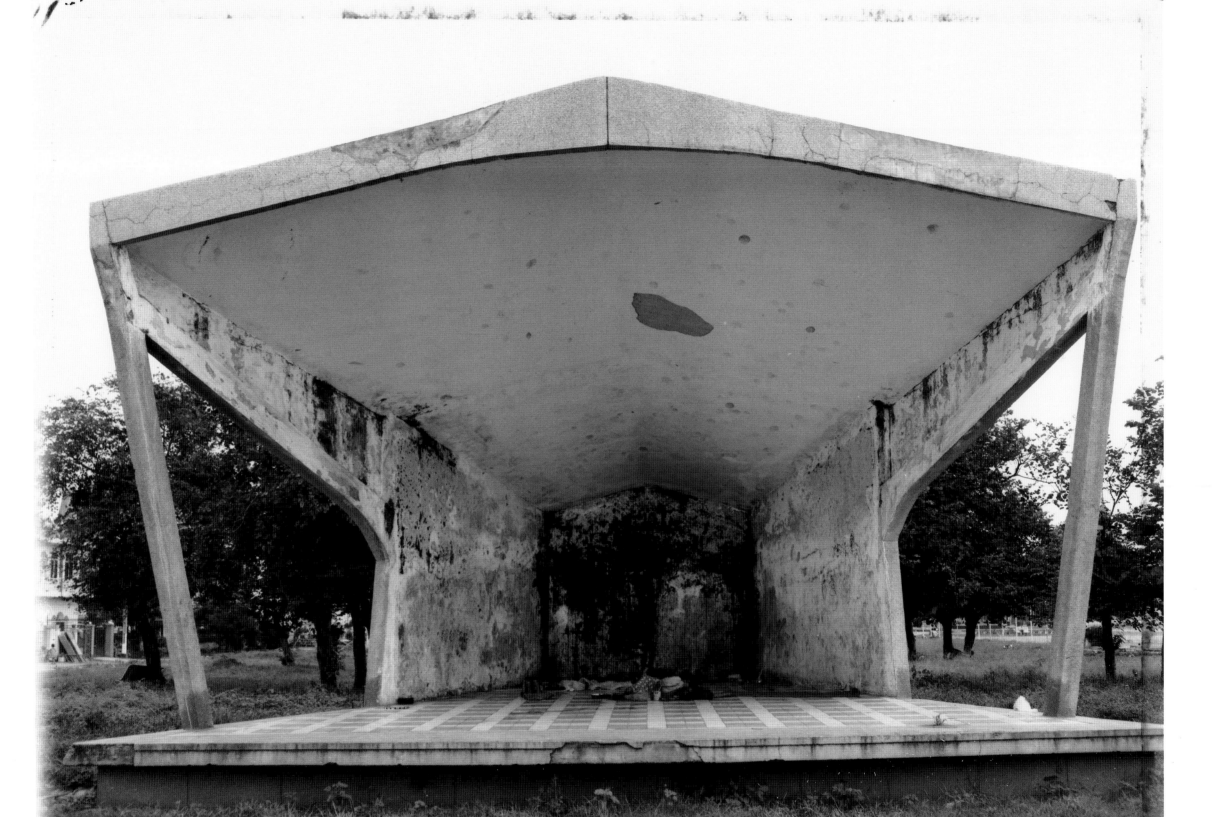

Band stand and resident 1993 Phnom Penh

Phnom Penh, 1997

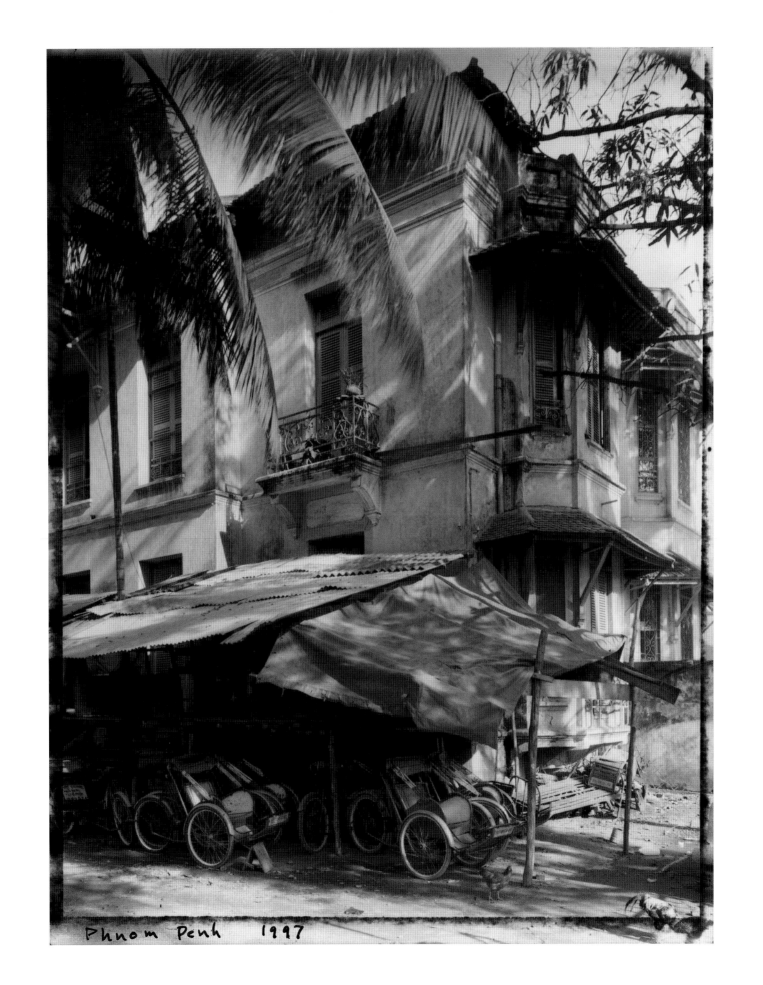

Phnom Penh 1997

Phnom Penh, 1993

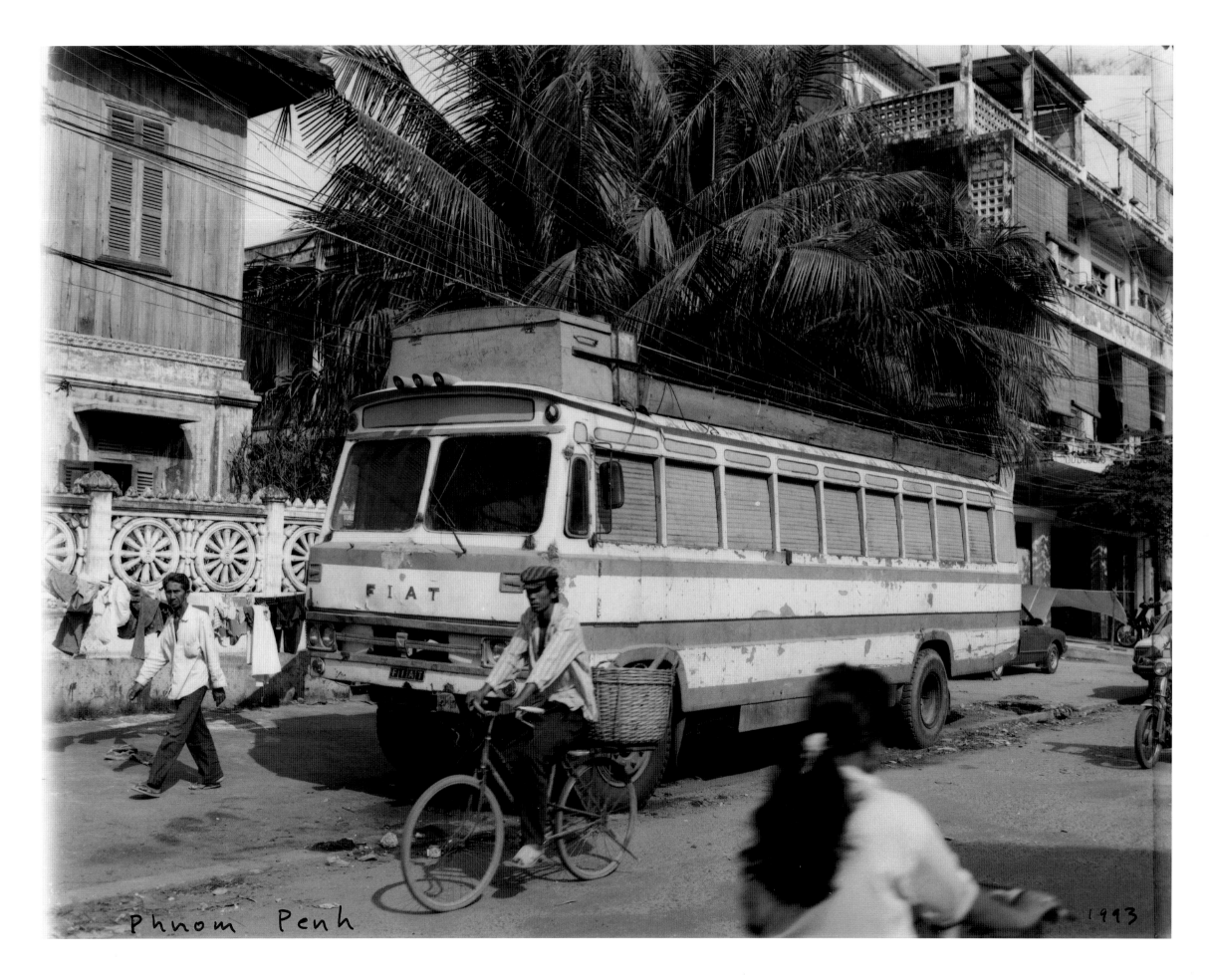

Phnom Penh 1993

Abandoned U.S. Consulate, Danang, 1994; demolished 1998

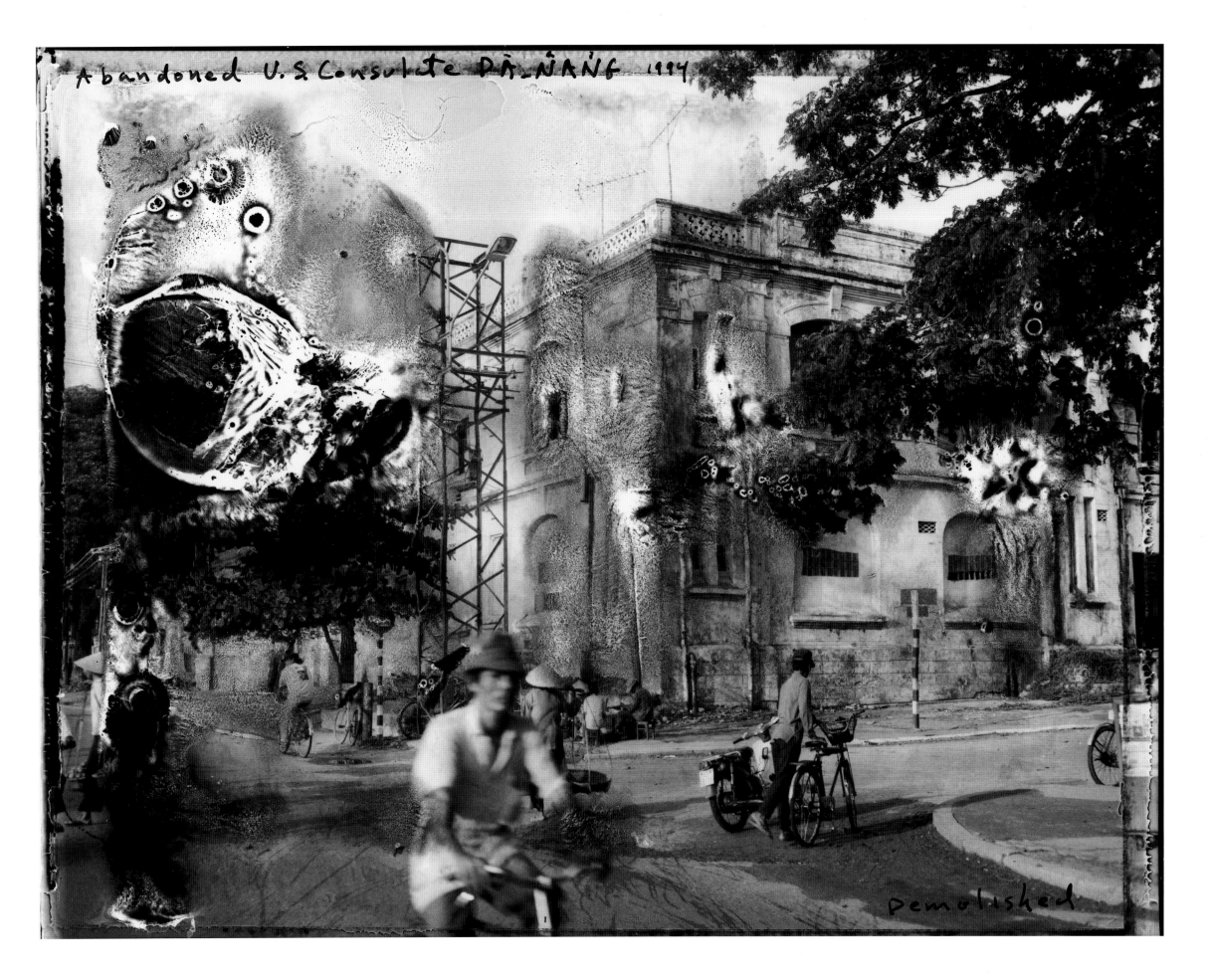

Abandoned U.S. Consulate DA NANG 1994

Demolished

Storage building built on U.S. cluster bomb cases, Ho Chi Minh Trail, Laos

storage building built on U.S. clusterbomb cases - Laos

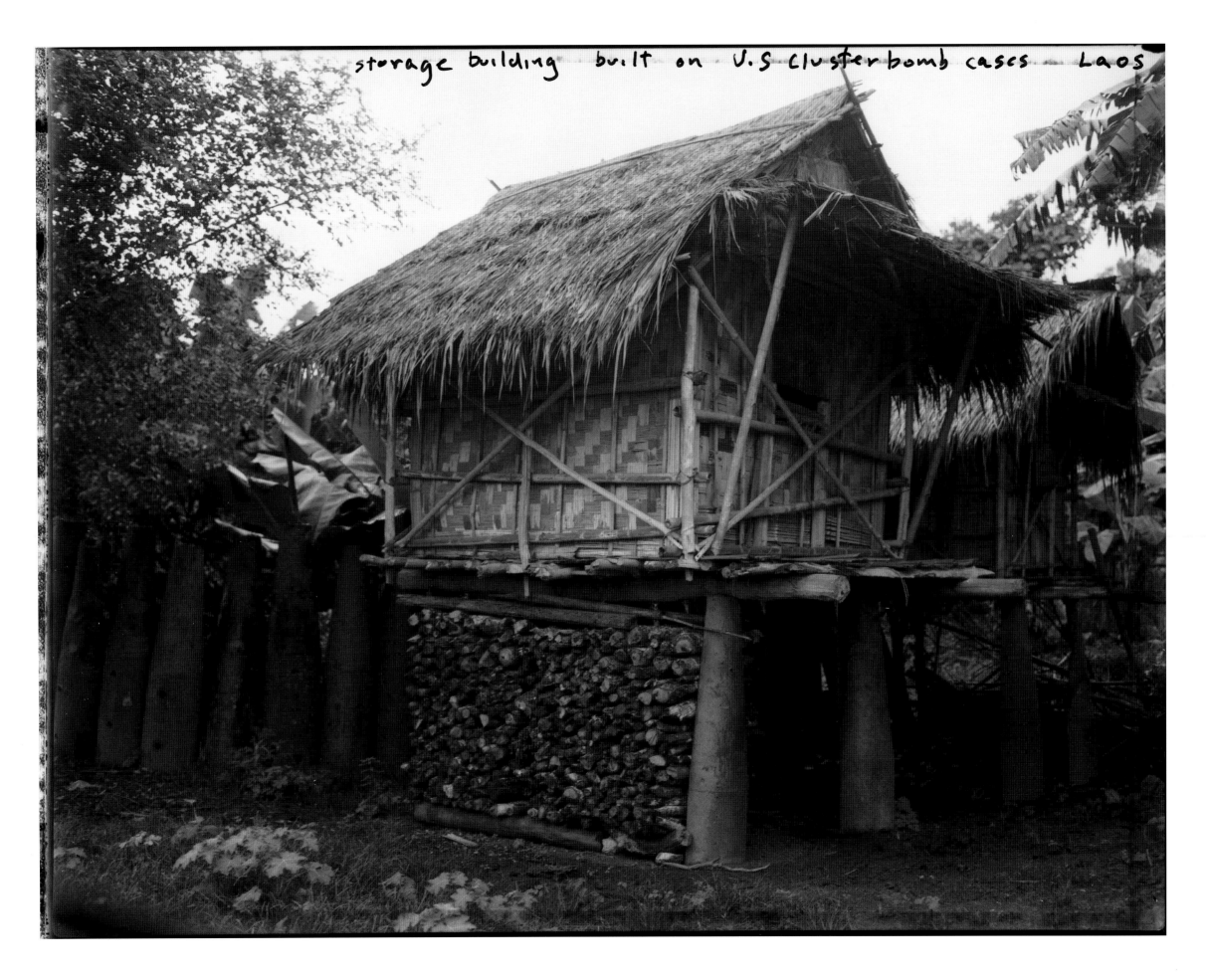

Road builder, Hoa Binh, 1995

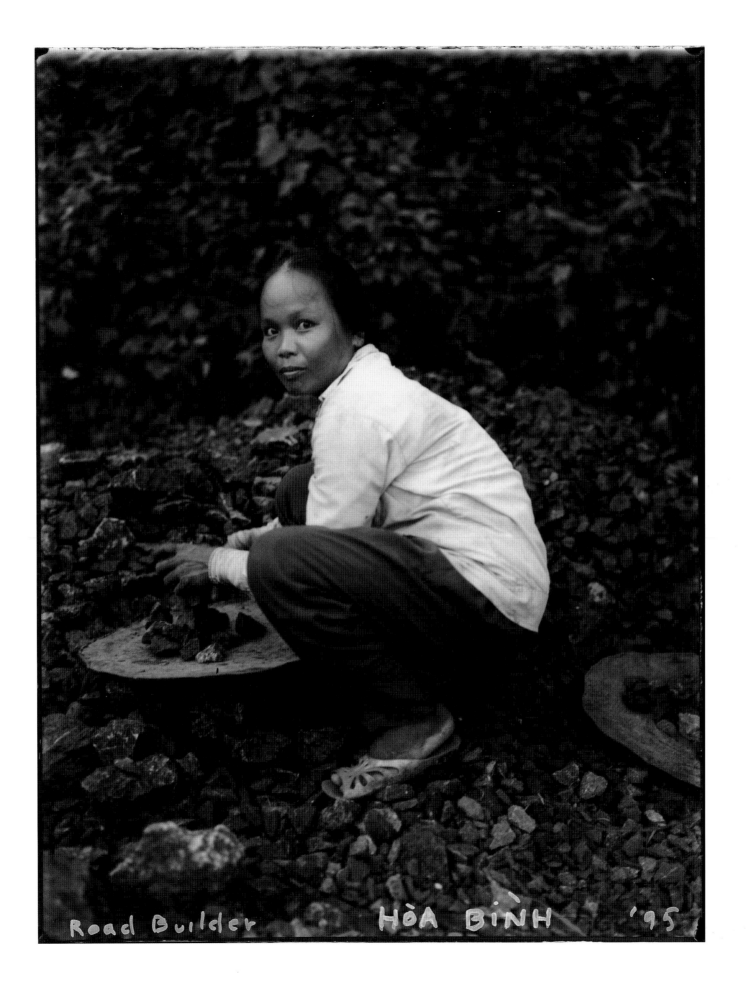

Road Builder HÒA BÌNH '95

Road builders, Hoa Binh, 1995

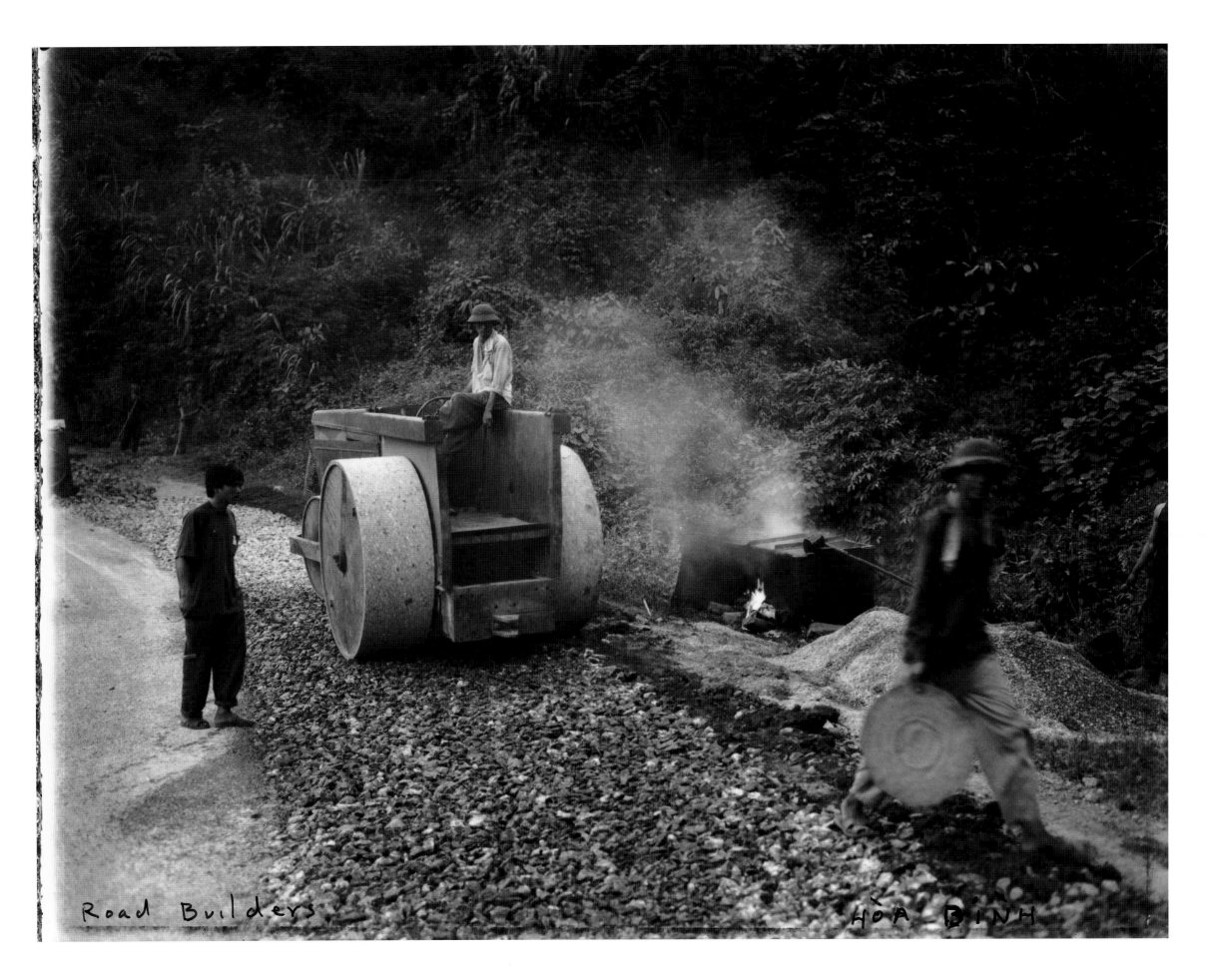

Road Builders HÒA BÌNH

Street repair, U.S. helmet used as a tar dipper, Phnom Penh, 1994

street repair Phnom Penh U.S Helmet used as Tar Dipper

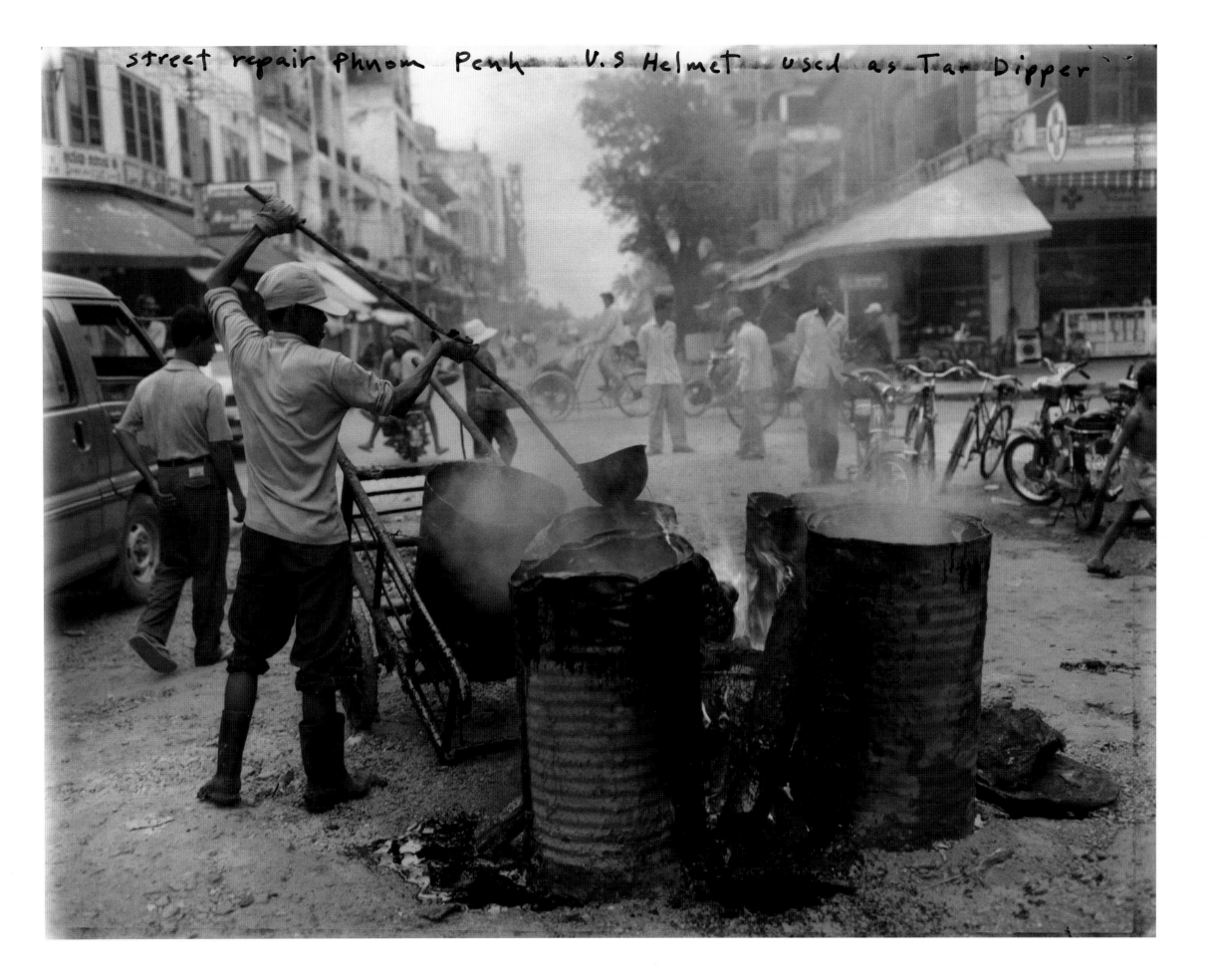

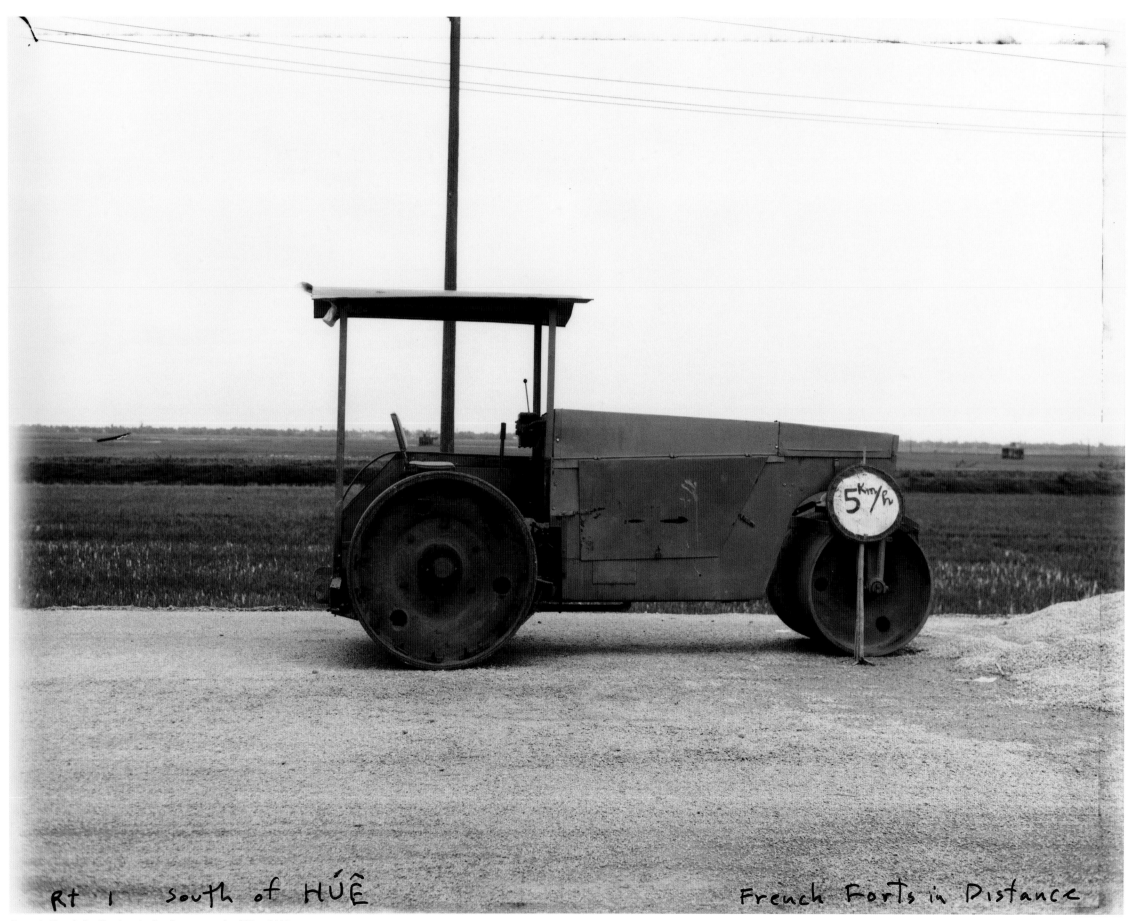

Rt 1 south of HÚẾ French Forts in Distance

Route 1, French fortifications in the distance, south of Hue, 2000

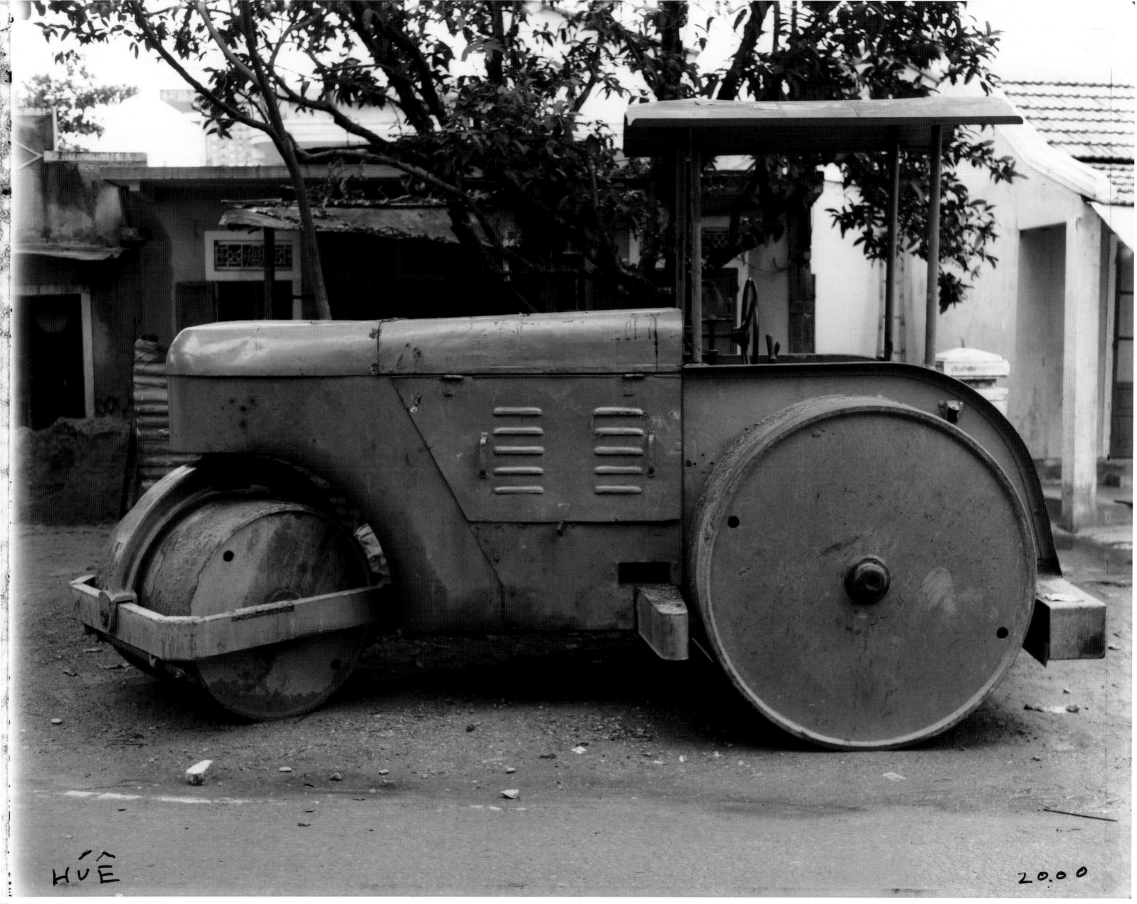

HÚÊ

20.00

Hue, 2000

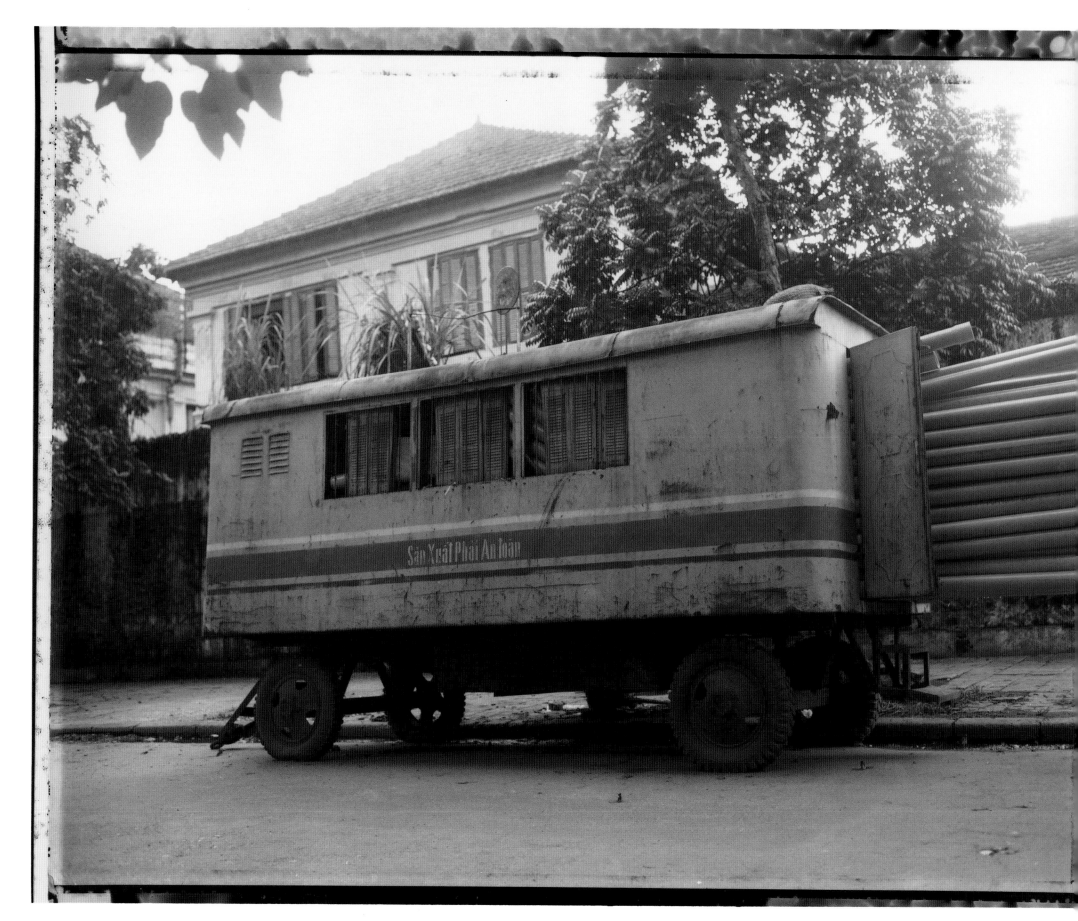

Hoa Lo Prison, built as a prison by the French, later called the Hanoi Hilton by American air crews who were captured and imprisoned here by the Viet Cong during the Vietnam War, 1995

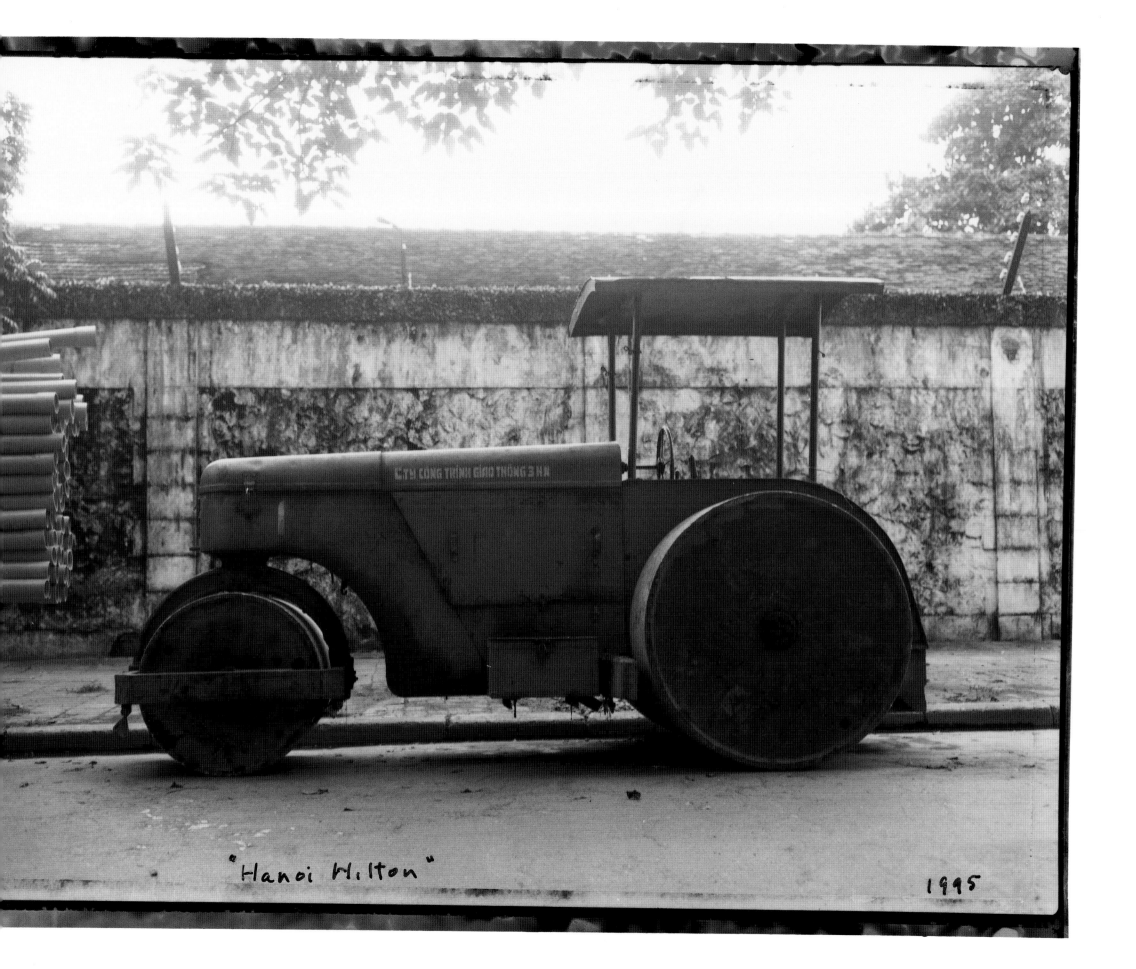

"Hanoi Hilton"

1995

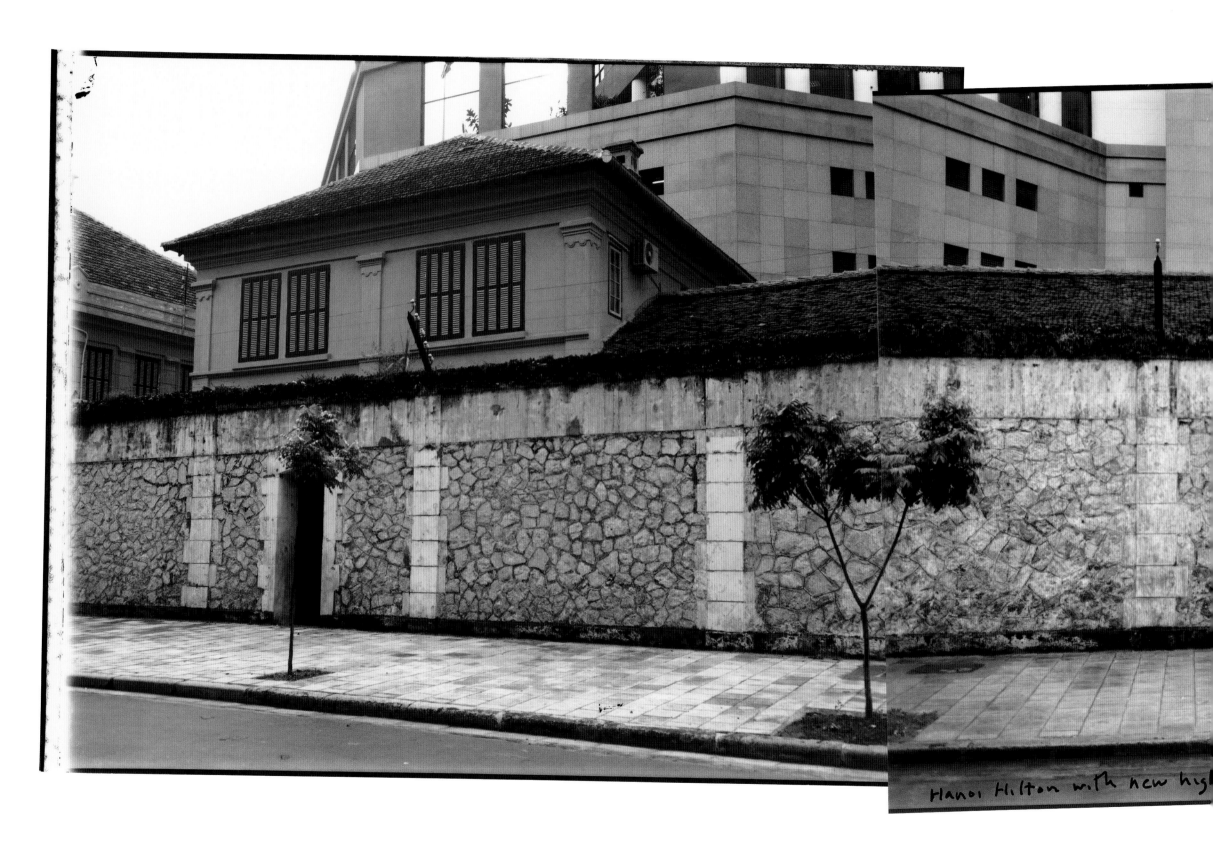

Hanoi Hilton with new hig[h]

Hanoi Hilton with the high-rise Singapore Hotel under construction inside the compound, 1998

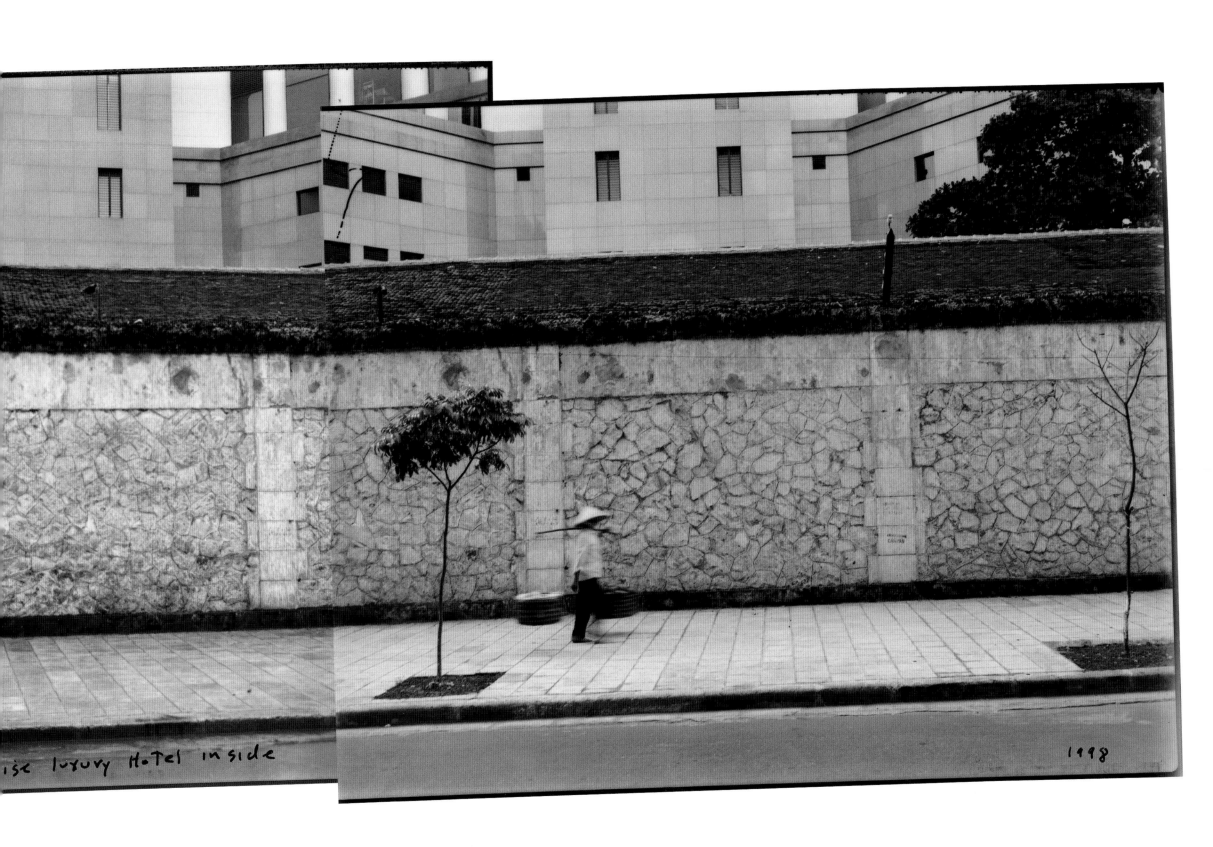

ise luxury Hotel inside 1998

Ministry of Fisheries, was the U.S. Embassy from 1970 to 1975, Phnom Penh, 1994
From the rear of this building, Ambassador John Gunther Dean, his staff, and Cambodian
friends boarded helicopters and left the country to the final victory of the Khmer Rouge.

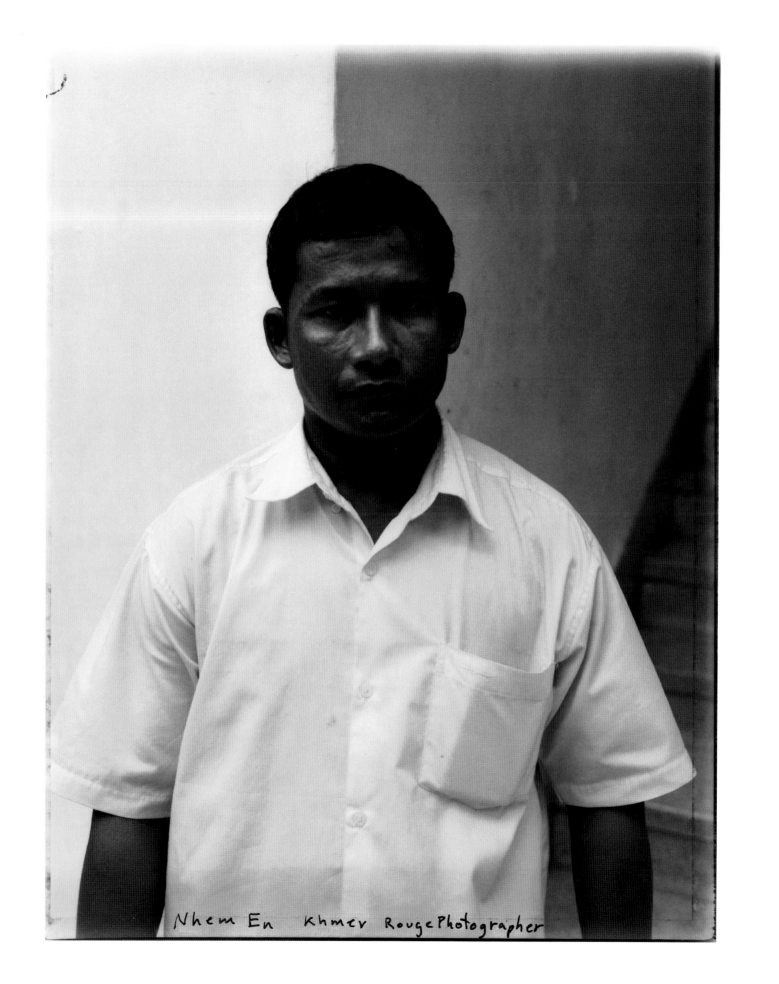

Nhem En Khmer Rouge Photographer

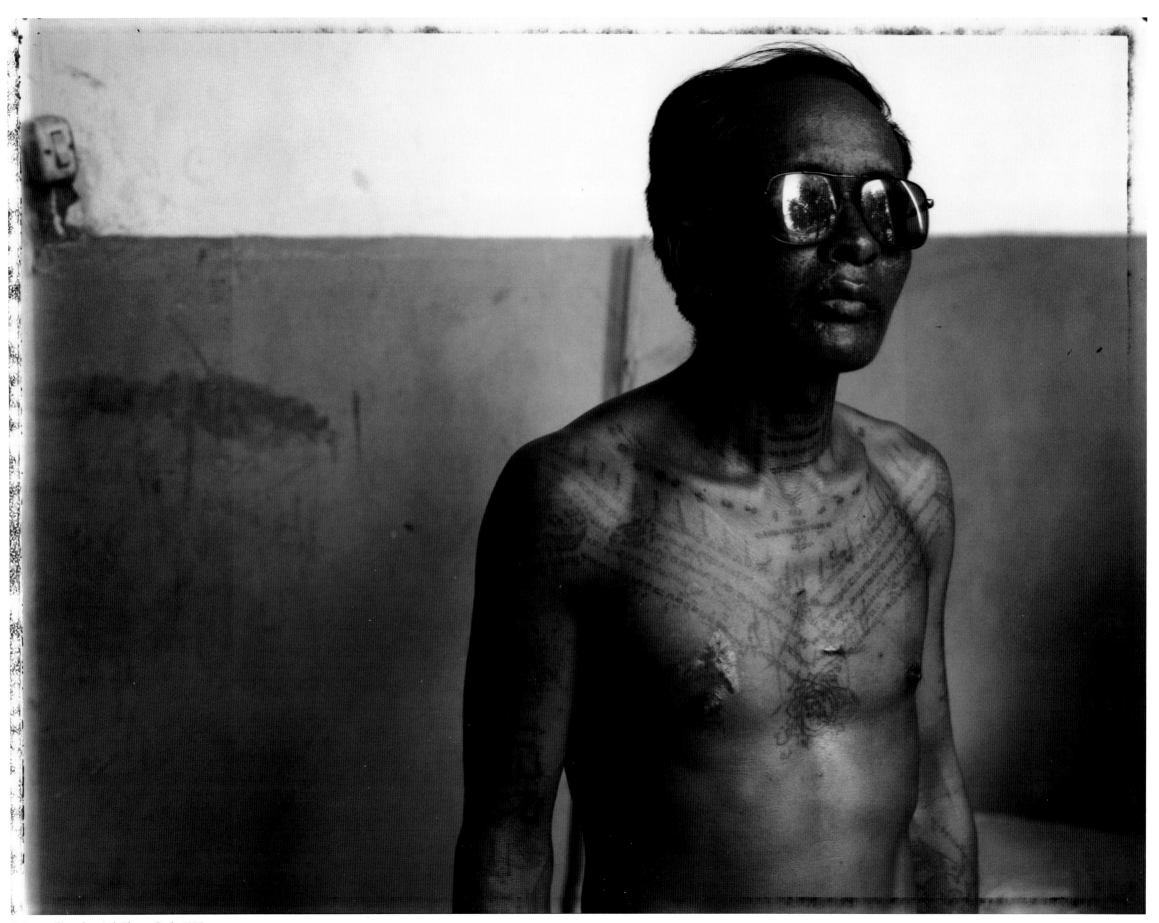

Patient, military hospital, Phnom Penh, 1995

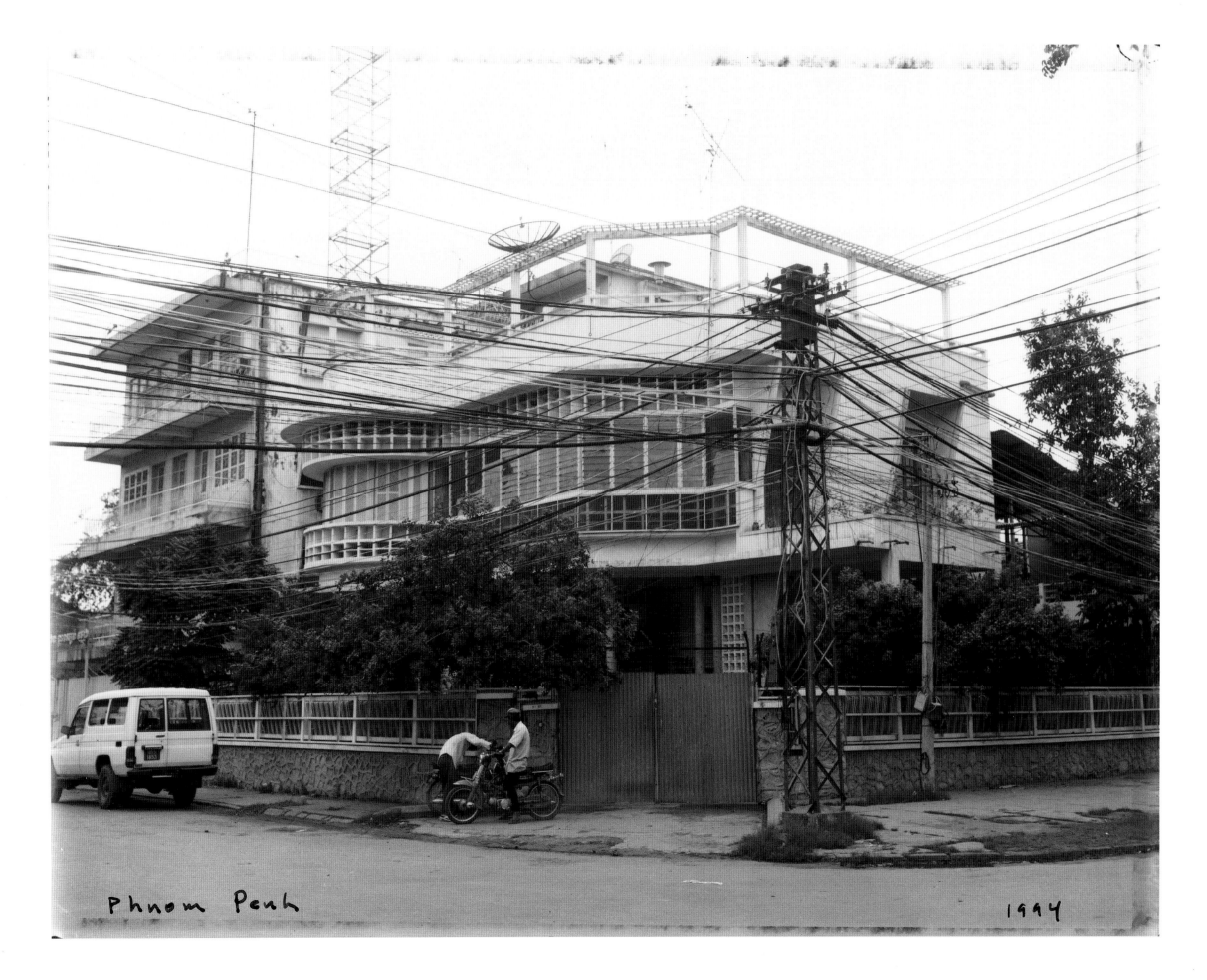

Phnom Penh 1994

Monks' residence, Wat Botum, Phnom Penh, 1995; demolished 1996

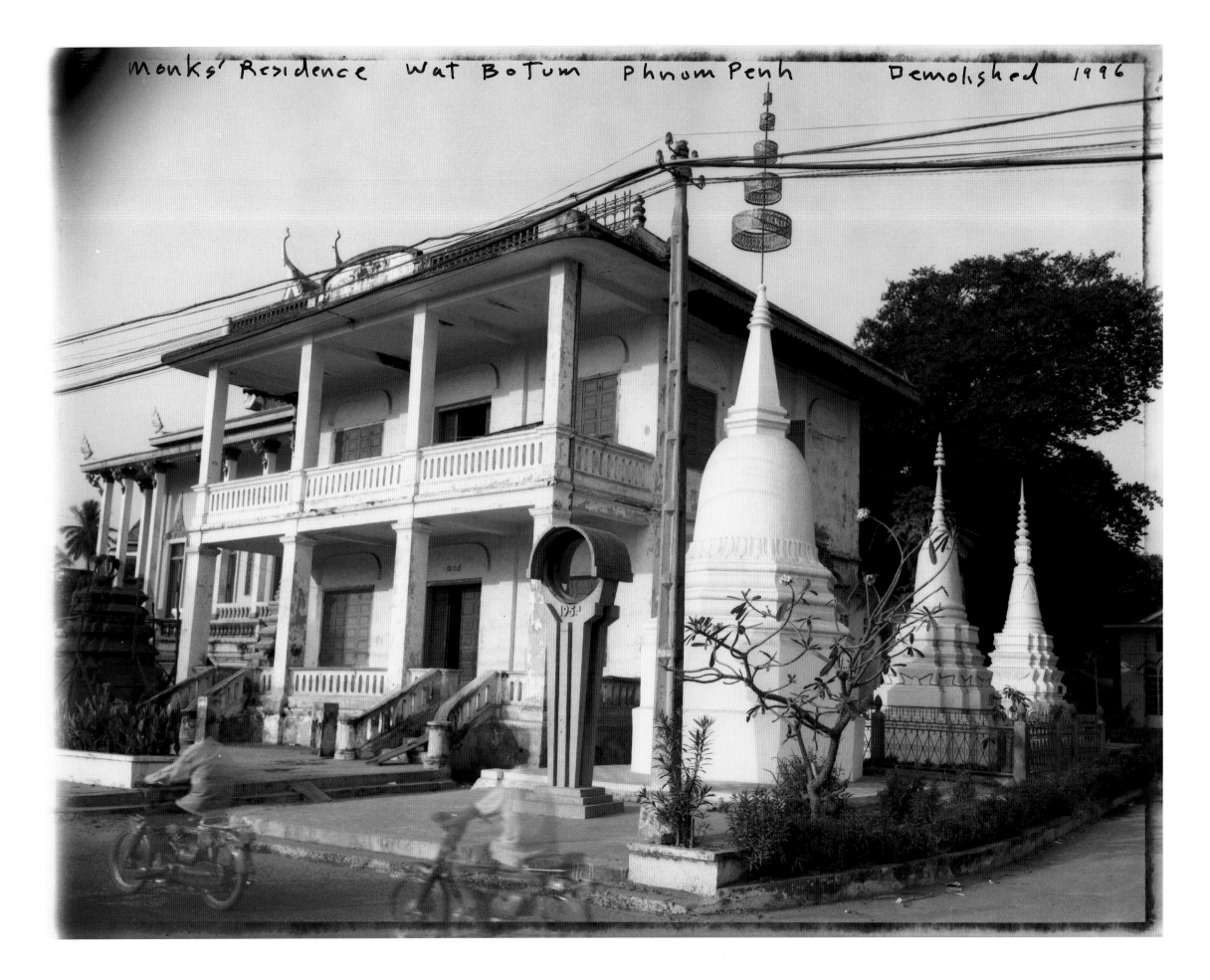

Monks' Residence Wat BoTum Phnom Penh Demolished 1996

Department of Motor Vehicles, Luang Prabang, 1996

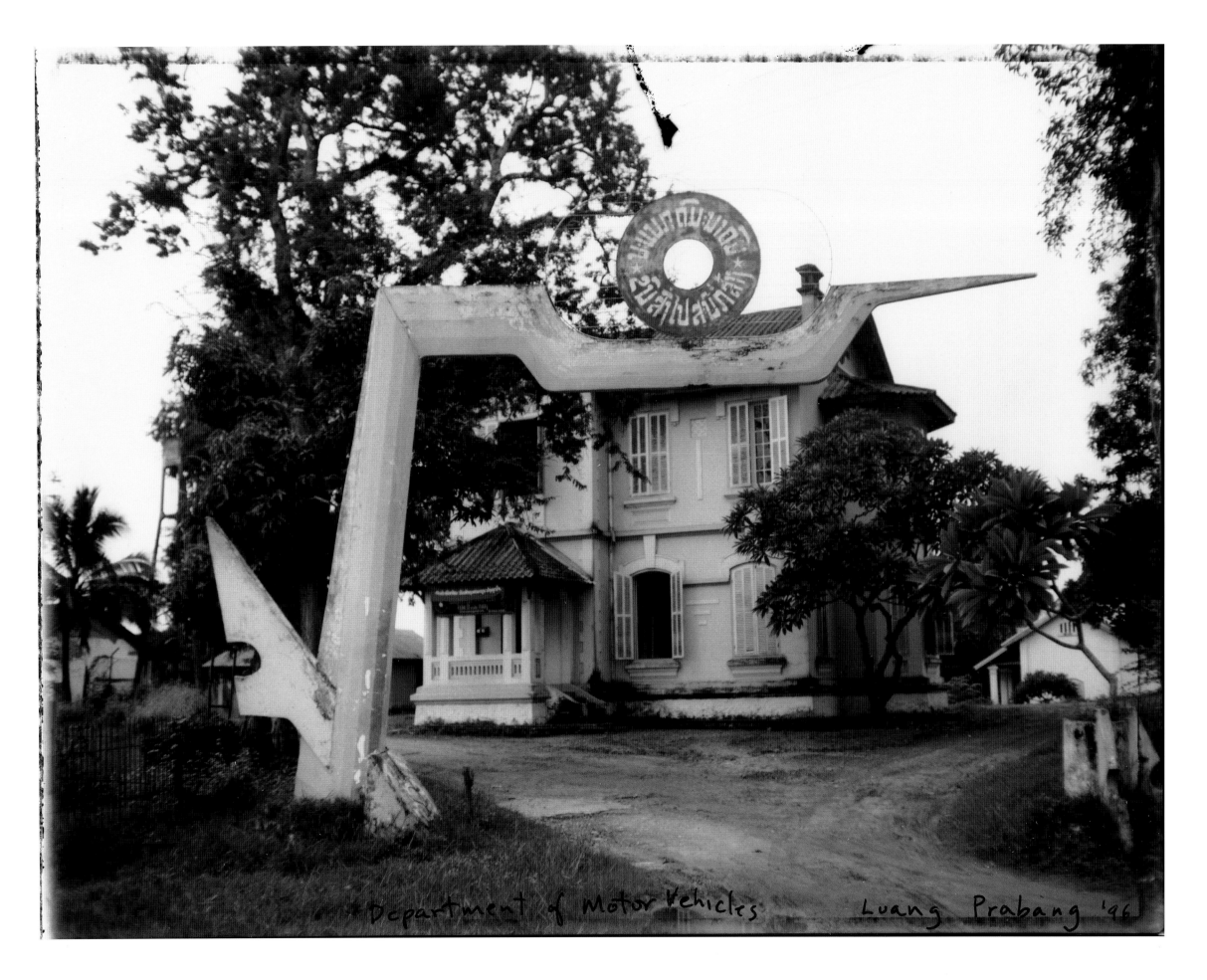

Department of Motor Vehicles Luang Prabang '96

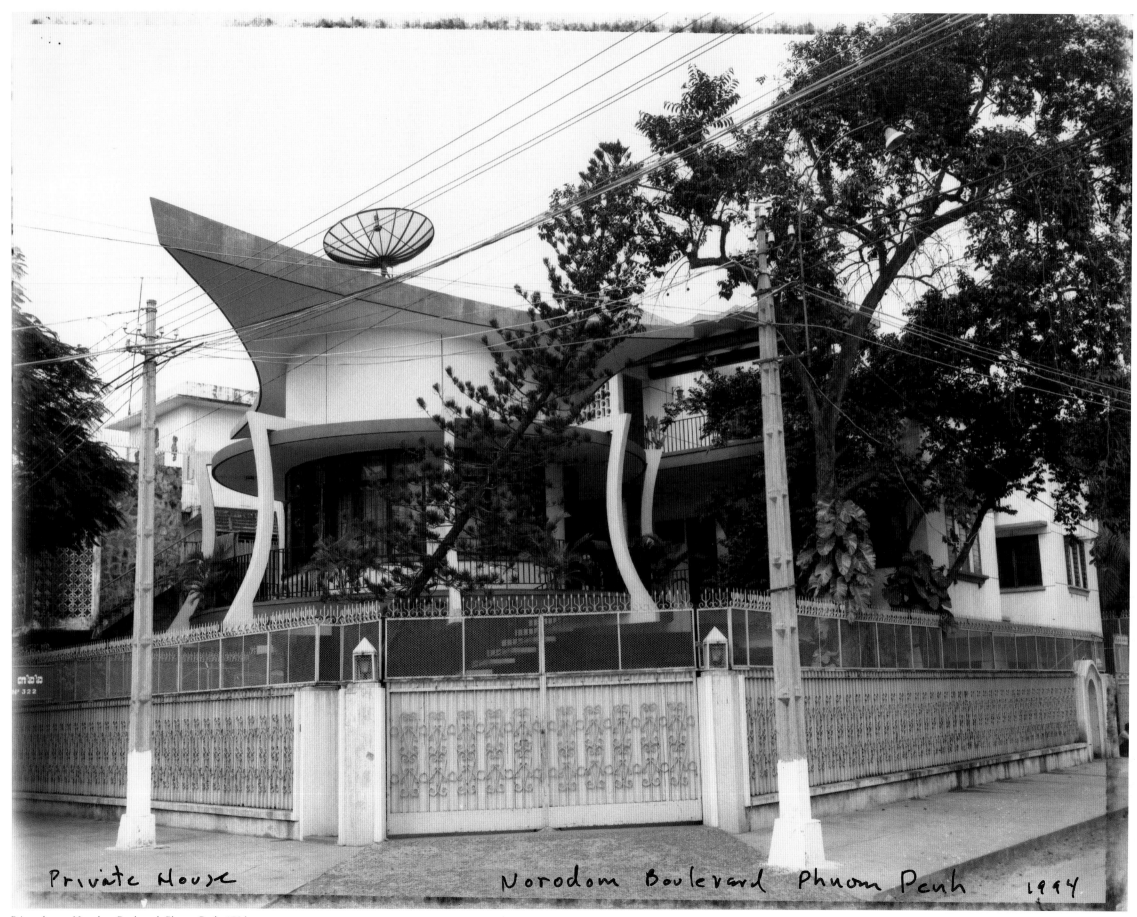

Private house, Norodom Boulevard, Phnom Penh, 1994

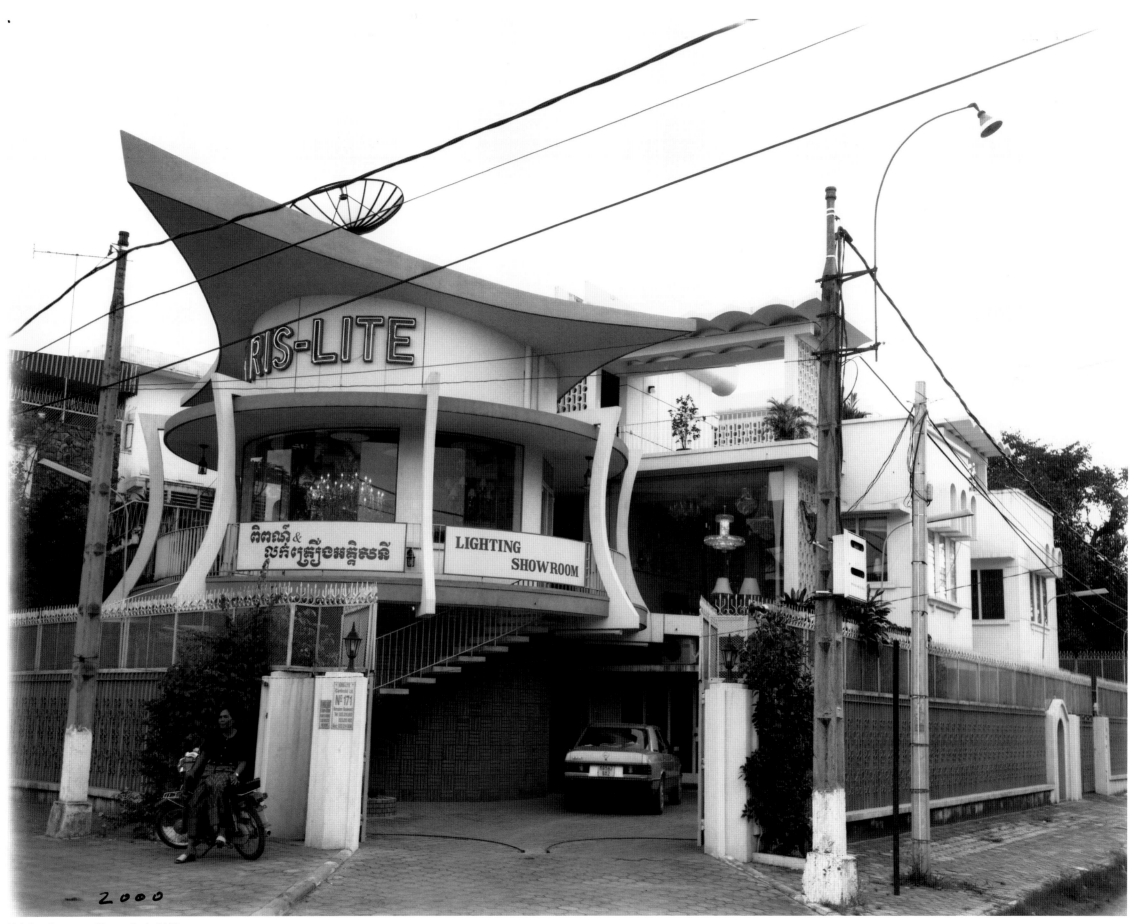

2000

Lighting showroom, Phnom Penh, 2000

Fuel storage, Danang, 1995

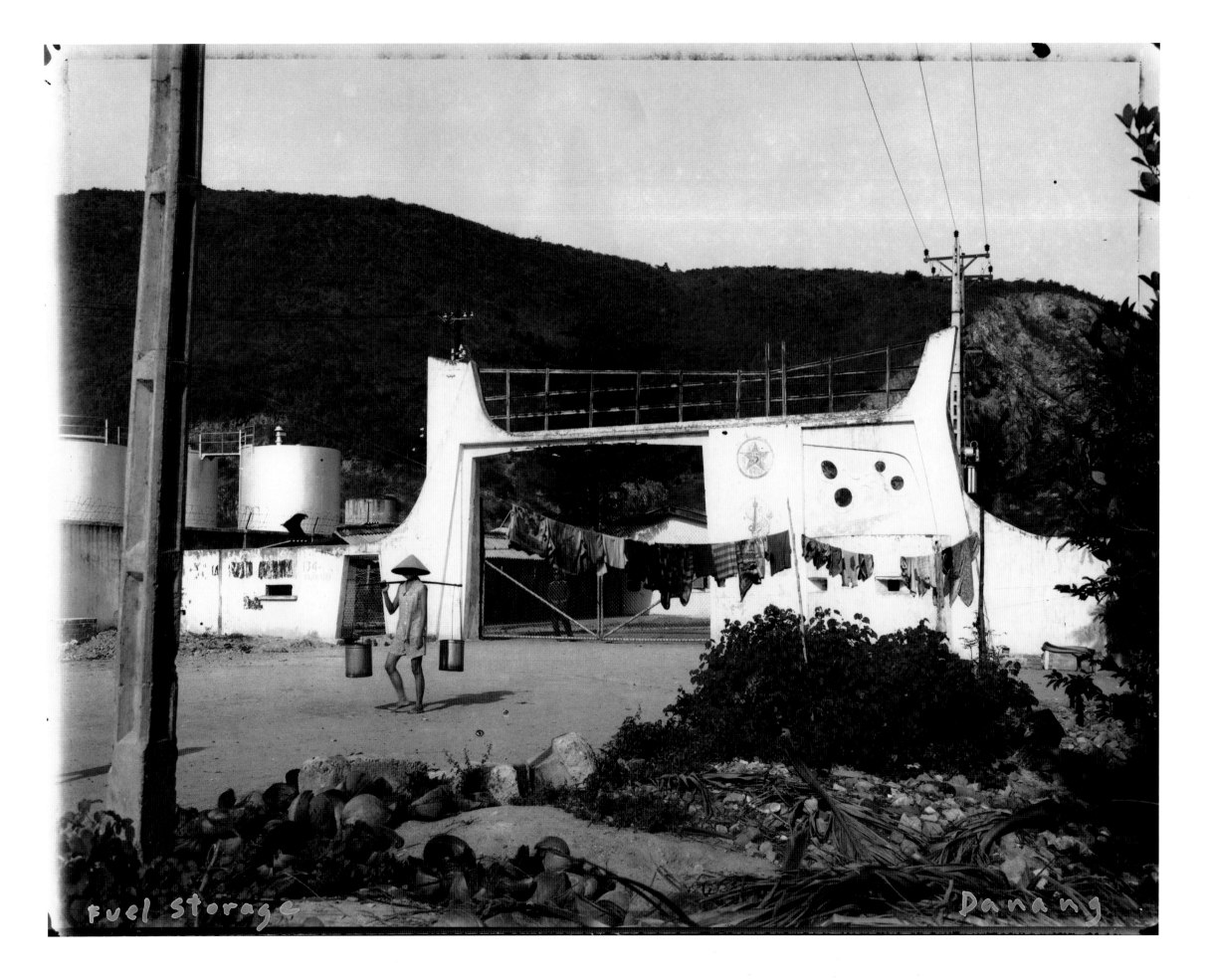

Fuel Storage Danang

Foto minilab, Hanoi, 1994

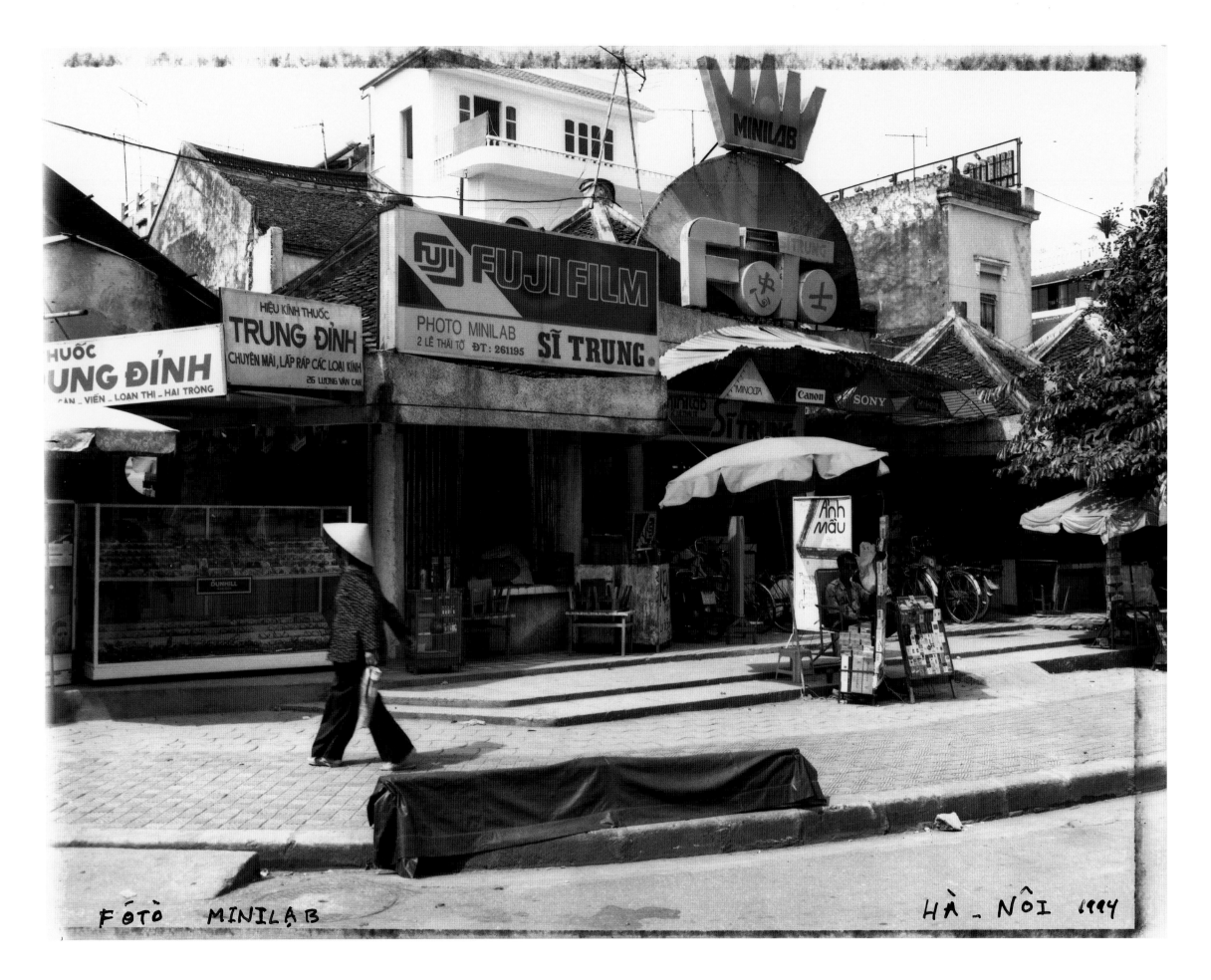

FOTÒ MINILẠB HÀ - NÔI 1994

Hue, 1995

Hue

1995

Apartments for government workers, Phnom Penh, 1995

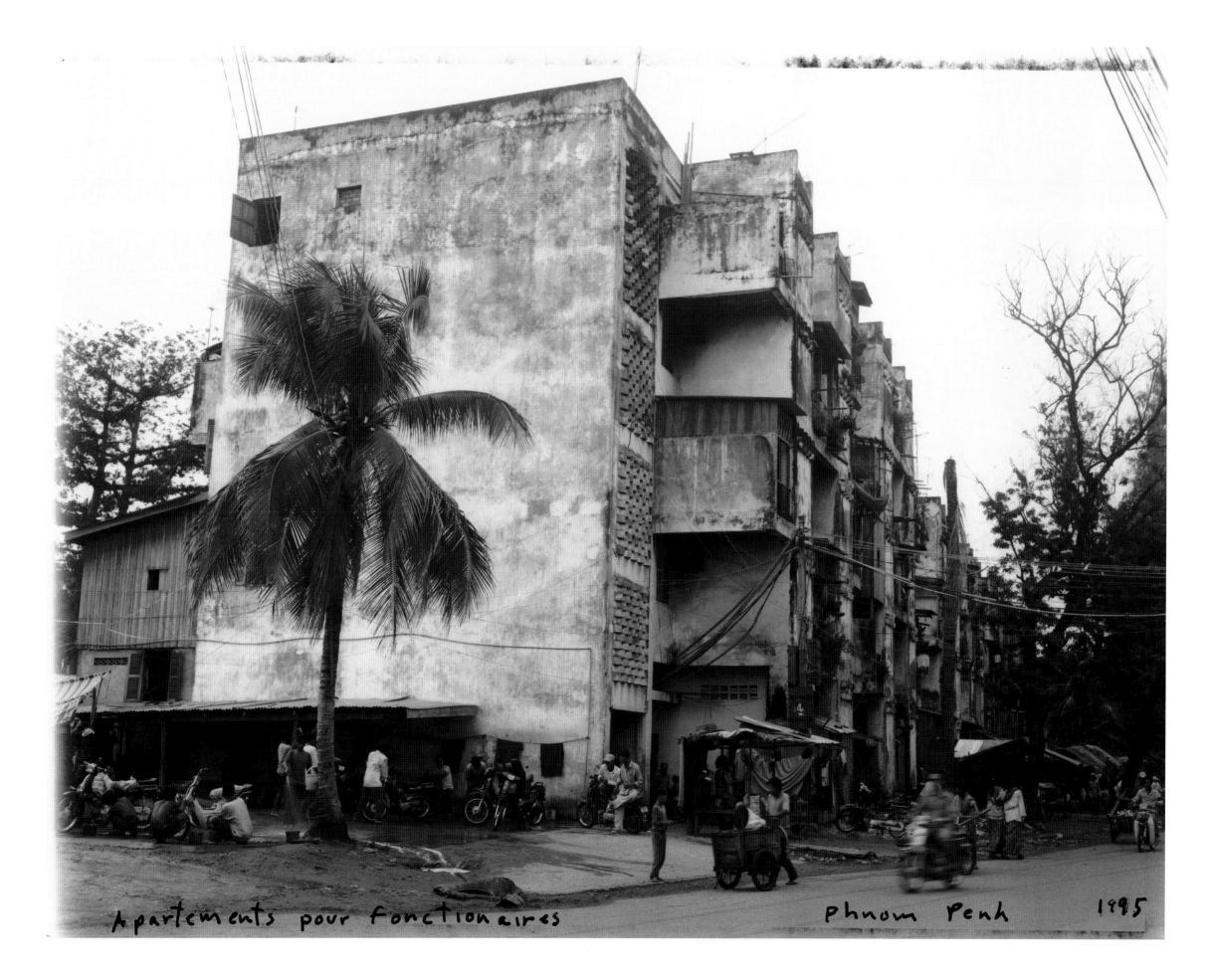

Apartements pour fonctionaires Phnom Penh 1995

Post office, Sihanoukville, 1997

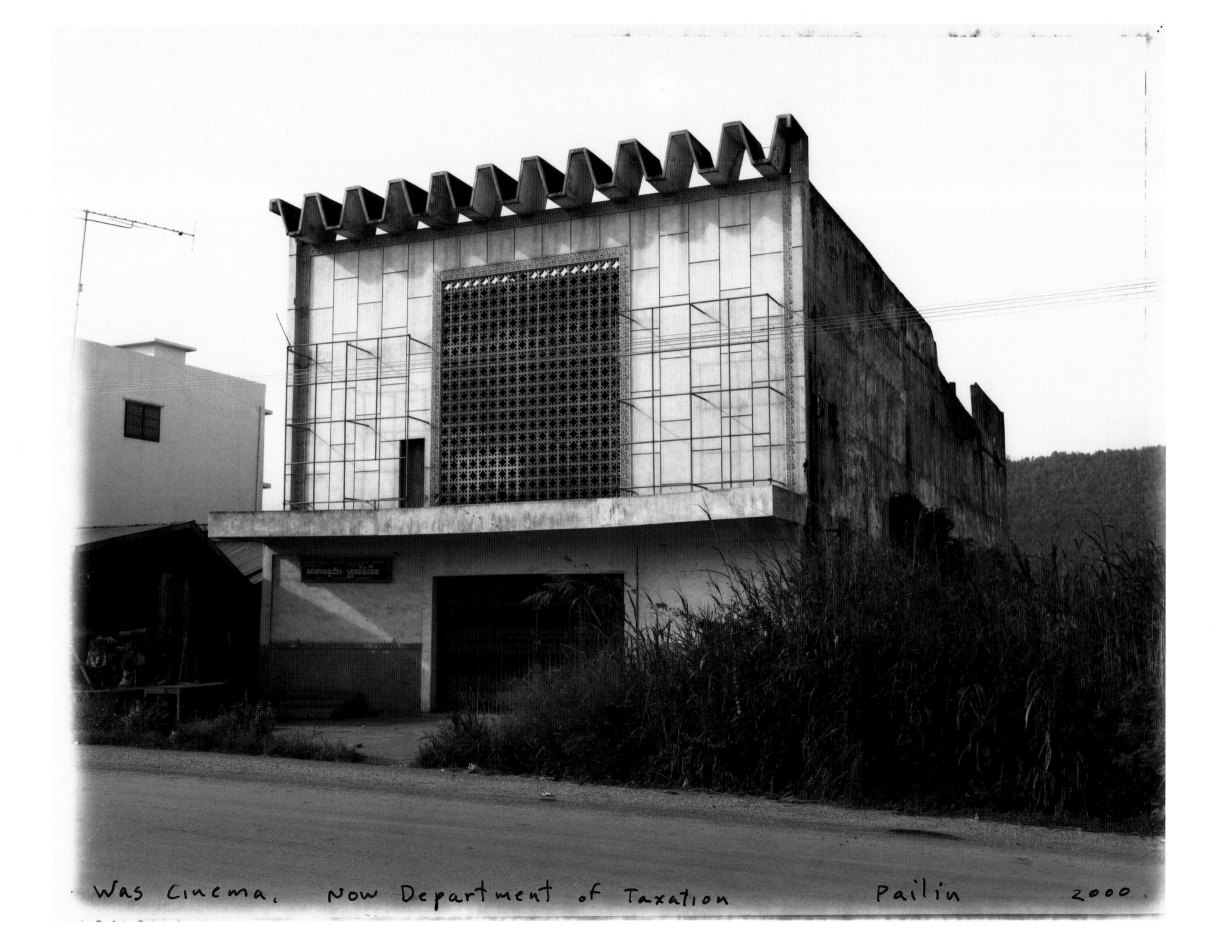

Was Cinema. Now Department of Taxation Pailin 2000.

Communist Party Headquarters, near Hue, 2000

West Lake, Hanoi, 1995

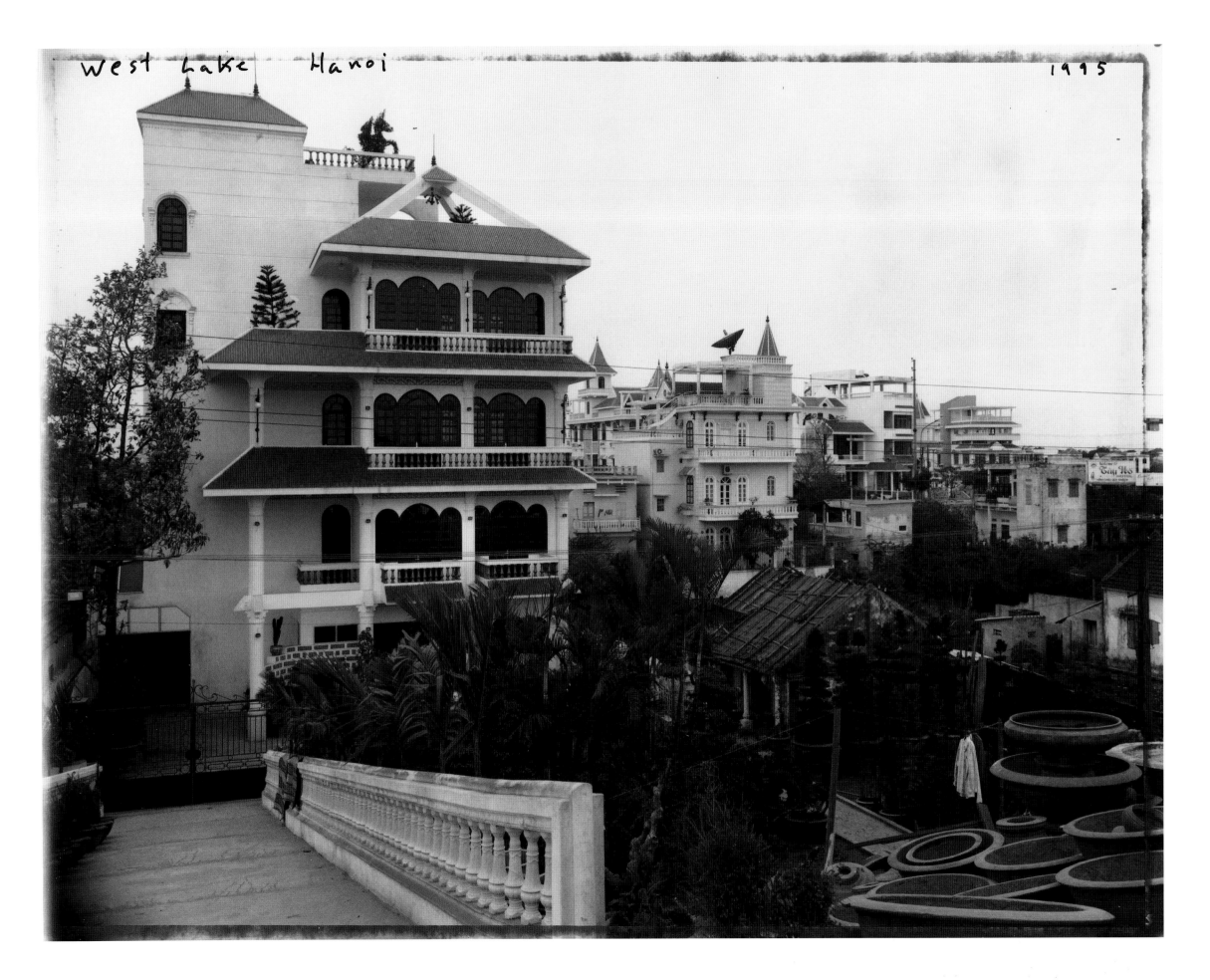

West Lake Hanoi 1995

Short Time Hotel, Hanoi, 1995

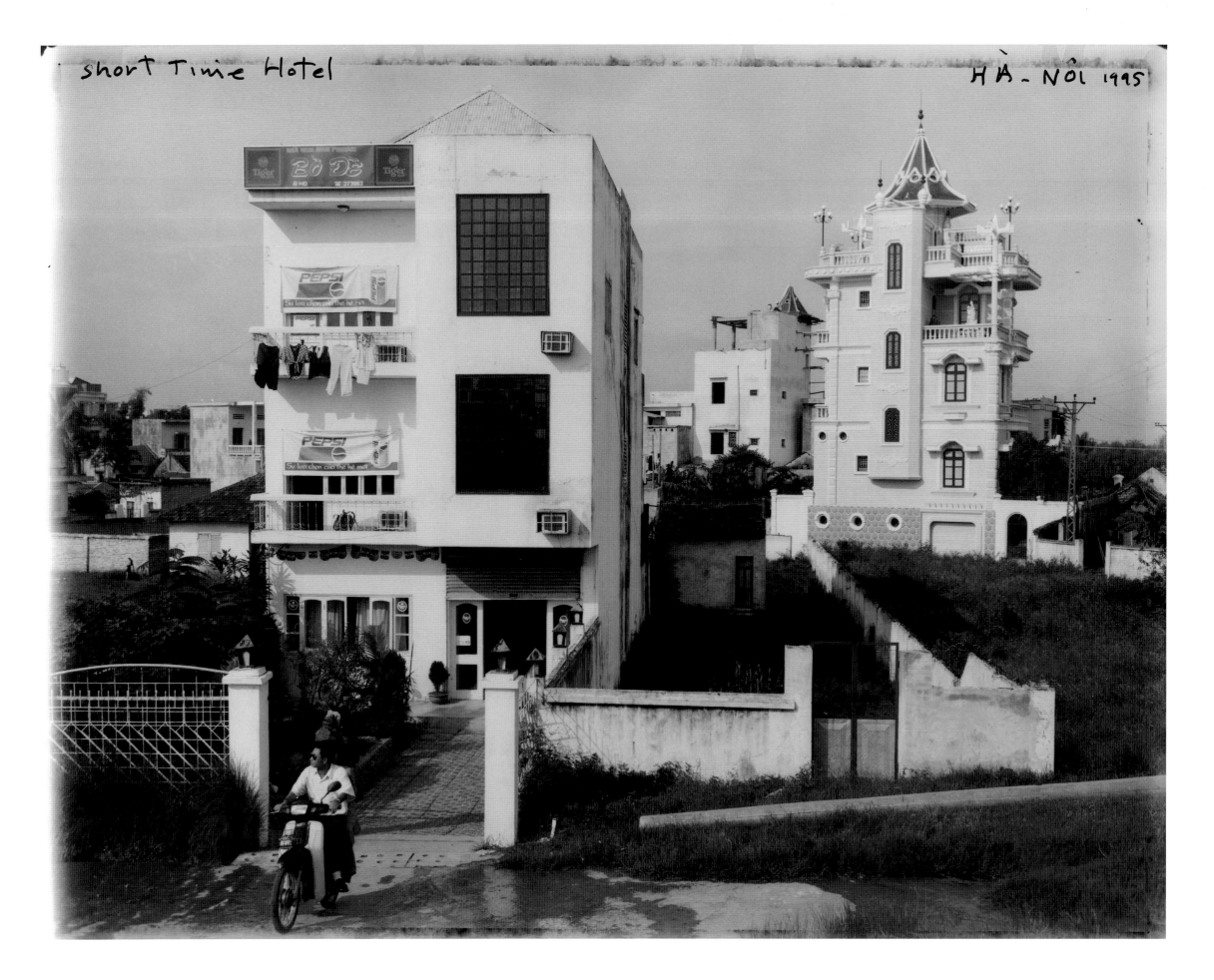

short Time Hotel

HÀ - NÔl 1995

Hanoi, 1995

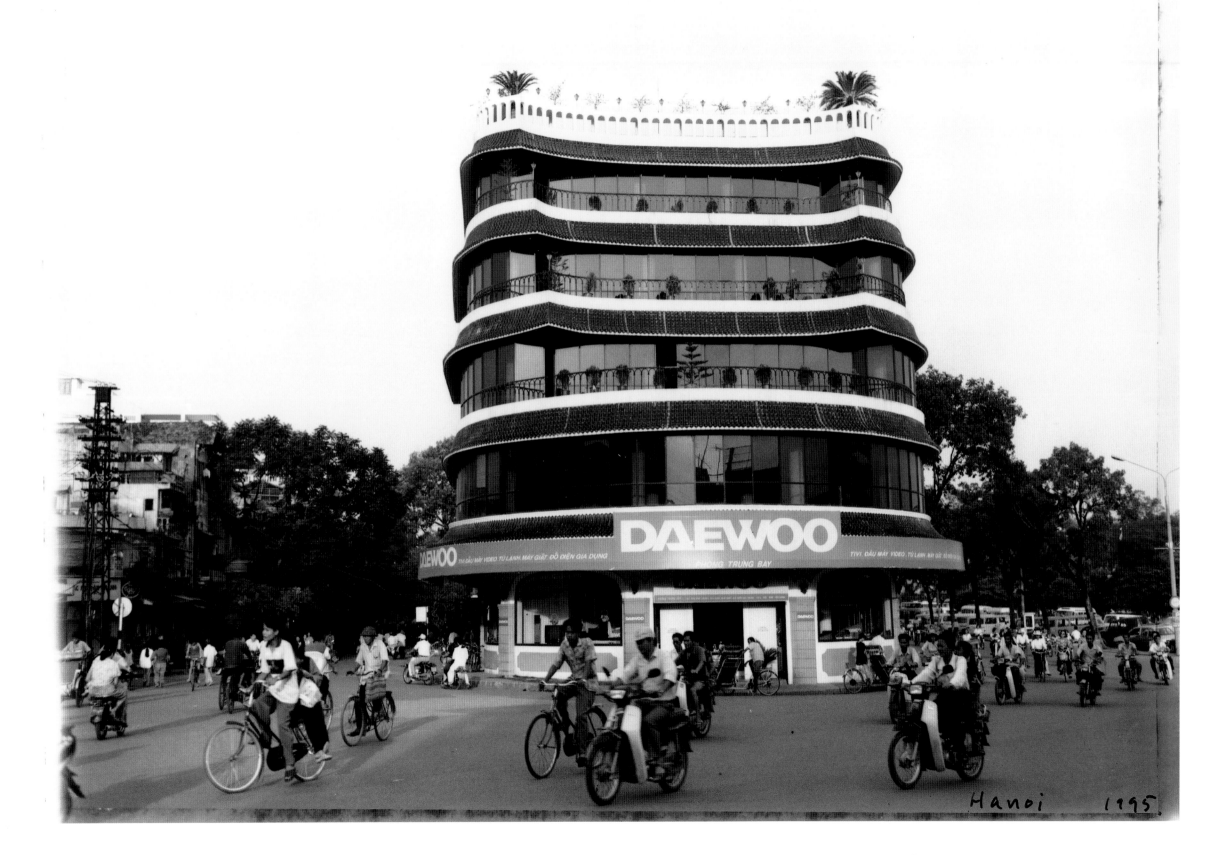

Hanoi 1995.

I've traveled and photographed in Southeast Asia almost every year since 1982. Much of my effort has been to make portraits of people that Richard Nixon would have made my enemies or allies or innocent victims in the sixties and seventies. My interest soon focused on Cambodia, Vietnam, and Laos, countries where I might have been asked to fight in what the Vietnamese call The American War. When I began to photograph there, wrecked B52s jutted out of the lakes of Hanoi. Restaurants in Saigon and Phnom Penh had grenade screens covering their windows. In Cambodia, people were still returning to the cities that had been emptied in 1975 by the Khmer Rouge. Village life was being lived in the capital. Young girls carried water from common faucets in the street down crumpled sidewalks into the mansions of an elite who had either fled or been killed. Cooking fires were made on the decorative tile floors.

My first glimpses of Indochina came at the end of a time when Soviet aid to Vietnam was dwindling and the locally corrupted interpretations of Marxism-Leninism were evolving. Recovery from the vast devastation of the war and the Pol Pot regime was going slowly. Moldering in the humidity and untouched by economic ambition, I found an architectural museum in which was displayed the history of the region. In these former French colonies and protectorates, I was moved by buildings that ranged from municipal offices built by the French in the 1860s to Michelin rubber plantation buildings from the turn of the century and the art-deco fantasy cinemas of the 1960s. I found consulates—built then abandoned by the Americans, and later reclaimed by local governments—still containing the typewriters and office furniture our foreign service left behind in its flight. I looked in Vientiane for the buildings that had been occupied by Air America pilots. I marveled at the stolidity of the recently constructed, regional Communist Party headquarters.

While I have been visiting these countries, they have been welcoming new business and tourism from the outside world with gathering speed. The explosion of capitalism in the region has already begun to devastate an architectural heritage that was well preserved in the refrigerator of socialism. What was not destroyed during decades of war, developers from the West and neighboring countries are busily replacing and defacing with postmodern shrines to commerce and corporate profit. This book is an attempt to preserve in pictures some of the buildings that are threatened or have already been destroyed, to depict the outside influences that have coursed through the region, and to honor the resiliency of the peoples who were struggling among themselves before the first Western trader arrived.

—Bill Burke

Socialism, the shortest route between capitalism and capitalism....

—Jacques Bekaert

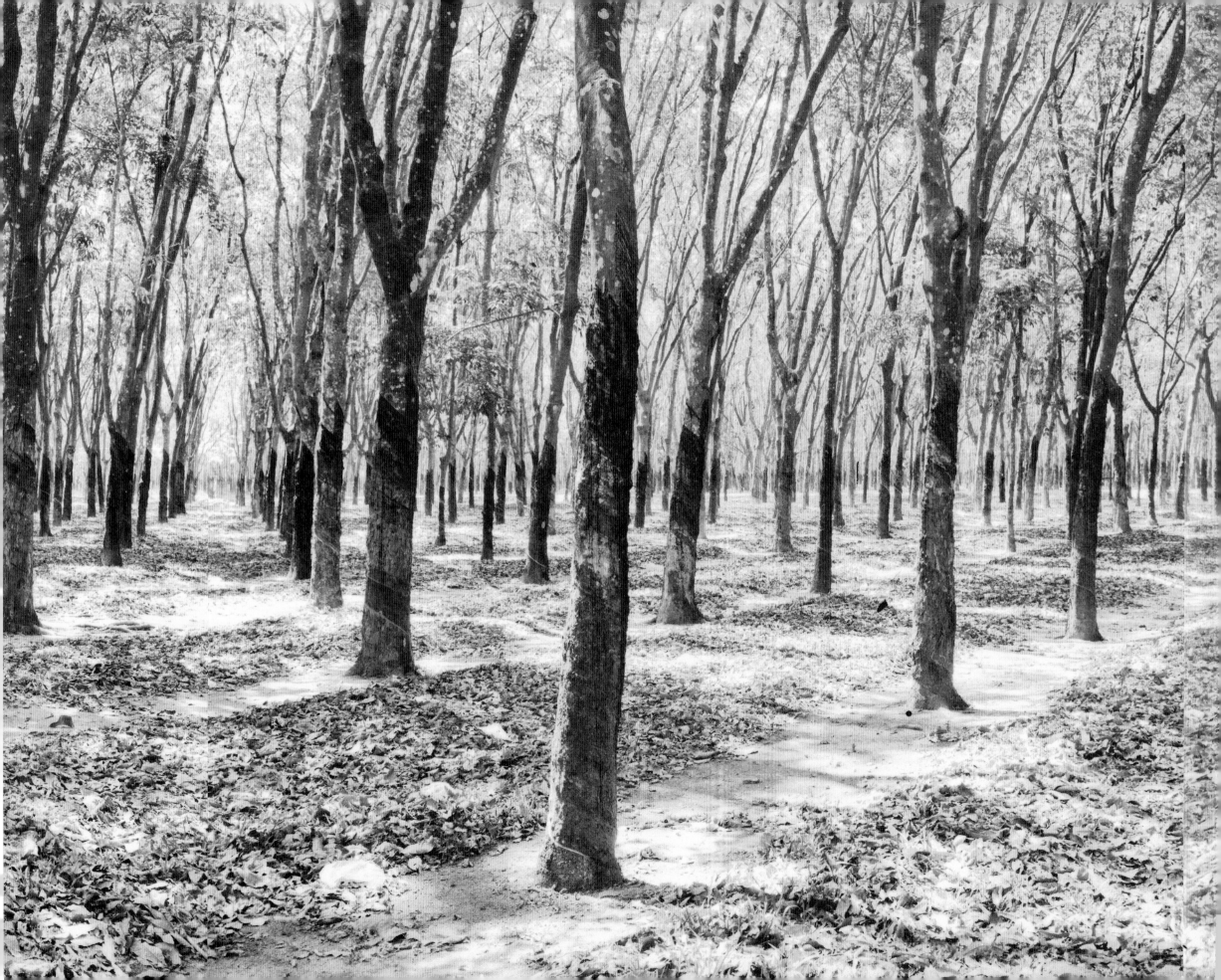